On
Criticism

There is no book like this – clear, sharp, witty, astute, professional, and humane. The reader comes out a better critic and certainly a better philosopher.

<div align="right">Arthur C. Danto, Art Critic, The Nation</div>

Noël Carroll has written a rare book whose intention is not to sell us some fashionable political stance toward the arts, but to throw light on the act of criticism itself – robustly understood as evaluation backed by reasons. This lucid work is bound to become a standard text in the theory of criticism.

<div align="right">Denis Dutton, Editor, Philosophy and Literature</div>

Noël Carroll is Distinguished Professor of Philosophy at the CUNY Graduate Center. He is the author of *The Philosophy of Horror* and *The Philosophy of Art: A Contemporary Introduction*.

Praise for the series

'. . . allows a space for distinguished thinkers to write about their passions.'
The Philosophers' Magazine

'. . . deserve high praise.'
Boyd Tonkin, *The Independent* (UK)

'This is clearly an important series. I look forward to reading future volumes.'
Frank Kermode, author of *Shakespeare's Language*

'. . . both rigorous and accessible.'
Humanist News

'. . . the series looks superb.'
Quentin Skinner

'. . . an excellent and beautiful series.'
Ben Rogers, author of *A.J. Ayer: A Life*

'Routledge's *Thinking in Action* series is the theory junkie's answer to the eminently pocketable Penguin 60s series.'
Mute Magazine (UK)

'Routledge's new series, *Thinking in Action*, brings philosophers to our aid . . .'
The Evening Standard (UK)

'. . . a welcome new series by Routledge.'
Bulletin of Science, Technology and Society (Can)

'Routledge's innovative new *Thinking in Action* series takes the concept of philosophy a step further'
The Bookwatch

NOËL CARROLL

On
Criticism

Routledge
Taylor & Francis Group
NEW YORK AND LONDON

First published 2009
by Routledge
270 Madison Ave, New York, NY 10016

Simultaneously published in the UK
by Routledge
2 Park Square, Milton Park, Abingdon, Oxon OX14 4RN

Routledge is an imprint of the Taylor & Francis Group, an informa business

Transferred to Digital Printing 2009

Typeset in Joanna MT and Din by
RefineCatch Ltd, Bungay, Suffolk

Library of Congress Cataloging in Publication Data
Carroll, Noël, 1947–
 On criticism / by Noël Carroll.
 p. cm.
 1. Art criticism. 2. Arts, Modern. I. Title.
 NX640.C37 2008
 700.1 – dc22

 2008014214

ISBN10: 0-415-39620-4 (hbk)
ISBN10: 0-415-39621-2 (pbk)
ISBN10: 0-203-88112-5 (ebk)

ISBN13: 978-0-415-39620-2 (hbk)
ISBN13: 978-0-415-39621-9 (pbk)
ISBN13: 978-0-203-88112-5 (ebk)

Dedicated to Joan Acocella
A friend in deed
And a critic-in-full

Acknowledgments

The following have generously helped me in the preparation of this book: Joan Acocella, Lorrie Moore, Susan Feagin, Margaret Moore, Aaron Smuts, Kristin Gjesdal, Paloma Attencia, Clyde Dunton-Gallagher, Sunwoo Choo, Kevin Feaganes, Thomas Hilgers, S. Charles Zamastil, Oscar Barragan, Oz Gurland-Blaker, Robert Clewis, Matthew Kieran, Taffy Ross, Khachig Tololyan, Robert Scholes, Cheshire Calhoun, Peter Railton, Geoff Sayre-McCord, Tamar Shapiro, Thomas Hill, Jerrold Levinson, Michael Smith, Maggie Little, Susan Wolf, Valerie Tiberius, Jesse Prinz, and Patrick Joseph Carroll (senior). They are not responsible for the short-comings to be found between the covers of this book. The defects are wholly my contrivances.

Introduction

This book is an exercise in the philosophy of criticism or, as it was once called, meta-criticism. This is a branch of the philosophy of art (or aesthetics) that takes as its object of inquiry the criticism of the arts.

The heyday of the philosophy of criticism stretched from the 1950s into the 1960s. At the time, some philosophers of art believed that meta-criticism was the central topic of philosophical aesthetics. For example, Monroe Beardsley's landmark treatise *Aesthetics* was subtitled *Problems in the Philosophy of Criticism.*[1] Perhaps one reason that meta-criticism flourished in the 1950s and 1960s is that, at the time, skepticism reigned about the prospects of the project of defining art. For, if you couldn't define art, how could you hope to develop a philosophy of art? In its stead, the next best thing seemed to be to construct a philosophy of criticism.

Of course, by the 1970s, definitions of art began to crop up with increasing frequency, along with full-scale philosophies of art, such as that of Arthur Danto. And since that time, the philosophy of criticism has taken a back seat in aesthetics.

However, I think that the time has come to rejuvenate the enterprise, since there is probably more art criticism being produced and consumed now than ever before in the history of the world. Moreover, I feel that we lose a great deal if we neglect the philosophy of criticism, because it not only

Introduction

1

addresses virtually every major problem in the philosophy of art, but it does so in a way in which what is at stake in solving those problems is crystal clear, precisely because it is connected straightforwardly with pressing conundrums about criticism. Furthermore, the manner in which one resolves the pertinent issues may open certain avenues of critical investigation while foreclosing others. And this, of course, is important, since criticism is an indispensable lubricant of the practices of art in contemporary culture.

Indeed, it is just because criticism plays such a vital role in contemporary culture that this is not simply a book for philosophers. Literate consumers of the arts depend upon critics to help them negotiate the avalanche of artworks on offer across an array of different media. For, not only is there more criticism than ever before; there is also more art available now than in any other period of history. We look to critics to recommend and guide our selection of what we shall attend to, and to assist us in comprehending and appreciating the vast amount of work that confronts us. Sometimes criticism introduces us to new ideas. Sometimes we feel the urge to debate with critical pronouncements. But to assent to or to reject works of criticism, we need a sense of what it is—a conception of its nature and function. We—and by that I mean all literate consumers of the arts— need a philosophy of criticism.

The philosophy of criticism patently belongs to the genre of "the philosophy of x." Unlike metaphysics, ethics, and epistemology—which would appear to possess their own subject matter—the philosophy of any x is a second-order inquiry. First-order practices of whatever x it is the philosophy of—such as mathematics in the case of the philosophy of mathematics—comprise its subject matter.

That is, a philosophy of x has as its topic some practice, like criticism, and it attempts to articulate what makes that practice coherent—to illuminate the aims of the practice as well as the concepts and patterns of reasoning that make the rational realization of the aims of the practice possible.

By claiming the mantle of the philosophy of criticism, I mean to signal that I am attempting to reconstruct rationally the practice (or practices) of art criticism. My intention is to try to develop a framework in which the practices of criticism can be rendered intelligible and ordered—at least to the extent that it is feasible to do so—while, in the main, also respecting the ways in which criticism is actually conducted (as well as taking seriously our abiding intuitions about it). I will not attempt to impose upon the practice an ideal of criticism hatched on the basis of some epistemological first principles drawn from elsewhere.

Instead, a consistent effort will be made throughout to stay as close as possible to the ways things are in the trenches—whether those of academia, belle-lettres, or journalism. For, it is against the practice of criticism as we know it that we should test our hypotheses, since, if the truth be told, we have no other touchstone.

Although I think that my conjectures about criticism should accord, for the most part, with the actual conduct of criticism, this book should not be mistaken for sociology, since there is a normative dimension to my investigation of criticism. I will not simply be describing what critics do, since critics themselves do not always agree about what they do or even what they should do. Inasmuch as I will be intervening in these debates and ruling, so to speak, for one side rather than another, I should not be regarded as a neutral onlooker (though I hasten to add that I will maintain that I am an objective onlooker).

Indeed, I will be arguing, for example, for certain standards about what should count as criticism, properly so called, and it will turn out that not everything folks are wont to call criticism will meet the criteria that I defend. For, as I said, this is a *reconstruction* of the practice, one governed by the norm of rationality. That is, I will strive to preserve as much of the practice and our intuitions about it as possible, while simultaneously making it internally coherent.

I suspect that there are a number of differences worth noticing between this book and other contemporary endeavors to canvas the domain of criticism. One difference is that many of those books are comprised of chapters devoted to expounding the rudiments of various different theoretical schools of criticism, such as Lacanian Psychoanalysis, Frankfurt-style Critical Theory, or Derridean Deconstruction, or Deleuzean Rhizome Theory. Each of these theories proposes a general method of criticism, ostensibly applicable to any work and alternative to each other. Books that summarize critical approaches of this level of generality take as their subject matter *theories*—theories about the way to conduct criticism, including a specification of what to be on the lookout for (e.g., sutures or aporias) when engaging in criticism and how to interpret the pertinent features when you find them.

In contrast, my book is neither a theory of criticism nor a summary of fashionable critical theories. Rather it is a philosophy of criticism. What's the difference? It is an attempt to excavate the foundations of any critical practice, whether theory driven or otherwise. Perhaps one way to understand the difference is this: a critical theory—like Althusserian Marxism—tells you how to interpret any art-work, whereas my concern is with, among other things,

the nature of and constraints upon anything that we should be persuaded is an authentic specimen of interpretation, including ones that take their marching orders from theories.

As maybe already insinuated, the majority of critical theories on offer today are primarily theories of *interpretation*. They are about getting the meaning, including the symptomatic meaning, out of artworks. They take interpretation to be the leading task of criticism. In contrast, I argue that evaluation is of the essence of criticism, especially in terms of the kind of artistic category or genre that the artwork at hand instantiates. Whereas I maintain that evaluation is central to the criticism of art, many of the reigning theories of criticism today appear to treat interpretation as key. But I can even envision examples of criticism sans interpretation, so long as they do include evaluation.

Contemporary theoretical critics may scoff at the aforesaid contrast. They will point out that they are quite often involved in a very particular sort of evaluation, namely political or ideological evaluation. Their interpretations, that is, frequently pave the way for negative evaluations of candidates in terms of sexism, classism, logo-centrism, etc. And this is a fair rejoinder.

Yet there is still a difference between us, since, as indicated above, I maintain that what might be called *artistic* evaluation—evaluation in light of artistic categories—is fundamental, whereas the ruling theories of criticism endorse primarily political evaluation and are often even suspicious of artistic evaluation. Of course, I would not contend that political evaluation is never an appropriate dimension of criticism. The difference here is more subtle. It is that I maintain that artistic evaluation is always apposite when criticizing an artwork, whereas many of the dominant theories of criticism do not.

Since my position puts me at odds with some of the most fashionable claimants to the title of criticism today, readers may feel that I have already betrayed my pledge to hew closely to the ways in which criticism is actually practiced. However, that commitment was not a promise to restrict my attention to the prominent styles of criticism of the moment. Rather, the pertinent data should come from a long view of the history of criticism and not merely from snapshots of the academic criticism of the last two decades or so. And in this regard, I maintain that I am not the revisionist here; current fashion is. For, historically, criticism has been generally aligned with evaluation. Moreover, even with respect to the contemporary scene, I am not convinced that criticism guided by Theory represents the predominant form of criticism in terms of either salience or the numbers. I suspect that even most of the criticism being written today is still, first and foremost, evaluative in my sense.

One last difference worth noting between the many contemporary theories of interpretation and my view of criticism is that generally those approaches focus on the operation of sub-personal and sub-intentional processes— such as the unconscious, the forces of production, or the operation of language itself—as the royal road to the meanings they are after. Instead, I place far more emphasis on the artwork as the intentional production of the artist as an individual creator of value. Thus, where many theorists of criticism and their followers in the critical estate are engaged in post-human or even anti-humanist criticism (i.e., criticism not fixated upon personal agency), my conception of criticism is resolutely humane or humanistic in that the achievement of the artist, construed intentionalistically, is, on my account, the pre-eminent object of criticism.

This book is also describable as humanist insofar as it does not recommend a general or theoretical approach to all artworks, but advocates the evaluation of particular artworks on their own terms—for example, in terms of their historical context and category membership. In this sense, I am defending criticism as a humanistic discipline rather than as an arm of some emerging, as it might be called, post-human science.

Lastly, this book may be described as an exercise in humane letters or as humanistic inasmuch as I regard the discovery of value as the primary task of criticism in contrast to the championing of criticism as the almost clinical dissection and interpretation of various codes or signifying systems or regimes of power. Rather, I maintain that evaluation is the crux of criticism and that this inevitable connection to human value is the litmus test of membership in the humanities (a.k.a. humanistic studies). That is, the link with value marks my commitment to humanism.

Although my focus is on criticism, as you will see, I do not regard everyone who sports that label as a critic. For me, the critic is a person who engages in the reasoned evaluation of artworks.* That person may be an academic, a journalist, or some other kind of art writer—so long as she is committed

7 Introduction

* This is the primary task of criticism on my view. There are undoubtedly others. For example, people may read criticism, even of works that they have not encountered and will not encounter, in order to glean clues about the way in which to engage and to appreciate the artworks that do come their way. Moreover, critics play the useful role of the disseminators and circulators of new ideas. Nevertheless, I suspect that these functions, and the other functions that critics play legitimately, derive from their primary role of evaluating artworks in terms of reasons (some of which may involve the new ideas just mentioned).

to backing up her evaluations with reasons. On the other hand, I shall not count as a critic the pundit who simply pronounces this or that to be good or bad. This, of course, will discount many reviewers from the coterie of criticism.

One kind of "critic" who falls outside my purview is the consumer reporter, the reviewer who records his or her likes or dislikes so that readers can use them to predict what shows, or books, or films, they will like or dislike. Another sort of critic manqué, on my account, is the writer who uses the artwork at hand as an occasion for ridicule and nothing else— the writer, for example, who treats the debut of a new television series as an opportunity for comic riffing. This is satire, not criticism.

Admittedly, these sorts of behaviors are most likely to appear in journalistic reviewing. However, I am no snob here. I would not deny that reviewers can be critics in my sense. For example, I think that Dave Kehr, the DVD reviewer for the New York Times, is one of the most reliably level-headed and accomplished motion picture critics in the business. And this is due to the fact that, like all genuine critics, his evaluations are grounded in reasons.*

The hypothesis that criticism is essentially evaluation grounded in reasons is the idea that organizes this book. It is defended in the first chapter. I attempt to offer a positive argument in behalf of this position, but spend a large part of the chapter fending off arguments to the contrary.

The second chapter concerns the object of criticism. The leading idea here is that criticism, properly so called, assists readers in discovering what is of value in the artwork before them. What is of value in the artwork is, on my view,

* For example, Kehr is especially good at contextualizing motion pictures.

connected with what the artist has achieved by means of her work. I refer to this value as "success value," and I defend the priority of success value over what might be called "reception value," the value the audience derives from experiencing the artwork.

According to me, the leading component of criticism is the operation of evaluation. The other activities in which critics engage—including description, contextualization, classification, elucidation, interpretation, and analysis—are hierarchically subservient to the purposes of evaluation. Evaluation is first among equals when it comes to the parts of criticism. The other activities that comprise criticism are generally in the service of articulating the reasons upon which sound criticism is based. The third chapter lays out the components of criticism, minus evaluation, and explores the nature of and the potential problems with each of these critical activities.

Since evaluation is the *primus inter pares* of criticism, it receives a chapter unto itself which examines its problems and prospects. This is the fourth and final chapter. The problems broached in this chapter primarily concern charges that criticism cannot be objective. In response, I try to show that *some* criticism can be objective and to explain the grounds for objectivity with respect to the relevant critical practices. Much of that defense hinges on establishing the possibility of objective classifications of artworks—that is, of inter-subjectively determining the categories to which artworks belong, such as their membership in artforms, genres, movements, styles, oeuvres, and so forth. For, when we fix the category to which an artwork belongs, we avail ourselves of the means for assessing whether or not the work is good of its kind.

Of course, although appraisal of an artwork in virtue of its membership in a kind or class may be the most common form of critical appraisal, sometimes we do issue cross-categorical evaluations of artworks. Thus, the fourth chapter concludes with a discussion of the ways in which cross-categorical evaluations may, at least sometimes, be rationally decidable and objective.

Criticism as Evaluation

One

I. INTRODUCTION

The topic of this book is *art criticism*, by which I mean criticism of any work within a certain group of artforms, including: literature, drama, dance, music, the graphic arts (encompassing photography), sculpture, architecture, and the moving-image arts (film, video, and computer generated visuals). This collection of artforms appears to have begun emerging as an established set around the eighteenth century, and it has been called alternatively the Modern System of the Arts or the Beaux Arts or the Fine Arts (or, more simply, the Arts with a capital A).

In the Middle Ages, an art was merely the correct way of making or doing whatever one happened to be making or doing. There could be an art of cobbling, or navigation, or medicine, as well as the martial arts. These were simply skilled or knowledge-based crafts or practices whose participants, properly so called, were those who had mastered the techniques for achieving the point of the practice at hand. Mastery of pertinent technique (from the Greek *techné* which was then translated into Latin as *ars*) was constitutive of art status in this pre-modern sense.

Nevertheless, around the eighteenth century, a subset of these arts (in the Latin sense) was separated off to comprise what we think of as the arts proper (Art with a capital A)—

i.e., literature, drama, painting, sculpture, dance, music, with the addition, sometimes, of architecture and, more rarely, of gardening. Later, photography, film, video, and computer generated imagery were annexed to the republic of art, and, undoubtedly, more technologies will be conscripted in the future. Informally speaking, we may think of the pertinent group of arts as those that live on the arts quad in universities or are the recipients of awards from organizations like the National Endowment for the Arts.

It is not the point of this book to explain the way in which this system of the arts arose and was initially rationalized or how it has been expanded, though we will return later to its origins in the eighteenth century, since that is when the modern practice of criticism begins to take shape. However, our only purpose now in reminding readers of the extension of the Modern System of the Arts is to earmark the kinds of foci of criticism that concern this book.

So far I have been concentrating on the *art* half of art criticism. Now let me begin to clarify the other half of the concept. *Criticism* as I am using the term is a genre of verbal discourse. Perhaps there is a sense where one painting might be said to "criticize" some other painting, or one piece of pure orchestral music another. But I suspect that such talk is most probably metaphorical. And, in any case, the criticism that I will focus upon herein is linguistic—either spoken or written criticism about artworks in the artforms cited above.

Criticism, needless to say, can come in many gauges. One could take as the target of one's criticism a single novel, such as *To the Lighthouse*, or an individual play, like *The Pillowman*, or one might make an entire stylistic movement, such as Photorealism, the topic of criticism. In what follows, I will be concerned mainly with the criticism of individual artworks.

In part, this procedure has been adopted for the sake of convenience. Examples of the scale of a single work will be more manageable than ones of a more ambitious scope. Yet, the choice is also embraced because I suspect that criticism at this level is primary. That is, criticism of bodies of work of greater magnitudes, it seems reasonable to presume, must ultimately rest upon the criticism of the individual works that make up those more extensive constellations. This is true of negative assessments of the genres and/or movements in question as well as of positive appraisals.

Art criticism is the verbal act of criticizing artworks. Yet what marks such criticizing off from other forms of discourse, notably other forms of discourse about artworks? It is the argument of this book that the distinguishing feature of the pertinent form of criticism is evaluation. Of course, criticism, properly so called, is not merely a matter of evaluating an artwork—of giving it a thumbs-up or thumbs-down. Critics are expected to supply reasons—indeed, good reasons—in support of their evaluations.

Criticism comprises many activities, including: the description, classification, contextualization, elucidation, interpretation, and analysis of the artworks on the docket.* But in

* These operations will be described more rigorously in a subsequent chapter. The meaning of most of the terms on this list is probably pretty obvious. The two exceptions are elucidation and analysis. By *elucidation* I mean giving the meaning of the conventional symbols in artworks such as words and their combinations into sentences, as well as clarifying codified signs by explicating the meaning of such things as the placement of an ostrich egg in a medieval painting. By *analysis* I am referring to the operation of explaining the ways in which the elements in the work function to realize the points or purposes of the work, or how they cohere as a unified whole, or the way in which they manage to embody whatever the work is about.

addition to these procedures criticism also involves reasoned evaluation. Indeed, these other activities are not generally thought to be ends in themselves; they are characteristically undertaken precisely for the purpose of providing the grounds for the critic's evaluation of the artwork in question.

The association of criticism with evaluation corresponds to the origin of the concept. The term "critic" derives from the Greek *kritikos*—one who serves on a jury and delivers a verdict. Notice that, in contrast to certain everyday usages of "criticism" in ordinary English, this notion of a critic as one who delivers a verdict need not be narrowly construed exclusively in terms of a negative verdict. A *kritikos* can issue a positive as well as a negative verdict. Likewise, an art critic in the relevant sense can offer constructive as well as destructive criticism. Although in common speech there may be a greater tendency to associate criticism with something negative (the adolescent beseeching her mother to leave off criticizing her is not asking for maternal praise to desist), ordinary language *also* nevertheless recognizes that criticism is more than fault finding. Critics may also commend and even recommend.

For me, the primary function of the critic is not to eviscerate artworks. Rather, I hypothesize that the audience typically looks to critics for assistance in discovering the value to be had from the works under review.[1] The common reader expects guidance from the critic concerning what is worthy in an artwork. We hope to grasp the value or significance that the critic intends to point out to us. This is, in fact, our leading reason for consulting critics, despite the fact that the title sometimes carries more negative associations.

Therefore, it is my contention that rather than identifying critics narrowly as those who carp about every artwork that comes down the pike, the plain reader more fundamentally

regards the critic as a skilled discriminator of quality in her chosen domain—whether literature, painting, sculpture, or whatever; that is, as someone who is capable not only in evaluating artworks, but who is also expert in the sense that she is adept at backing those verdicts up with reasons.*

Of course, what I have said so far may strike you as completely unobjectionable and bland. I have boasted that it is the argument of this book to establish that criticism is, first and foremost, evaluative discourse supported by reasons. Yet you may be tempted to say that by calling this observation "the argument of this book," I am indulging in an inexcusably pretentious and over-inflated gesture of self-congratulation. Doesn't everyone know that this is what criticism is? Haven't previous paragraphs established that this is what etymology and common sense take criticism to be? Isn't it blatantly trivial—clear to all with eyes to see and ears to hear that criticism is connected to evaluation?

The short answer is "no."

Throughout the twentieth century, there have been numerous arguments designed to sever criticism from evaluation. In our own day, in a recent poll of practicing art critics (by which I mean critics of painting, sculpture, photography and architecture), 75 percent of the respondents reported that rendering evaluations—their own personal assessment on the artwork at hand—was the least significant aspect of their work.[2] But, one does not need polls in order to confirm the

* That is, on my view, critics are beholden to the canons of reason. This is not to deny that sometimes critics, properly so called, may fall short of this ideal. Rather, I contend only that genuine critics are committed to describing accurately and reasoning validly (even where their premises may mislead them).

reluctance of many critics to broadcast evaluations.* It is evident in what they write. Indeed, an art critic as prestigious as Arthur Danto of the *Nation* explicitly disavows that evaluation is part of his job description.[3] And turning from the domain of fine art to those of theater and dance, Frank Rich, formerly the drama critic of the *New York Times*, has said: "For me, passing judgment on a play is absolutely the least interesting part of the job"; while Deborah Jowitt, the lead dance critic of the *Village Voice*, says that she does not like to sit in judgment over others.[4]

In the next section of this chapter, I will attempt to refute some of the most influential reasons offered by our contemporaries in favor of jettisoning the work of evaluation. However, before defending the view that criticism is essentially evaluative negatively—that is, by taking on all comers—let me suggest that there are some positive philosophical considerations on behalf of my view, in addition to those already advanced on the basis of the history of the idea.

I want to argue that criticism necessarily or essentially requires evaluation, notably evaluation or appraisal grounded in reason and evidence. But why think that? Well, because otherwise art criticism is not really distinguishable from comparable forms of discourse about art.[5] For example, certain forms of historical discourse about art will mobilize

* It may seem as though if 75 percent of practicing critics have so low an estimation of their role as evaluators, that should count against the thesis that criticism is essentially evaluation, especially for someone like me who claims to be modeling the practice as it is. However, I would contend that the phalanx of critics polled above is quite slight when weighed against long-standing historical trends in the practice of criticism (not to mention contemporary criticism of artforms other than the fine arts).

description, elucidation, contextualization, classification, interpretation, and/or analysis. For example, an economic historian of art might describe and analyze Rembrandt's tendency to have large swaths of black in his pictures in order to explain that in this way Rembrandt was able to undertake, for the purpose of maximizing his profit margin, a very large number of commissions, since those empty, unarticulated, black spaces of canvas could be painted very quickly. Or, the art historian might describe and analyze Otto Dix's turn to distortion as the result of his suffering a stroke to the right hemisphere of the brain, or the diffuse detail and the predominance of red in Rembrandt's late painting as a function of the inevitable aging of his eyes.

But what differentiates historical discourse of the preceding sort from criticism, properly so called? The notion that, additionally, criticism engages in evaluation provides us with a ready differentia or rationale, which suggestion is also amply supported in everyday speech. Thus, the challenge that confronts the skeptic regarding the claim that criticism is essentially concerned with evaluation is to propose another distinction—a more effective and more persuasive dividing line between criticism and comparable modes of discourse— than the one I am advancing.*

Under the rubric of criticism we include a number of operations including the description of the artwork, its contextualization, classification, elucidation, interpretation, and analysis. But criticism is not the only form of verbal

* Of course, the skeptic might also wish to deny that there is a difference between criticism and these other forms of discourse, but that would appear to defy the intuitions readily available in ordinary usage.

discourse that incorporates these activities. In our own times, with the advent of semiotics (perhaps most decisively after Roland Barthes' popular book *Mythologies*), and the subsequent emergence of cultural studies, performance studies, visual culture studies and their vicissitudes, the procedures once reserved for the discussion and illumination of artworks have been aimed at everyday objects and practices, often in order to divulge the operation and/or significance—frequently said to be primarily ideological in nature—of quotidian phenomena, such as the language and role-playing of the female escorts at dating services.

Yet what distinguishes the application of the subroutines of the art criticism of yesteryear from their deployment in the arena of inquiries like cultural studies today?

The answer cannot be simply that art criticism takes art as its object, and that semiotics, cultural studies, et al. do not, since these latter-day inquiries sometimes do elect to focus upon artworks of the sort stipulated above. Rather, the best posit available in order to discriminate these genres of verbal discourse from art criticism appears to be that, in addition to description, elucidation, classification, contextualization, interpretation, and/or analysis, art criticism, properly so called, *must* involve something else, viz., evaluation.*

This is a positive defense of the notion of criticism as quintessentially evaluation (appraisal backed by reasons). But what are the arguments against this view?

* Evaluation appears to be not only the feature that sets criticism off from comparable discourses. It would also seem to be the central aim of criticism insofar as the other parts of criticism appear hierarchically subservient to it. But more on this in the next chapter.

II. THE RETREAT FROM EVALUATION

The reasons on offer for eschewing the ineliminability of evaluation for criticism are various and differ in their manner of resistance to the notion that criticism is by its nature evaluative. In some cases, the rejection of evaluation is based upon the idea that it is not necessary or that it is redundant. On other views, it is that there is something counter-productive, suspect, illegitimate, or even impossible about regarding criticism as essentially evaluative. I cannot hope now to survey all of the reservations about the identification of criticism with evaluation, though I will attempt to capture a fair sample of them. Furthermore, some of these objections will require more detailed and protracted engagement in later chapters. In this section, by providing initial responses to some frequent objections, I am only trying to defend a *prima facie* case for the primacy of evaluation by shifting the burden of proof to those who would deny it.

Perhaps one reason for rejecting the view—that an essential feature of criticism, properly so called, is reasoned evaluation—is that I have misplaced the moment of evaluation. I have the evaluation emerging from various supporting operations, such as description and interpretation. But it may be urged that evaluation really comes way before that and, more importantly, in a manner that fails to differentiate criticism from neighboring forms of verbal discourse. Consequently, evaluation is not sufficient to the conceptual task I've assigned it.

This argument is based on the fact of selection. That is, the critic must select an object of criticism and selection is a form of evaluation. The critic in the act of criticizing is privileging one object of attention over others. Evaluation is built into the operation of directing our attention to one thing rather than

another. Thus, the critic starts with evaluation. But, it may be argued, so does the mere historian, the semiotician, etc. Criticism does involve evaluation, but so does everything else from which I had hoped to segregate it. So, my hypothesis fails to provide us with a sufficient condition for differentiating criticism from adjacent forms of verbal discourse.

The problem with this view, however, is that the identification of selection with evaluation seems suspect on a number of fronts. The critic need not have selected the work she is criticizing. It may have been assigned to her, by her editor if she is a journalist or by the curriculum if she is an academic.

Moreover, the idea that selection is evaluation seems connected to the idea that selection, inasmuch as it is evaluation, is a matter of positively evaluating or privileging the work so selected. But one may negatively evaluate what one has elected to criticize, as well as what one has been delegated to criticize. Thus, the notion that with selection comes evaluation is specious and, therefore, the argument before us does not evaporate the difference between criticism, properly so called, and other genres of comparable verbal discourse. Reasoned evaluation in my sense of evaluation—in contrast to the dubious selection = evaluation viewpoint—is still viable. Indeed, even if the premise that selection = evaluation were true, that will still not logically preclude the reasoned evaluation hypothesis, since reasoned evaluation could be an additional and distinct form of evaluation, coming at the end of the critical operation rather than at the beginning, as the selection argument presupposes.

In response, it might be urged that whenever art historians or practitioners of cultural studies elect a topic for study, they are implicitly signaling that "This topic is worthy of study."

But it is a matter of equivocation to erase the distinction between claiming that a topic is worthy of academic study and asserting that there is something valuable about the work. The Holocaust is worthy of study, but historians of the Holocaust are not claiming that it was a vehicle of positive value.

It may also be suggested that evaluation is not a necessary condition for criticism. That is, evaluation is not a requisite element in criticism, since not all criticism involves evaluation. One rarely finds an academic critic at a conference or even in the classroom wrapping up a critical presentation by saying: "And on the basis of my description, classification, contextualization, elucidation, interpretation, and analysis, we see that King Lear is a play that possesses genuine value, in fact, a great deal of it." Such a statement might strike listeners as redundant and even pedantic.

This observation rings true, but it is not clear that it shows what its proponent intends. Since it is through operations like interpretation, description, analysis, classification, contextualization, etc. that one grounds one's evaluations, when it comes to criticizing canonical works, if, for example, these routines bring to readers a view of the unity, complexity, sophistication, and wisdom of the work, then it may not be necessary to round off one's critical remarks with overt commendation. The recommendation may be implicit. But this only shows that the evaluative moment in criticism need not be explicit. Such examples only indicate that it need not always be voiced. Evaluation, that is, may be implicit in context and, therefore, cases like the one involving King Lear are not genuine counterexamples.*

* I think that when it comes to canonical works, the listener or reader's default assumption is that the interpretation, etc. presented by the critic is

In a related vein, some critics, notably Arthur Danto, have claimed that evaluation is not part of the critic's job.[6] It is someone else's responsibility. Following up on the previous example, it may be alleged that it is the canon's responsibility to elect the good works. After the valuable works have been so anointed, then the critic goes to work analyzing them, interpreting them, etc.

Danto himself is primarily a critic of the visual arts. On his view, it is not his job to evaluate the works he writes about. Rather, institutions like museums, galleries, art fairs, biennials and the like select certain works for attention and thereby implicitly evaluate them. The curator is the decider, or, at least, the evaluator. She exhibits pieces for our attention and for the attention of the art critic. And then the art critic digs in, contextualizing, analyzing, interpreting etc. The education of the audience, it might be said, is the critic's primary brief.

Danto's view is also connected to his philosophy of art. Like Hegel, Danto thinks that something is an artwork only if 1) it is about something and 2) it embodies whatever it is about in a form appropriate or fitting to its content. This supplies Danto with his critical agenda. First establish what the work is about by means of description, classification, contextualization, and interpretation and then analyze the ways in which the form in which the content is embodied is suitable or appropriate. Putatively, for example, the gallery elects the work as valuable and then the critic explains why.

supposed to support a positive evaluation. With a canonical work, if the critic means her interpretation or analysis to count against the work, she will usually have to make that explicit. Moreover, with recent and/or otherwise non-canonical works, analyses of the work are advisably accompanied with explicit, positive evaluations.

Explanation not evaluation is the critic's job. The critic explains how the work works.

Yet not only does one find evaluative terms incidentally peppering the writings of Danto and of others who deny that evaluation is part of their job description. In at least one respect, normativity seems essential to Danto's enterprise. Recall that part of the critic's task for Danto is to demonstrate that the form in which the content of the work is embodied is *appropriate* to whatever the work is about. Consequently, it would appear that the critic must assess whether the form is appropriate as well as explaining how it manages to be so. But surely, *pace* Danto, determining whether the form of the work is appropriate to its content is evaluative. It is tantamount to declaring the work a success.

Moreover, Danto's conception of the institutional structure of the art world runs into some problems that are not unrelated to the selection-as-evaluation idea. It is not self-evident that in merely selecting certain paintings for exhibition, the curator or gallery owner is evaluating them positively. It may be that what is intended is an exhibition of egregious art akin to anthologies of bad poetry,[7] or it may be that the art on display is work of questionable value by an influential artist or patron which must be shown for economic or even political reasons. Indeed, turning to the art of film, a producer may release movies in a certain genre not because he evaluates them positively, but because he needs product for a hungry market.

Of course, one might say in defense of Danto's view that usually when a gallery, or a museum, or for that matter a publisher or a film producer, presents an artwork to the public, the default assumption is that he is recommending it as a candidate for positive evaluation. But the presenter in

simply presenting the work is not typically grounding claims about the goodness of the work in reasons and reasoning. That remains the critic's task.*

Danto himself discharges that responsibility when he shows the reader the appropriateness of the form of the work to its content (to what it is about). Even if he refrains from stamping the work outright with his seal of approval, his demonstration of the appropriateness of the form is one way in which he implicitly signals his conviction concerning the artistic value of the work.

Artists often complain about evaluative criticism. You often hear that evaluative criticism is not productive. It doesn't support the arts. This, of course, is to think of evaluative criticism solely in negative terms. But there is positive and constructive evaluative criticism as well. Moreover, even negative criticism may be productive, since it may lead to improvement. One reason that we engage in reasoned criticism with people is that people, even artists, unlike rocks and the insects that live underneath them, can be influenced by it. Criticism, even negative criticism, can encourage change for the better.

Artists also question evaluative criticism because they think it is mean-spirited. From their viewpoint, the critic pontificates by leveling witty barbs at hapless artworks at the expense of the artists. Of course, there are so-called critics who specialize in savagely ridiculing whatever they review and there are readers who relish these public tongue-lashings.

* Although a presenter could *also* be a critic, were she, for example, to accompany the presentation with a pamphlet explaining the value of the work. That is, there is no reason that one person could not perform both roles, even though the two roles remain distinct.

But buffooneries hardly count as *reasoned* evaluations. They are often more of the nature of comedy routines.

Also, some artists dismiss critical evaluations on the grounds that since the critic is not an artist, she cannot possibly be in a position to assess the work. But there is no reason to suppose that critics are uninformed about the artworks they contemplate. It is only mean-spiritedness on the part of artists that suffers this charge to persist.

Sometimes artists claim that evaluative criticism is prescriptive and that prescription has no role in the realm of art.* That is, no prescriptions should stand in the way of the explosion of artistic creativity. For the moment, I will leave to one side the question of whether prescription is ever appropriate with respect to artistic creativity. It is more important to confront the notion that a critical evaluation is equivalent to a positive prescription or directive.

A critic may judge a specific artistic choice to be ineffective, but that does not entail mandating another choice, i.e., making a positive prescription. The critic may find the last chapter, "Bellerophoniad," of John Barth's book *Chimera* to be flawed because it is overly complex without thereby prescribing an alternative way that it ought to have been written.[8]

* Here, the notion of prescription amounts to the claim that the critic is telling the artist what he should be doing. The complaint is about the critic putatively issuing a positive directive. It may be a truth of language that negative criticism generally appears to carry the prescriptive implication that whatever the artist has done should have been done differently. However, I hasten to add, the critic typically does not spell out any preferred alternative in a way that would count as a positive directive.

A related objection to evaluative criticism is the observation —again, often voiced by artists—that there are no rules of art. Artists, working under the imperative of creativity, abide by no fore-ordained, general principles. As Kant put it, artistic genius does not follow rules but gives the rule to nature. Indeed, for many artists, notably avant-gardists, it is their self-appointed responsibility to flout anything that might pose as a rule of art.* But, then, the artist surmises, if there are no rules of art, there can be no evaluative criticism. Here the assumption is that evaluative criticism would be a matter of umpiring—of determining whether artists were playing by the rules or not.

The mistake here, of course, is to assimilate the evaluative critic to the umpire with his rule-book in hand. The evaluative critic is not calling strikes or fouls. If rules of art are pertinent at all, they pertain to artists. They belong, again, if at all, to the production side of things. On the reception side, it is the effect that gets evaluated, and not in terms of whether it obtains by following certain rules, but, rather, in terms of whether it is moving, funny, informative, etc., irrespective of whether or not those effects were generated by certain tried and true routines. It is the taste of the pudding the critic cares about, not its adherence to an established recipe.

Moreover, the kinds of considerations that the evaluative critic brings to bear on evaluating artworks are nothing like what one supposes rules of art would be like. Rules of art, were there such, would be guides to action. But the things that lead critics to evaluate artworks as successful or not are quite often too general to serve as guides to action.

* Although if one lives by this imperative, it would appear, oxymoronically enough, that one believes there is at least one rule of art.

I favorably assess Fra Angelico's predella *The Beheading of Saints Cosmas and Damien* for its compositional unity due to its rhyming the execution of five saints on a landscape with five cypress trees before a cityscape with five towers. In making this judgment, I am commending the painting for its compositional unity, but *compositional unity* hardly constitutes a rule that might guide the action of painters; there must be an indeterminately large number of ways—say millions—whereby an artist might secure compositional unity. Critical terms of appraisal are characteristically too generic, in other words, to serve as rules of art, at least where one conceives of a rule as a reliable and informative guide to action.*

Undoubtedly connected to the complaint about rules of art is the rejection of evaluative criticism on the grounds that every artwork is unique. If every artwork is unique in a non-trivial sense—one that amounts to something more impressive than that the artworks are numerically distinct individuals—then evaluative criticism is inoperable, since evaluation presupposes comparison, but comparison is conceptually infeasible where everything is unique and, therefore, strictly incommensurable.

My objection to this, perhaps needless to say, is that the alleged utter uniqueness of artworks is sorely exaggerated. This is simply a Romantic and then Modernist fantasy. Artworks fall into genres, stylistic movements, artistic oeuvres, artforms, and so on, and, as members of the relevant class or category, they can be placed and then assessed in

* Obviously it would also be crazy to take the "rule" underlying my critical pronouncement about the Fra Angelico to be: wherever you have five saints in the process of being executed, have five trees and five turrets. That's far too particular to be a creditable rule of art.

terms of the ways in which they realize or fail to realize the points and purposes of the kinds of artworks they are.

Moreover, where artworks do not obviously fall into established genres, it is still possible to construct reference classes of comparable works—as French movie critics did with the category of film noir—in such a way that one can get a handle on the point of the work at issue by thinking about the other members of the constructed comparison class.* And more recently, David Denby has isolated the slacker-romantic comedy with reference to movies like Knocked Up.[9] In short, although most artworks are numerically particular, they are not so absolutely incommensurable that they cannot be appraised in terms of the way in which they implement the purposes of the category or categories to which they belong.

A less easily dismissed argument than the one based on artistic uniqueness is that there can be no authentic critical evaluation because there are no general evaluative criteria when it comes to artworks. It is presupposed by almost all contemporary commentators, except nowadays perhaps by the friends of the aesthetic theory of art, that there is no one general criterion of artistic value, nor even a set of general criteria, that pertains to all artworks across every category. And if there are no such general criteria, then there can be no reasoned critical evaluation of artworks. For, such reasons would have to be connected to some general criteria. Reasoning, that is, presupposes general premises. And consequently evaluative reasoning presumes the existence of general evaluative premises, such as general criteria of artistic excellence.

* How one might go about doing this objectively will be discussed in a subsequent chapter.

This is a complicated issue that will be addressed at greater length in a later chapter. Nevertheless, an opening rebuttal is at least possible. There may not be general evaluative criteria when it comes to art—that is, criteria applicable to every work of art of every sort. However, as noted in the preceding rejoinder to the uniqueness argument, artworks can be placed in categories—such as genres, styles, movements, oeuvres, etc. and, in addition, combinations thereof. Furthermore, these categories are linked constitutively to certain points or purposes. These points and purposes are not perfectly general across the arts. But they are *general enough* to ground evaluative criticism of the work at issue relative to the category or class that it inhabits.

That is, a genre, for instance the mystery story, has certain points or purposes, and realizing those points and purposes is criterial to the success or failure of any example of the genre, its value or disvalue *qua* mystery story. If, after the first paragraph, every reader *knows* the parlor maid did it, then the critic has reason enough to rebuke the novel. For, one of the central points or purposes of a mystery story is to sustain the reader's curiosity from beginning to end. That supplies the critic with a criterion that is general with respect to mystery novels, though not, of course, general for all artworks. With other kinds of artworks, such as artworks in other genres, curiosity may be inapposite—something else, like awe or terror, might be what is called for.

Yet, even though curiosity may not be criterial for success in every artistic category or kind, it is undeniably pertinent for success in the mystery genre. So if critical reasons have to make contact with general evaluative criteria, there are criteria that are general enough, relative to the category or categories the artwork instantiates, for the critic to mobilize

with regard to the work under examination. I acknowledge that this is not the end of this particular debate. So, the discussion will be resumed anon. Nevertheless, let it suffice for the time being as a temporary holding maneuver, one that for the moment shifts the burden of proof to the defender of the lack-of-general-criteria argument.

The lack-of-general-criteria argument serves as a major premise for a series of other arguments against the thesis that criticism is necessarily a matter of reasoned evaluation. These arguments do not deny that criticism contains an evaluative moment. Instead they deny that the evaluation is *reasoned*. According to this line of thought, the evaluations are emotive rather than cognitive, or subjective rather than objective, or are merely covert political ploys, either at the beck and call of some ideological agenda or, failing that, in the service of the critic's insatiable will to power.

The way in which the criteria argument abets these conclusions should be fairly obvious. Reasoning requires general premises. If there are no general criteria for the evaluation of art, then said evaluations are not based on reason. So the evaluations must be based on something else. Historically, some of the leading candidates for that "something else" have been emotion, subjectivity, or political motivations (either politics in the large sense, as in the case of classism, racism, or sexism, or politics in the sense of interpersonal power relationships).

As I have said, I deny that there are no general criteria for art evaluation, even if there is no general criterion that applies to every artwork *qua* Art with a capital A. If my previous argument in this regard is successful, then the aforesaid conclusions are dead in the water. But, for the sake of the debate, let us imagine that my arguments above missed the bull's eye.

Let us grant, for the time being at least, that there are no general criteria whatsoever for the evaluation of artworks.* Under that supposition, how do the skeptical conclusions in the preceding paragraph fare?

The contention that evaluation sans general criteria is a matter of emotion rather than cognition has an extremely positivist bias. The idea is that since there are no criteria upon which reasoning could base its evaluative findings—either deductively or inductively—then those conclusions must be reached by non-cognitive means. This surmise rests on a strict separation between emotion and cognition (a.k.a. reason, for our present purposes).

I, as indicated already, reject the proposition that the critic is bereft of the sort of premises she needs to render evaluations; instead, I maintain that she has the logical wherewithal to meet the positivist's highest standards for genuine cognition. Yet, even if it turned out that emotion enters the process of critical evaluation, that would not appear necessarily to cancel out the possibility that critical evaluation is reasoned. For, the kind of emotions that are germane to art criticism are what are often labeled "cognitive emotions," emotions governed by norms or criteria of appropriateness, as fear is tethered to the apprehension of harmfulness. These emotions are not mindless or cognition-less, as the positivist would have it. Rather, many emotions are rooted in cognition involving the recognition of appropriate patterns.

Ex hypothesi, the emotions that are relevant to critical evaluation are cognitively grounded emotions. My pronouncement

* I suspect that for many readers this won't be much of a stretch, since they might not have been very impressed by my earlier argument. But have no fear. We will return to this dispute in a subsequent chapter.

that the work at hand is sublime is governed by corrigible criteria. An ordinary matchbox is not sublime; sublimity requires the estimation of some exceeding largeness—of either a material or spiritual nature. The experience of sublimity is not of the species of mindless emoting to which positivists attempt to reduce all emotions. Hence, even if art criticism lacked evaluative principles that licensed evaluative arguments and this forced critics to rely upon their emotions, this would not necessarily render critical evaluation non-cognitive in a way inimical to reason.

Indeed, it may take some cogitation and reasoning to get to the point where the critic feels (correctly) that a work is sublime. So, *pace* the positivist, even if it turned out that emotion sometimes takes the place of general criterial premises when it comes to art evaluation, that, in itself, would not entail that critical evaluation cannot be reasoned.

With regard to the positivist's argument, there is a similar, related argument of much older vintage: that since there are no general criteria of artistic evaluations, artistic evaluations cannot be objective. So they must be subjective. But if critical verdicts are not objective, they cannot issue from reason. Yes, the skeptic concedes, there are critical evaluations of artworks, but they are not reasoned evaluations; they are nothing more than the expression of personal preferences or likings, i.e., they are a purely subjective affair. Moreover, this view is also linked to the putative observation of the intractability of critical disagreements over artistic evaluations. Presumably this observation is of ancient origin—so ancient, in fact, that the Romans had a slogan for it: "De gustibus non-disputandum est" ("Concerning matters of taste, there is no disputing").

This issue has engaged some of the greatest minds in

western philosophy, including both Hume and Kant. Consequently, I do not expect to settle matters right now in a few brief paragraphs. For that reason, we will need to return to this discussion in a subsequent chapter. But in preparation for that more arduous confrontation, let me start the ball rolling with some initial remarks.

One thing to note is that the terms of this debate have shifted over time. In the eighteenth century when it was said that the judgment of taste—e.g., the statement that "Gainsborough's Blue Boy is beautiful"—is subjective, what was meant was that the beauty (defined as an experience of pleasure on the part of the percipient) is in the subject. Just as we locate pain in the person who has been stabbed and not in the knife, likewise it was asserted, especially by empiricist philosophers such as Hutcheson and Hume, that beauty, understood as a sensation of pleasure, is in the subject and not in a stimulating object such as the Blue Boy.

Notice two things about this usage: first, subjective here does not mean uniquely personal and even idiosyncratic, as it usually does to us today. Moreover, in this internal-sensation sense of beauty, it could be the case that the experience of beauty when exposed to certain art objects converges amongst subjects as regularly as does the experience of greenness among normal viewers worldwide when confronted with pine trees of the relevant species. But in the case of convergence, it is consistent with the proposition that critical judgments are subjective (in the eighteenth century sense) that there could be bridging laws connecting the regular correlation of art objects with certain properties to uniform sensations across normal human populations, which laws, in turn, could be inter-subjectively verified and used as major premises in evaluative arguments.

That is, the notion that critical judgments are subjective, in the eighteenth century sense of the term, does not conceptually preclude the possibility that there could be the sort of principles that would satisfy the highest standards of logical objectivity (where objectivity means something like "inter-subjectively verifiable"). On the eighteenth century reading, in other words, the assertion that artistic judgment is subjective does not present a necessary threat to the claim that critical evaluation is objective (in our contemporary sense of *inter-subjective*).

What is more perilous for the doctrine that art criticism is reasoned evaluation is the more modern understanding of *subjective* as meaning individual or idiosyncratic. This is the view that everyone likes what they like—from pretzels to Picassos—and there's an end to it. Since there are no general criteria, there is nothing to commensurate these wildly varying tastes. That I prefer Dean Koontz as a novelist and that you prefer Anthony Powell are just facts about you and me. Without general criteria, there is no way of determining which of these facts gets it right and which wrong about the novelists, for, in truth, there are no facts of the matter but only facts about you and me.

Why believe this? The consideration often adduced is that our evaluations of works of art—where we are counting even distinguished critics as one of us—are supposedly wildly divergent and obdurate. Even the most musically informed may remain at odds over the question of whether Mozart is better than Beethoven. So, since we cannot reason our disputants into agreeing with us, our evaluations, strong as they may be, are not reasoned.

Without attempting to foreclose this debate, certain comments need to be made about the weight placed on

disagreement in the preceding paragraph, since disagreement is what is being advanced as evidence for the incommensurability of what are said to be our broadly divergent appraisals of artworks. First, along with the evidence of a diversity of critical appraisal, there is also a perhaps even greater amount of data showing converging appraisals. Does anyone deny that *Hedda Gabler* is at least a good play? Such convergence needs to be accounted for as well as the disparities. Moreover, it is not clear that, once we have an explanation of these convergences, we will not have logical grounds for the possibility of maintaining that some critical evaluations are objective and some not. And if some critical evaluations can rest on objective grounds, then it seems plausible to conjecture that ideally criticism aspires to reasoned evaluation.

Furthermore, it is important not to make so much of the phenomenon of disagreement when it comes to the appraisal of artworks, not only because there is also a great deal of— perhaps even more—agreement (the *Hedda Gabler* cases) in the supposedly anarchic realm of criticism, but also because there is raging disagreement in disciplines that are the epitome of reasoned discourse. Philosophers—ironically, those most likely to disparage the rationality of art criticism—haven't agreed with each other about the deepest matters, like the nature of the good, since Socrates first padded his way down to the Piraeus over twenty-five hundred years ago. Shall we say that this shows that philosophy is not reasoned discourse? But even if you are ready to throw philosophy to the wolves (who are probably other philosophers), remember that physicists and biologists are also often locked in great debates that seem as irresolvable as those about works of art.

And lastly, intuition pumps—like the imagined dispute between those who favor Mozart over Beethoven or vice

versa—are not as significant as we are often encouraged to believe. These are debates about the comparative ranking of works that everyone acknowledges to be good, in fact, very, very good. The disagreement that is foregrounded in this alleged disagreement occludes a truly massive amount of critical agreement concerning the value of these two artistic giants.* This is not a debate about whether one of the candidates is not valuable, but over who is better.

Later I will argue at length—as I have already asserted—that the primary function of criticism is to say what is good in a work. Ranking works is not the primary occupation of the critic. Art critics are not like bookies handicapping horse races. If ranking art is anyone's primary responsibility, it is perhaps the connoisseur's or the fan's.

Moreover, there is something peculiar about intuition pumps based on establishing the ranking of recognized masterpieces, such as the work of Mozart and Beethoven. One wonders what the point of such rankings really amounts to. Probably everyone can live with the irenic proposition that Mozart is very good in his way and Beethoven is very good in his way, especially if we can identify what those ways are. It seems beside the point to go on to ask which of those ways is the better one. What would that add to our understanding?

* This may sometimes be obscured when devotees of one artist hyperbolically degrade the talents of a competing artist in the heat of debate. Perhaps, to underscore his point, the friend of Mozart might make a cutting remark about Beethoven—wondering aloud how anyone could think he was any good. But when things cool down, any friend of Mozart will admit that Beethoven has something going for him, just as the lovers of Beethoven will acknowledge the same of Mozart.

How would establishing that, if it could be established, assist us in accessing what is of value in the works in question? And isn't that what we expect of critics? (As I protested earlier, I realize that this is not the end of this particular debate. I only hope that this is enough to keep you interested until we rejoin the fray down the line.)

One standard response—of which I have availed myself—to the skeptic's citation of the phenomenon of disagreement is to counter it by stressing the phenomenon of agreement: for example, that Mozart and Beethoven are admitted to be good, nearly across the board. Those of us who hope to show that criticism can be objective demand an explanation from the skeptic of how this is possible. People like me think the best answer is that these critical judgments rest on objective reasons. But there are other, rival explanations that are less supportive of the notion that criticism is a matter of reasoned evaluation.

One competing answer is that whatever convergence there appears to be is really nothing more than a politically manufactured confidence trick or ideological scam. That is, that a great deal of the apparent consensus about many critical appraisals is an illusion whose fabrication has been motivated to serve partisan interests.

Consider our canon of fine arts. Much of the work included in it was produced for clear-cut political purposes—the exaltation of the king or the feudal order or of successful burghers or the majesty of the church. The political values that led to these objects being included in the canon were then perpetuated as subsequent items were added to the canon on the basis of their affinity with earlier items. Critics and art lovers alike are recruited into the art world as informed citizens by essentially being indoctrinated—albeit

37 **Criticism as Evaluation**

to a certain extent subliminally—into the values of the canon, which, among other things, tend to be altogether elitist: racist, sexist, homophobic, and classist. That there is wide-scale consensus about where artistic value lies should come as no surprise, since we have been brainwashed by our earlier exposure to the canon with its noble kings, commanding popes, and gentle, subservient, and virginal madonnas. The canon is nothing short of a conspiracy.

But does this view really square with the facts? The canon seems quite diverse and, in any event, it is always expanding, often in unpredictable directions. The conspiracy theory of convergence makes the canon more coherent than is plausible. It includes monuments to pharaonic grandeur, but it also includes works of the anarchist Gustav Courbet. It would be very difficult to tease anything resembling a party line from it. Moreover, the canon is always being extended. Entry into it by opposing political voices, especially repressed voices, has not been the exception in the modern period, but rather the norm; the epoch of the avant-garde has frequently aspired to being revolutionary on the social front as well as the artistic one and it has succeeded.

At this point, the endorser of the view that criticism is political evaluation, not reasoned evaluation, may retrench the battle lines, abandoning claims about the politics of the canon and alleging no more than that every critic's appraisal is motivated by political or ideological interests, though adding that, of course, the political and ideological interests of different critics are often very different. F.R. Leavis abhorred the dominance of emerging utilitarian and technocratic tendencies in England and his criticism showed this, as Lionel Trilling's criticism showed his opposition to Fascism, and Robert Brustein's articulates his commitment to progressive

social criticism. And, of course, Roger Kimball and Benjamin Buchloh have very different agendas.

It is impossible to deny that there are critics whose evaluations are influenced by their political, economic, social, and ideological interests. Commentators like Hilton Kramer and Lucy Lippard are quite frank about their allegiances, although, I hasten to add, neither would probably assent to the idea that their politics render of their criticism something other than reasoned evaluation. However, even if some critics are political, that hardly shows that all critics are political.

Personally, as a sometime motion picture critic, I find it eminently possible to profess that Mel Gibson's *Passion of the Christ* and Sergei Eisenstein's *The Old and the New* are both artistically valuable in that both have discovered powerful cinematic strategies with which to embody their themes— the carnal suffering and sacrifice of the Christ-become-human, on the one hand, and the urgent need and promise of agricultural collectivization for the infant Soviet state, on the other. Though I am both an atheist with respect to the Christ and an anti-Stalinist with respect to the Soviet collectivization, I can acknowledge that both films possess artistic value. That the films are at odds ideologically with each other as well as at odds with my political convictions, I submit, indicates that my evaluations are based on something other than politics.

Rather, I would contend that my evaluations are derived from the reasonings I've employed to establish that the means these two directors have invented for advancing their very different points in each case were extremely appropriate and effective. Both films are well done, in my estimate. The conspiracy theorist may, in turn, accuse me of self-deception.

But unless he shows how the reasoning I adduce to defend my judgments is flawed, that is no more than an insult parading as an explanation.

Why? Because: the conspiracy theory is of the nature of a debunking account. It unmasks the hidden motivations that are allegedly the real causes of our behavior. The explanations we offer of our actions, including our critical appraisals, are little more than confabulations. And once the confabulations are exposed, the conspiracy theorist tells us what is really going on.

Yet note that before it makes sense to debunk my explanation of my evaluation in terms of reasons, there is a burden of proof weighing upon the conspiracy theorist to show that my self-explanation is bogus, which, in this case, would involve showing that my reasons are so implausible that they could not really be what is animating my verdicts. In order to demonstrate that I or any other critic is hiding something, the conspiracy theorist must tear off the camouflage. That would require working through my arguments and through the arguments of all those other critics whose politics or ideology is not worn upon their sleeves. Unfortunately, that is precisely what the conspiracy theorist rarely does. Rather, he shoots first.

If this is persuasive, then the conspiracy theorist is in no position to accuse each and every critic of evaluating by the lights of his or her political commitments rather than by the light of reasons. To mount a debunking argument, you must establish that there is something to be debunked. The conspiracy theorist has failed to show that it is not possible for some critics to transcend their real-world political affiliations and interests, and to evaluate the artworks before them on the basis of good reasons.

No one would deny that criticism can be distorted by political or ideological bias. Yet such bias need not obtain in every case. In some cases, criticism can be reasoned evaluation rather than ideological spinning. Consequently, since some criticism can be a matter of reasoned evaluation, it seems that reasoned evaluation is a plausible goal for criticism to pursue. Indeed, even conspiracy theorists should concede this point. Otherwise they would not be in the debunking business.

So far, I have been disputing the argument that criticism is a form of disguised politics, where politics is understood in terms of group-ideological tendencies, such as Stalinism, racism, conservative Catholicism, elitism, etc. But the argument might be given a more individualistic slant. The claim might be that criticism is political at the level of the "war of all against all," that is, in terms of an assertion of personal power over others, including other critics, the audience, and/or artists. Criticism is motivated by the will-to-dominate. This is the view of the critic as bully.

Certainly there are critics who are bullies and critics who abuse their influence for personal gratification. But is this true of all critics? Some critics appear to dedicate themselves selflessly to what they find to be worthy in art, as did Jonas Meekas in his championing of the New American Cinema.

Will the skeptic here (or is he merely a cynic?) re-interpret this as Nietzsche dealt with Christianity, treating meekness as just another lever of dominion? Yet doesn't this sort of transvaluation smack of ad hocery? And, in any event, the personal-politics hypothesis is not really an authentic competitor to the reasoned evaluation view, given the simple fact that even if critics are seeking some measure of esteem through their profession, many, possibly numbering the great

majority, conspire to achieve their place in the sun by supporting their evaluations with what they construe to be excellent reasons.

Some critics, especially academic or academically influenced ones, would object to the notion that criticism is reasoned evaluation, not because they are suspicious of the role of reason in their activities, but because they are uncomfortable with evaluation. In the past, such critics, perhaps intimidated by positivism, have advocated that criticism become more like science, that is, value-free or neutral. However, value-free criticism, like value-free ethics, sounds like a contradiction in terms.

Of course, what these critics may have in mind is that the proper reach of criticism would incorporate only some of the operations of criticism, namely: description, elucidation, contextualization, classification, interpretation, and/or analysis. But that, I propose, fails to differentiate criticism from other forms of inquiry, including certain types of art history. Thus, to subtract evaluation from the critic's job description is to change the subject. That is, we are simply no longer talking about criticism. The value-neutral approach is not a matter of reforming criticism, but of abandoning it.

In recent years, the urge in the humanities to emulate the hard sciences has slackened. However, certain practices have arisen which, though they might offer themselves as successor disciplines to criticism, are really something very different. What I have in mind are the sorts of hermeneutical approaches that Arthur Danto has dubbed "Deep Interpretations."[10] Examples might include Freudian-derived hermeneutics such as Lacanianism, Marxist-derived hermeneutics as popularized by Louis Althusser, or post-structuralist practices like deconstruction. What these tendencies have in

common is that they target sub-intentional processes—such as the operation of the unconscious, or of the material forces of production, or the operation of language—as key to understanding artworks.

This then frees exegetes of these approaches from the onus of evaluation, since the evaluation of an artwork is focused on what has been done in an artwork relative to its purposes. But what has been done as well as what was meant to be done are connected to artistic intentions. Thus, insofar as Deep Interpretations bracket intentions in favor of determining forces that exert pressure from below the intentional stance, Deep Interpretations may be detached from evaluation.

In this, they may even lay claim to be contemporary ventures in the new post-human sciences. But these adventures in post-human science are nevertheless different from criticism in a way that once again amounts to changing the subject, as well as being highly contestable on other grounds, such as internal coherence and factual accuracy.*

III. THE NATURE AND FUNCTION OF CRITICISM: A RECAPITULATION

Art criticism essentially involves evaluation. By that I do not mean that criticism is just evaluation and nothing more. Criticism involves a number of activities, including description, elucidation, classification, contextualization, interpretation, and/or analysis. But in addition to these activities, a necessary condition of criticism, properly so called, is the production of an evaluation. That is, evaluation is an essential feature of

* These flaws will not be explored in this book, since they have to do with the scientific and/or philosophical pretensions of these approaches, whereas the topic here is criticism.

criticism such that if a piece of discourse lacks explicit or implicit evaluation, it would not qualify as criticism.

I have attempted to support this conjecture by arguing that this is the best explanation of the difference between criticism, properly so called, and certain adjacent forms of verbal discourse, such as art history and cultural studies. I have also tried to bolster this hypothesis by criticizing a large sample of the reasons people might offer against it. The upshot has been that it appears safe (for the moment, at least) to regard criticism as evaluative in the sense defined above.

However, criticism is not just a simple declaration that an artwork has or lacks value. Criticism grounds those evaluations in evidence and reasons. The other components of criticism—description, elucidation, classification, contextualization, interpretation, and/or analysis—are procedures for advancing the evidence and reasons that are relevant to support the evaluation the critic reaches.

Moreover, there is a hierarchical relation amongst the activities that comprise criticism, since evaluation determines which descriptions, elucidations, contextualizations, and so forth are pertinent and which are digressive or extraneous. Although evaluation is only one of the activities that compose criticism, it is first among equals. It frames the other activities—that is, it provides the framework. It constrains and governs the other activities; it calls the shots.

When I say that it is of the nature of criticism to evaluate, I mean that it is a necessary condition of criticism which when conjoined with the other activities that go into criticism is sufficient to differentiate criticism from its near neighbors in the realm of verbal discourses and, as well, that the task of evaluation sets the tune for the other activities that go into the production of criticism.

The nature of criticism is to evaluate artworks—to discover what is valuable or worthy of attention in artworks and to explain why this is so. One can criticize for oneself, of course. But the critic also occupies a social role. In that social role, the primary function of criticism is to enable readers to find the value that the critic believes that the work possesses. It is the task of criticism to remove any obstacles that might stand in the way of the reader's apprehension of that value.

Often the critic is at pains to contextualize a work—to place it in its historical context, both artistically and more broadly—exactly so that the audience can see how the artist under discussion was addressing a problem or question or issue from within his own circumstances, which might not otherwise be obvious to contemporary readers, listeners, and/or viewers. Assisting audiences in apprehending and understanding what is valuable in the works at hand is the primary function of the critic and her critical work.

In acquitting this function, criticism is strong criticism insofar as it renders its evaluation intelligible to audiences in such a way that they are guided to the discovery of value on their own. This is achieved by backing up critical evaluations with evidence and good reasons which readers can use to structure their own encounter with the artwork under scrutiny.*

* Sometimes we read criticism of works with which we are not familiar. We may not do this simply to prepare ourselves to encounter the work in question. We may do it in order to pick up tips or strategies or approaches that may serve us in our negotiations with artworks of our own choice. Critics instruct us about how to discover value in artworks. The most straightforward way of doing this occurs with works that we share with the critic. But we also may read critics solely in order to pick up techniques for

Critics should be respected for their skill in arguing their case—for grounding their evaluations in good evidence, good reasons, and good reasoning which audiences can reproduce and expand upon on their own.* Critics should not be applauded like those lawyers who are honored for merely persuading jurors by any means possible—including, often, bad reasoning. Criticism, ideally, is a reputable estate, one whose inhabitants should strive to provide the best grounds for their evaluative verdicts.

I have claimed that criticism is primarily committed to the discovery and illumination of what is valuable in artworks. I do not intend thereby to imply that criticism is not also concerned to identify disvalue in artworks. However, I do think that this is a lesser charge than that of isolating what is valuable. Value is what we look for most of all in criticism. For, surely we, as consumers of criticism, derive a lot more from criticism that guides us to what is valuable in a work than we do from attending to flaws.

I hasten to add that this is not to say that pointing out flaws is out of bounds when it comes to criticism, but only that it is

excavating value in works not addressed by the critic at hand. We may read critics, in other words, to improve our skills as appreciators.

* This is not to deny that there is also a perceptual dimension to criticism. As Hume advised, the critic should have the ability to see and hear subtle differences in the pertinent stimulus. At the very least, this will contribute to the accuracy of the critic's descriptions of the work. But the value of certain works of art may also be substantiated for audiences by critics who are able to get us to see or hear subtle features of a work. That is, the value of the work may derive from its capacity to enable us to see fine shades of difference and the critic will be doing her job insofar as she gets us to see the work afresh.

not the central target of our desire—not what we primarily hope to gain—with regard to criticism. Indeed, a constant diet of negative criticism—relentlessly pointing out the bad and the ugly in artworks—would be so impoverished that I suspect it could not be sustained for very long. For, it is the promise of contact with what is valuable that we ultimately hope for from criticism. Without that, consuming criticism would have little point.

As Dryden says: "They wholly mistake the nature of criticism who think its primary business is to find fault. Criticism as it was first instituted by Aristotle was meant as a standard for judging well, the chiefest part of which is to observe those excellencies which should delight a reasonable reader."[11]

In claiming that the primary job of criticism is the discovery of what is valuable in a work or an oeuvre, and the explanation of why it is valuable, I also mean to be casting doubt on the view that criticism is centrally concerned with ranking artists and artworks. Critics do need to compare and contrast artworks, but principally in order to illuminate that which is special about one or more of the works or artists juxtaposed. Critical comparison is a crucial instrument for becoming precise about artists and artworks. It is not of major importance for the sake of constructing a pecking order. In fact, many of these exercises in ranking are downright silly, as will be discussed in subsequent chapters.

The Object of Criticism

Two

I. INTRODUCTION

As noted in the previous chapter, we don't criticize rocks in nature. Since rocks are not sentient, there is no point in criticizing them. They won't listen anyway; they're hopeless. Furthermore, rocks in nature have no God-given purposes. Consequently, we lack a perspective from which to issue our plaudits and brickbats. Of course, when rocks enter the circuit of human affairs—as, for example, building materials or paperweights—we can evaluate them relative to the uses to which people put them. A three hundred pound paperweight, for instance, is a bad one for anyone save Superman.

Once rocks become embroiled with people, that is, they are suitable objects of criticism. For people have purposes and, in virtue of those purposes, we can assess whether the rock enhances or impedes them and say why. (A three hundred pound rock is a bad paperweight *because* it is too heavy for nearly anyone to lift with ease.) Needless to say, it is not the rock per se that we are discussing. It is what the pertinent people mean to be doing with the rock. Moreover, this suggests what, in the broadest sense, the object of criticism is, namely, human doings.

Since art criticism is a member of the genus criticism, it is directed at what the relevant human persons are doing with the artwork in question. But who might the relevant persons

be? There are two alternatives—the artists or the audience members. One fashionable approach to criticism in academia —with labels like reception theory or reader-response criticism—suggests that it is the activity of the reader, listener, and/or viewer that should be the focus of critical attention.

I grant that for certain forms of historical or sociological research it is legitimate to attend only to the audience's response to the artwork. However, this is not a plausible alternative, if we are speaking of criticism in an evaluative register. For, unless we already know the reaction that the artwork truly deserves, how would we know whether the audience was responding well or badly when they applaud the artwork? Criticism would have to establish the appropriate range of audience responses before the worthiness of those responses could be estimated. That is, there would have to be a prior critical evaluation of the artwork before we could assess the audience's use of it. Therefore, since it is not what the audience does that is the object of criticism, it must be what the artist does (or what the artists do) with or by means of the work.

Furthermore, the idea that the audience might be the target of our criticism doesn't square with ordinary critical discourse. When we chide an artwork for its shortcomings, our disapproval is not aimed at the audience. They are not responsible for the defects in the artwork. The artist is. So, it is what the artist is doing or has done with respect to the art-work that commands the critic's attention. Perhaps this seems so obvious to you that it hardly requires argumentation. If that is so, then we're on the same page.[1]

What the artist does or has done in producing the artwork is the object of criticism. The object of criticism is a certain process of doings that result in the artwork. Artistic doings are

actions—specifically artistic acts[2]—and human actions are purposive. So, in acting, the artist has certain purposes. Those purposes, among other things, provide a standpoint from which to determine whether or not the work has succeeded or failed on its own terms. That is, the activity of the artist is guided by intentions that have certain ends-in-view, and those ends-in-view imply a certain range of value or disvalue. As we shall see in a later chapter, this is not the only consideration we may bring to bear when evaluating an artwork. However, I shall argue that it is always part of what is involved in appraising a work.

For example, I commend the movie *Memento* because of the way in which it skillfully engineers its surprise ending (or, actually, its surprise beginning) by keeping under wraps the protagonist's earlier revenge quests. The critic enables the viewer to understand the nature of this achievement by showing how strategically and unobtrusively certain information about the world of the fiction has been withheld or camouflaged. No assessment of *Memento* would be complete without noting how the filmmakers have crafted the flow of information (and misinformation) even if one thinks the movie should be evaluated on other dimensions as well.

In the previous chapter, I claimed that the function of criticism is to say what is of value (and/or disvalue) in an artwork and to say why—that is, to ground one's assessments in reasons. I may applaud a hard-boiled detective novel on the grounds that it is very suspenseful and show how this has been carried off successfully due to the careful way in which the author has stacked the odds against the hero without making the situation appear absurd. In other words, the critic lays out the case for claiming that this hard-boiled detective novel possesses value insofar as it is suspenseful due to the

author's narrative craftsmanship. The reader can then use the critic's brief as a guide to what qualities to look for in the novel and as an aid in understanding the way in which those qualities were secured.

To say that something is of value (or just valuable) is to claim that it has some feature or features that are worthwhile to have or to be. Of course, as remarked in the previous chapter, a critic might do this for herself; she might want to clarify her reactions to some artwork by articulating them in writing. Perhaps this is the sort of criticism that Marx had in mind when he said we might spend our afternoons in Utopia practicing it.

But this is not the most common form of criticism in our culture. Criticism is usually undertaken to present to others. With respect to artworks, the critic isolates what is worthy (or unworthy) about the artwork for audiences and enables them to grasp the nature and provenance of that worthiness.

Since the point of criticism is to say what is valuable about an artwork, what is valuable about the artwork is the object of criticism. It is what the work of criticism is about. However, we have already established that the object of criticism is something that the artist is doing or has done in producing the artwork. So how can we combine these two insights about the object of criticism in a way that affords a more precise understanding of it?

That is, if the object of criticism is what the artist has done, what is the connection between the artist's action and what is valuable in the work? The answer, I propose, is this: what the artist has done should be construed in terms of whether and how it is an achievement (or a failure). That which we value or disvalue in the work is the artist's exhibition of agency in the process of having created the artwork.[3] The critic focuses

upon the artistic acts performed in the work; the object of criticism is what the artist performs, his or her artistic acts, in terms of their achievement (or failure).[4]

What is it about that which the artist has done or is doing with respect to the artwork that gives the artwork value? Presumably, when what the artist is doing or has done with the artwork is appraised felicitously, it is the fact, at the very least, that the artist has achieved something in the course of producing the work through the way in which she has proceeded and by means of the processes that she has elected. The artwork has positive value, first and foremost, because it is an achievement or a series of achievements by an artist. We can call this the success value of the work.[5]

The critic commends the artwork inasmuch as the artist has achieved something in the creation of the work. The work of art is said to have value because it is an achievement (or to have disvalue because it is a failure). The critic identifies what is valuable in the artwork by limning what the artist has achieved—by explaining how, thanks to what the artist has done, the work works relative to its underlying purposes. And explaining this, in turn, enables the audience to grasp something about what is valuable in the work, or, at least, it is to be hoped, to comprehend with still greater clarity the achievement they may have already detected.

The primary task of criticism is to evaluate—to say what is valuable about the artwork under discussion. What makes the artwork valuable—to the extent that it is—is in large measure what the artist has achieved in the process of producing the work. Thus, the object of criticism is the artist's achievement. For that is wherein much of the value of the artwork resides.

II. SUCCESS VALUE VERSUS RECEPTION VALUE

The object of criticism is what the artist has done—his or her achievement (or failure). This characterization locates the value that the critic excavates on the artist's side of the transaction between the artist and the audience. I call this success value, since the value in question is, to an appreciable degree, a matter of whether or not the artist has succeeded in achieving her ends. However, this way of conceptualizing things is not uncontroversial. I suspect many philosophers of art would be inclined to locate what is valuable in the artwork elsewhere. Specifically, it might be hypothesized that what is valuable about the work is the positive experience that the work affords the audience.

The value to be had from the work, it may be contended, hinges upon whether or not the work occasions valuable experiences. Since this species of value is linked to the audience, I will call it reception value. Moreover, if the value of the artwork is its reception value, then the role of the critic will be to instruct the audience in the ways in which to derive the fullest possible positive experience of the work.

This view of the role of criticism fits nicely with the evolution of the consumption of art since the beginning of the modern period, say around the eighteenth century. In the ancient and medieval periods, the arts were the beneficiaries of patrons like the state, the aristocracy, the guilds, the confraternities, and the church. Art was put in the service of larger social enterprises: to display the power and virtue of the ruling class, to educate the populace in Christian mores, to instill reverence and obedience, to celebrate historic moments, to curry loyalty, and so forth.

With regard to artworks such as these, the experience that the viewer, reader, or listener was supposed to undergo was

tied to the function of the work. If the statue was designed to cultivate respect for the king, then the experience the statue was intended to elicit was admiration. If the altarpiece was meant to apotheosize God's grandeur, then an experience of awe was the mandated reaction, and, where the artist succeeded in this endeavor, the appropriate reaction to boot.

However, with the appearance of the bourgeoisie, artists acquired new patrons, well-heeled clients with a continually growing amount of leisure time on their hands. Money was time, and the arts began to be conceived of as a pleasant way of filling it.

These clients, though sometimes commissioning works, also bought them on the open market. Art became a consumer commodity. The bourgeois consumers of art often sought artworks related to the traditional functions of art. Just as aristocrats had themselves and their families memorialized in portraits, so did wealthy burghers. And the emerging middle class also used the arts for devotional and instructional purposes. Yet, at the same time, the arts became increasingly identified with leisure. Thus, artforms such as the novel became popular as a form of cultivated amusement or entertainment.

Whereas previously music had often been wedded to religious or state ceremonies, or associated with work and war, when the concert hall was born, music was sequestered from social activities and functions. Music was given its own palace—out of the flow of life—in which it was played solely to be enjoyed. Likewise, museums emerged which removed the pictures and statues of princes, generals, and saints from the public sites to which they added social meaning, and relocated them to the quiet corridors of galleries where the only function possible for them, it seemed, was to be

contemplated, an activity traditionally associated with pleasure.

In the previous chapter, we spoke of the way in which the modern system of the arts coalesced in the eighteenth century into what we call the Arts with a capital A. The assemblage of just those practices into an established grouping, of course, called for a rationale. At first, it was suggested that membership in the group required that the practice in question be engaged in the imitation of the beautiful in nature. This postulate, nevertheless, soon became unsustainable with the advent of absolute music. For, by and large, most absolute music has no truck with imitation.

So another rationale had to be found. One highly influential suggestion was that these arts belonged together because they stood in contrast to other arts which were useful. That is, our Arts with a capital A serve no social function; they are ostentatiously useless. They exist solely in order to grace our leisure time—to provide positive experiences for the weary. Their value, in other words, is their reception value.

Initial characterizations of the relevant positive experiences were in terms of pleasure or, sometimes, *disinterested* pleasure— that is, pleasure detached from personal and, even sometimes, social advantage. Early critics like Joseph Addison took it to be their charge to instruct, primarily by example, their readers in how to derive such pleasures—the pleasures of the imagination as Addison called them—from artworks. Periodicals sprung up—like the *Tatler*, the *Spectator*, and the *Review* in England, the *Mercure de France* and *Journal de Paris* in France, and *Propyläen* and *Kunst und Altertum* in Germany—in order to tutor audiences in the pursuit of this variety of pleasure.

But this conception of the relevant experiences of art, however, is ultimately unsatisfactory, since sometimes the

worthwhile experiences to be had from works of art are not by any means what one would call pleasant or pleasurable. Goya's *Black Paintings* provoke fear and anxiety; much avant-garde art is purposefully unnerving; and so forth. Consequently, the positive experiences to be had from art have often been re-conceptualized even more vaguely as experiences valued for their own sake. That is, the reception value of art, it is claimed, is a matter of undergoing experiences that the audience values for nothing other than the having of those experiences.

The critic's task under this dispensation is to enable the audience to realize whatever positively valuable experiences the work of art affords. The art critic might draw the spectator's attention to the pleasing symmetries of form in a painting by pointing from one part of the picture and then to another, thus prompting a delightful shift in the organization of one's visual field. Similarly, the critic might also do this by putting two pictures side by side, or, alternatively, by describing the painting in powerfully evocative or metaphoric language, thereby helping the prospective viewer see it afresh.

Likewise, the literary critic may enrich the reader's experience by showing how all the disparate incidents and characters in a work can be organized or colligated under an overarching concept or theme, as Sartre's *Nausea* is unified around the idea of choosing a life-plan of one's own. Here the critic's efforts enable the reader to experience the work as a whole and to have the satisfying experience of cognizing the function of the parts of the work in the service of its overall unity.

The notion that the critic should be preoccupied with the reception value of the work may be reinforced by a certain philosophical presupposition or, perhaps better, bias, namely,

that the only things that are valuable are experiences. This view probably has its origins in the species of hedonism that says that all value ultimately reduces to pleasure. This view, maybe needless to say, is insupportable. For, certainly there are experiences that we value that are not pleasurable under any unforced use of the word.

Surely, for example, the ascetic values his experiences of sacrifice and self-denial, but it would be strained to allege that they are pleasurable or that he finds them so. Were they pleasurable, they would be self-defeating. But there is no reason to suppose that self-abnegation is conceptually impossible. It may not be to our taste. Yet it is undoubtedly feasible.

Thus, the hedonistic hypothesis is usually diluted in such a way that it amounts to the more moderate empiricist conjecture that the only thing that is valuable is experience. This is motivated by certain metaphysical commitments and backed up by thought experiments. For example, imagine a world in which there are no experiencing subjects. Suppose it is a world that contains all manner of what we would call beautiful things—gorgeous sunsets, sparkling brooks, lush savannahs, etc. Wouldn't such a world, despite the plethora of these things, be a world devoid of value, precisely because there are no beings to savor them or to find them worthy of attention?

This view is at least debatable. Even if there would be no value in a world without subjects capable of experience, it does not follow that subjects capable of experience only value *mere* experience as such. Imagine being offered the option of having your brain stimulated in such a way that for the rest of your life you will be led to believe that you are having the adventures, successes, and romances of a 007; the experience

will be an illusion, but there will be nothing about the experience that will give that away. Now suppose you can sign onto this life or you can remain just living the quotidian life you are trying to get through right now. Which will you choose?

Most, I reckon, will prefer to go on with the actual life they have. That is, they wouldn't trade it in for a counterfeit life of contrived experiences, no matter how much more vivid than their daily routine. For, they value reality more than what we might call mere experience as such.

Thus, the notion that experience is the only source of value is not incontestable.[6] Nevertheless, metaphysics aside, it still may be the case that when it comes to the value of art, reception value—the value located in the audience's experience of the work—is what the critic should care about. The critic's job is to inform the rest of us about where and how to look at the work of art in order to get the richest possible experience out of it (or, in some cases, to warn us that positive experiences are unlikely or even impossible to derive from an encounter with the work in question). But is a concern with reception value really a superior line of approach for the critic rather than a concern with success value?

It seems improbable that the preoccupation with reception value could be the right way to go, if its proponent is recommending it as the exclusive focus of critical concern. For, if we want to characterize the ambit of criticism, it appears reasonable to require of our conjectures that they mesh with existing critical practice. Our hypotheses, in other words, should not be revisionist. However, the suggestion that reception value is the sole sort of value that is of interest to the critic does not jibe with very deeply entrenched critical practices.

For example, one kind of value that practicing critics constantly find in works of art—and are at pains to explain to the rest of us—is originality. But the originality of an artistic achievement is not something audiences can experience. One way to see this clearly is to consider cases of the flagrant failures with regard to originality, namely, plagiarism and forgery.

Imagine the perfect forgery of a work of stupendous originality historically—say Picasso's *Les Demoiselles d'Avignon*. This forgery looks exactly like the canvas painted by Picasso. Shape by shape, brushstroke by brushstroke, pigment by pigment, the two paintings are indiscernible not only to the most erudite scholars, but, let us imagine, to Picasso himself. Only the use of sophisticated x-ray equipment and carbon dating techniques enables us to cut the difference between the original and the fake.

Because there is no difference that the human eye—including the most informed human eye—can find between Picasso's canvas and the forgery, there will be no difference experientially between the two. The originality of Picasso's work makes no detectable difference in our experience in comparison to our experience of the perfect forgery. Both are of equal reception value, since both can support exactly the same audience responses. But that just shows that, with respect to our entrenched critical practices, reception value cannot be the whole story.

There are other loci of value, apart from originality, of which the reception-value approach loses sight. Historical impact and/or influence are others. Andy Warhol's *Brillo Box* helped close down certain high roads to artistic ambition, such as abstract expressionism, at the same time that it opened the gateway to the postmodernist art of the 1970s and

to post-historical pluralism ever since. This is not something the critic could ever commend a forger of *Brillo Box* for achieving, since his faux boxes, in point of fact, influenced nothing.* But experientially the forged *Brillo Box* affords every iota of stimulation that Warhol's does.

There are further pertinent sources of value in artworks than originality and historical impact. But reference to these two should be enough to establish that reception value cannot be the exclusive concern of critics in their endeavor to tell us what is valuable about the work at hand. Or, at least this follows if you agree that our characterizations of the scope of critical concern should concord with well-entrenched critical practices. For, in truth, against what else can we test our conjectures about criticism?

Another problem with the reception-value view of criticism is that, without qualification, it seems to grant to the critic a specious methodological license to turn many a sow's ear into too many silk purses. Recall: on the reception-value view, the critic should supply the audience with the where-withal to have positive experiences of the work. So, imagine before us one of those lurid, black-light, velvet, day-glo extravaganzas from the late 1970s. Ordinarily we might dismiss things of this sort as beneath contempt. But, the critic smitten by the reception-value viewpoint who whole-

* It may seem that my notion above of the historically influential is no different than the concept of originality. Yet this is not so, for two reasons. First, a work may be original, but not influential. It may be innovative, but without takers. Second, a work may be influential but not original. In a certain respect, Warhol's *Brillo Boxes* were direct and obvious descendants from Duchamp's readymades, though it was Warhol's work that primarily influenced the direction of subsequent American art.

heartedly embraces his task might feel justified in telling his subscribers: take it as a parody; have a good laugh; there's a positive experience for you.

Actually things like this have happened more than once in the era of Postmodernism. In no less hallowed venues than *Artforum* and *Film Comment*, J. Hoberman, the movie critic of the *Village Voice*, declared Ed Wood, the perpetrator of outrages like *Plan Nine from Outer Space*, to be a primitive modernist—a guy who outed the protocols of the science fiction genre by abiding by them in the most transparently ineffective and desperately inexpensive ways imaginable.[7] For example, his flying saucers were literally and quite obviously plates suspended on strings. Under Hoberman's direction, you need not be pained by Wood's gaffes. You can relish them as bracingly transgressive gambits in the tradition of master-filmmakers like Buñuel.

However, this viewpoint only makes sense if all you care about is how the viewer can get off on things like *Plan Nine from Outer Space*. The reception-value critic, like Hoberman, can give you a framework for enjoying your guilty pleasures. Yet the issue is whether these guilty pleasures have anything to do with the value that should concern critics. After all, anything can be repackaged as parody or irony, so long as it is creditable to suppose that whatever is happening on the production side of things may be conveniently bracketed from our attention.

Nevertheless, most of us, I think, would hesitate to make this move. For just as we prefer a real life to the simulacrum of life, so we want experiences of authentically transgressive films. If for no other reason, it is a matter of self-respect. Isn't there something willfully silly about regarding *Plan Nine from Outer Space* in the company of *Breathless*? It is a matter of

self-consciously embracing the role of a fool or a dimwit. It is like convincing yourself that tea leaves are communicating your future to you. For a rational person to do this voluntarily would surely be self-degrading.

Of course, the friend of the reception-value viewpoint can finesse his position in a way that blocks this type of objection. He may stipulate that the relevant experiences of concern to the critic would be the informed experiences of prepared audience members—that is, people who know the historically correct framework for experiencing the artwork and who are prepared to employ it. In this regard, the critic's task is to inform and to prepare the audience to have said experiences or, if they are already informed and prepared, to make them more so.

Undoubtedly, this is an important service that critics perform. But the question is: why is it important that the experiences be informed and prepared? So long as the experiences the critic enables are engaging, what need is there for them to be apposite? One answer might be that that just happens to be the way our practices of artistic reception work. However, that seems to beg the question, since we may still persist in asking: why is it that our practices of artistic reception work that way?

One obvious answer to this challenge, of course, is to say that our practices are calibrated for tracking artistic excellence (or the lack thereof). The audience wants the critic to inform and prepare them to appreciate the genuine article. But in that case, it is the success value of the artwork that is primary and which serves to determine the particular kind of reception value of the work about which audiences and critics should care.

That is, the kind of experience that has authentic reception

value is experience that is informed and prepared. The critic primes the audience for such an experience by describing and elucidating the work accurately in ways that support plausible interpretations and/or analyses, and/or by placing the work in the correct category or categories as well as typically contextualizing its historical (including contemporary) origins adequately. The critic uses these operations to ground his or her valuation of the work in such a way that the audience member can replicate the critical process on her own and, in the best of cases, add to it on the basis of her own experience of the work, as inspired by the critic.

The experience of the work should be informed and prepared because the overriding concern of the audience and critic alike is with what is valuable in the work. Thus, pinpointing what is valuable in the work is the primary task of the critic. A proper experience of the work on the reception side of things needs to be directed at what is valuable in the work. So determining the success value of the work or, at least, providing insight into a part of the success value of the work is the first order of business of the critic. It is by doing this that the critic helps to prepare the audience for deriving the appropriate sort of reception value from the work. That is, the reception value of the work that is relevant to criticism is connected to the success value of the work. The success value is prior to a determination of the kind of reception value in question.

Although I emphasize the success value of the work, I, of course, do not deny that a work, if it is successful, may be an achievement precisely because it affords the basis for an informed and prepared experience which has what we are calling reception value. Nevertheless, there may be a lingering question about the way in which the critic should

comprehend this value from the perspective of his primary concern with success value.

The artist does not produce something that willy-nilly furnishes the opportunity for some valuable experience or other. The artist designs the artwork to elicit, or, at least, to support, some definite experience or range of experiences. The master builder raises the cathedral spires to the skies in order to draw the congregation's eyes heavenward. Engendering or encouraging certain experiences from prepared audiences is part of the point or aim or purpose of the work. Where the artist succeeds in affording the experience the artistic structure is meant to call forth, the capacity to elicit just those experiences is part of the achievement of the work. Thus, whether or not the work is capable of eliciting an informed and prepared experience that is valued by viewers, listeners, and/or readers is of critical concern, at least insofar as the critic is committed to weighing what the artist has managed to accomplish non-accidentally in producing the work.

The work is criticized in large measure in terms of what people intend it to do. Here, the relevant person is the artist, who in a great many cases means audiences to derive positive experiences from it.* Therefore, when the work is up to delivering its intended reception value to audiences, this achievement redounds to its success value. The artwork is an *artifact* and should be evaluated as such—that is, in terms of what it is *designed* to do.

* Of course, this is not universally true. Some artworks, like warrior masks and shields, are intended to engender negative experiences—to strike terror in the hearts of the enemy. See, for example, the Asmat shield on p. xxiv of Gell's *Art and Agency*.

Perhaps another way in which to advance the hypothesis of the primacy of the success value of the work over reception value is to offer the following analogy. Imagine a baseball game between two champion teams where the fielding, batting, and pitching on both sides is record breaking. Imagine that the level of expertise mobilized by every player reaches legendary levels. In the annals of baseball, this game counts as nothing short of superlative.

Now also imagine that this game is held as a private match between the two teams. There are, so to speak, no civilian spectators. Does the game have less baseball-value for that reason? It would not seem so. For the value of the game lies, first and foremost, in what the players have done. Indeed, the reception value of a baseball game for spectators depends itself on the value of what the players achieve. And if this is so with baseball, why suppose things are different when it comes to artworks?

III. THE RELEVANCE OF ARTISTIC INTENTIONS TO CRITICAL EVALUATION: ROUND I*

The critic focuses on what the artist has done or is doing in producing a work of art. That is, the critic regards what the artist has done as an action. Actions, as opposed to sheer reflex responses and spasms, are, in turn, intentional doings. Intentions are pertinent to determining exactly which action the agent is performing. This is as true of the creation of artworks as it is of every other human endeavor. Even if the

* I call this Round I because there are also issues of artistic intention that arise with regard to the interpretation of artworks. I will consider those issues in the next chapter. In this chapter, it is the role that artistic intentions play with respect to evaluation that is our topic.

artist has ostensibly produced his work by aleatoric means—
by dripping paint à la Jackson Pollock or by casting
runes after the fashion of John Cage—adopting those very
decision-procedures is itself intentional.

In order to assess what the artist has achieved, part of what
the critic needs to do is to ascertain what the artist is up to.
That is, in order to appraise what the artist has done, the critic
requires a sense of what the artist was doing. What the artist
was doing—what action or actions she was performing—is,
of course, connected to her intentions, which, for obvious
reasons, we shall call artistic intentions.

In criticism, the critic is evaluating the work of the artist.
The artist, through his skill and artistry, creates a work of art.
The work of art, from the critic's perspective, is the work of
the artist, a display of the artist's agency. To estimate the value
of that work—that action, that agency—the critic must divine
what the intentional undertaking before her amounts to.

In order to establish what those guys with the bats, and
balls, and leather gloves are achieving, it is essential that I
know that they intend to be playing baseball and not some
other outdoor game, like rugby. Similarly, to appraise a mys-
tery novel by Agatha Christie, I must recognize that it is a
classic detective story and not an in-depth, psychological
character study. Knowing what the artist intends to do—
knowing the playing field he/she means to be on—supplies
the critic with a set of expectations that aids the critic and her
audience in understanding and following the work. But
knowing what the artist is intending to do also gives us access
to the purpose her work is supposed to sub-serve—which,
pari passu, supplies the critic with an important goalpost against
which to measure the achievement of the work under
scrutiny.

Pinpointing the intention behind the agent's action is crucial to identifying what action it is. If I were absent-mindedly to clear off the pieces from a checkerboard by means of a set of movements that just happened to correspond to what the red side would have to have done, given the disposition of pieces on the board, in order to win the game, it would not be the case that I had won a game of checkers (played in solitaire-like fashion against myself). For, though I was intending to move those pieces, I was not intending to be making checker moves in doing so.

Likewise, before commending Ed Wood for transgressive, convention-busting, avant-garde filmmaking, we need to reassure ourselves that that was what he intended. For, if he was aiming at something else, like making a classy Hollywood science fiction film such as *The Day the Earth Stood Still*, then commendation is hardly in order. If that was Wood's goal, then *Plan Nine from Outer Space* is patently a failure.

The stress I am placing on the relevance of artistic intention to the evaluation of the work of the artist probably sounds rather commonsensical to most readers. After all, isn't the consideration of the intentions of agents an important part of the way in which we identify and evaluate the actions of other people in everyday life? Why should things be any different when the agent is an artist and her agency is her artistry? If intentions are relevant when it comes to the understanding and the evaluation of ordinary words and deeds, it stands to reason that they should be relevant when the words and deeds are those of an artist.

And yet there are powerful and influential arguments— which collectively add up to the so-called "Intentional Fallacy"—designed to show that artistic intentions are irrelevant when it comes to the assessment of artworks.[8] The

first declares the artist's intentions out-of-bounds critically on the grounds that intentions are inaccessible. Call this the inaccessibility argument. The second alleges that there is inevitably some vicious circularity involved in admitting artistic intentions into the evaluative process. This is the circularity argument. And the third charges that artistic intentions are irrelevant to critical appraisal because critical appraisal is concerned with what the artist achieves, not what he attempts (or intends) to achieve; for the road to paltry art, like the road to hell, can be paved with good intentions. We can dub this the achievement argument.

These arguments are overlapping. Before confronting them, let me lay them out in greater detail.

The inaccessibility argument presupposes that intentions are states detached from the artwork and unavailable to the critic. We have the work before us. The intentions are elsewhere, perhaps in the artist's brain, or thereabouts, and anyway beyond our reach. This goes for any artist, living or dead. But the problem is especially acute with dead artists.

Who really knows what Homer intended? He didn't record it anywhere. The same goes for Shakespeare, not to mention the anonymous authors of works like *Gilgamesh*, *Beowulf*, and so forth. Can we ever be certain about what is going on in other minds in general, let alone in the minds of artists in particular?* Also, many artists are strange birds. They have peculiar beliefs about what they are doing—intentions so arcane that one could scarcely guess at them on the basis of

* Moreover, those who favor the idea that the critic should be concerned with reception value are likely to add: "And why should we care about the intention of the artist anyway, since it is the impact upon us, the audience, that counts ultimately?"

their works. Scriabin, I believe, intended that the ending of his *Victory over the Sun* would occasion the end of the world. I suspect that, if only on the grounds of interpretive charity, few of us would attribute such an outlandish thought to any composer.

The circularity argument is not unrelated to the inaccessibility argument. It also presupposes that the artist's intentions are not directly accessible to the critic. This forces us, it is said, to rely completely upon the work in order to divine the artist's intentions. Consequently, we will have to infer that the work is how the artist intended it. If it is boring, for instance, we will have to infer that it was intended to be boring. But if we are using our best approximation of the purpose of the work as one of our evaluative measures of the work, then we will have to declare that the boring work is a success because it realizes the artist's intention to be boring (which intention we have inferred from the way the work is).

That is, if we rely upon the work as our sole means of getting at the artist's otherwise unavailable intention, then there will not be enough distance, so to speak, between the work and the intention we impute to it on the basis of the work. Since the work is boring, it was intended to be boring, which implies that the work is a success, at least on its own terms, insofar as boredom was, we suppose, the artist's point. But clearly this is circular, at the same time that it appears to entail unfortunately that we will never be able to declare any artwork to be a failure, especially on its own terms.

In a related vein, it may be charged that if the artist's intentions are relevant to critical evaluation, then that gives the artist too much power. For in order to score a critical kudos, all the artist need do is to set her intentions very, very low. Imagine the dancer who, with no postmodern

ambitions, announces her intention to simply bend over and pick up her car keys. Once she completes this action, does she deserve our applause? But it seems that the only way to avoid that conclusion is to disallow the relevance of artistic intentions to critical evaluation.

Yet this worry seems to me to be hyperbolic for two reasons. First, artists generally create works that are most typically connected to categories—like genres and movements—which commit the artist to ambitions more strenuous than bending over successfully. And, second, as a matter of fact, artists rarely aim low. If anything, they usually overreach rather than underreach. You may think that Mel Brooks's *The Producers* is a counterexample, but recall that it is the producers, not the artist, who intend to make something awful and, furthermore, the story is comic precisely because it is incongruous to make a musical intended to flop.

The last argument, the achievement argument, like the circularity argument, also reminds us of the need for distance between the artist's intentions and the work, but it places a different spin on the matter. Artists often have bold aspirations for their works, but very frequently fail. Many artists testify that they never fully realize their intentions. There is a gap between what they intend to accomplish by producing their artwork, and what, in fact, they accomplish. Artworks most often fall short of their creators' expectations.

Yet when it comes to evaluating artworks, critics should care about what artists have succeeded in doing, not what they intended or wished they had done. That is, the critic is concerned with what the artist achieves, not with what she attempted to achieve. The critic doesn't award As for effort; the critic should only award As for achievement.

These arguments have convinced many, but I am not

persuaded that they are as decisive as they are usually supposed to be.

The contention that artistic intentions are inaccessible is far too exaggerated. Although we cannot ascertain the intentions of others with absolute certainty on every occasion, in the ordinary course of affairs we are actually very good at discovering the intentions of others. Mind reading, as the evolutionary psychologists call it, is one of the most important advantages that natural selection has bequeathed to human beings. The man lines up to the hot dog stand and the vendor recognizes that he intends to buy a frankfurter. My secretary knocks on my door, and I infer she needs something signed. The driver stops behind my parking space and waits for me to pull out; I suspect he wants my space.

We spend our days and nights reading the minds of our conspecifics continuously, and a simply stunning number of our surmises are correct. Other people are hardly consummately unfathomable. We are wrong on numerous occasions, but most of us are right far more often than we are wrong. If we weren't, neither our life nor human life in general would probably last for long. But if we are so good at grocking intentions in everyday life, why suppose we sour at it when we turn to art?

The inaccessibility argument holds that intentions are things dwelling in the minds of others where they cannot be retrieved by the critic for inspection. However, intentions are not occulted thusly in everyday life. On the contrary, we seem to have easy access to them. Why would things be different with artworks?

The proponent of the inaccessibility argument reminds us of the problem of finding out the intentions of dead and anonymous authors. Yet, again, unless there is some special

problem with art, we notice that historians, physical anthropologists, and archaeologists, among others, are often in the business of determining the unrecorded intentions of figures from the past. We find nothing amiss with enterprises like these. So, again the question arises as to why anyone imagines that the art critic faces any obstacles over and above the historians, physical anthropologists, and anthropologists at whose search for unrecorded intentions no one looks askance.

At this juncture, my remarks may be spurned as so much bloviating on the grounds that, although I declare we are so very good at mind reading, I don't really explain how it is done. Do I think this occurs mystically? Yet if I think it happens magically, then I haven't really got a leg to stand on.

Needless to say, I don't think that there is anything magical at all about how mind reading works. This is not the place to explore the ways in which we go about mind reading our conspecifics in everyday life. But I can say a few things about how we establish the intentions of artists when we encounter their works.

One very important access road to the intentions of artists has to do with the fact that artists produce works that belong to acknowledged categories. That is, in general, artworks belong to categories—like genres, styles, movements, periods, oeuvres, etc.—and/or they have lineages and traditions. We can locate the pertinent kind or combination of kinds to which the artwork belongs by, among other ways, calculating the number and salience of features that the work being criticized has in common with members of the prospective class of artworks to which we suspect it belongs.

Different types of works of art, of course, are underwritten by certain publicly acknowledged purposes, such as outraging

the bourgeoisie or inculcating Christian virtue. Moreover, it seems fair to presuppose that *generally* artists want to reach their audiences, something they can do by emphasizing or at least not obscuring the category or tradition to which their work belongs and abiding by the existing agenda or agendas of the type of art in question.

Therefore, since our default assumption is that artists want to connect to their audiences, we presume that if they create something that gives every appearance of belonging to a certain recognizable artistic category or tradition or classification, then we infer that they intend their works to pursue the purposes associated with those categories, traditions, and classifications.

Admittedly, this procedure is not infallible. But the fact that it is not infallible hardly lends succor to the claim that artistic intentions are always inaccessible. Sometimes, very often, they are not, and the procedure sketched above explains why they are not, in a surprisingly large number of cases.

Perhaps it will be observed, fairly enough, that this method requires the presupposition that artists typically possess at least one intention that I appear to impute to them almost automatically, namely, the intention to make contact or to communicate with, or to secure uptake from, their audiences. This is what predisposes them to highlight the category or tradition (with its subtending points and purposes) to which their work belongs. But, is it really so unreasonable to postulate that most artists, most of the time, want to relate to their audiences, and especially to critics?

Of course, the preceding is not the only way in which we may come to know the artist's intention. There are many other ways, including, most obviously, the fact that we may be told the pertinent intentions by the artist herself. In novels

up until the end of the nineteenth century, authors often included introductions in which they stated their intentions. Interviews often discharge much the same service today across the arts. And the most outré avant-garde work is generally accompanied by a manifesto or the like.

Many commentators dismiss artistic pronouncements concerning their intentions on the grounds that the artist may be dissembling. But, again, in order to get our bearings, it is useful to compare this case to what happens in everyday life.

People lie about their intentions all of the time. However, very often we are quite adept at detecting their dishonesty, especially when the avowed intentions of fakers don't line up with their actions. Similarly, we can unmask artistic dissembling when the declared intention seems so out of kilter with what was done in the artwork such that no one of sound mind could have had the alleged intention with respect to the work in question. This is why we frequently and rightly reject the claims of the producers of excessively brutal movies when they say they really mean to discourage violence in society.

Related to the suspicion of authorial pronouncements on the grounds that they may be lying outright is the worry that they may be self-deceived. They may report their intentions one way, but unconsciously they are otherwise. However, unconscious intentions are still intentions and unearthing them is still a form of intentionalism. Moreover, it should be clear that we are often very good at ferreting out unconscious intentions in everyday life, despite the agent's disavowals, as in the case of the Idaho senator, Larry Craig, and his adventures in the stall in the men's room at Minneapolis airport. Why suppose that the unconscious intentions connected to the creation of artworks are in principle more remote?

Another possible objection to the position I am recommending regarding artistic intentions is that my view appears to give the artist too much authority in establishing the identity of the artwork. The artist shouldn't determine the category to which her work belongs. That, it might be urged, should be up to the audience.

But I see no problem in allowing the artist to choose his playing field, so long as we can reject his explicit claims about his intentions when we have good reason to believe that he is lying, self-deceived, or confused. Indeed, I find nothing strange in giving the artist at least a *prima facie* license with regard to identifying his intention. When we are perplexed and we ask our co-workers what they are doing in the ordinary flow of events, don't we usually grant them exactly this authority?

In answering the inaccessibility argument, we are on our way to answering the circularity argument. According to the circularity argument, if we have no direct access to the artist's intentions—no cerebroscope, so to say—then the artwork is the only evidence for the intention. We must presume that the work is just what the artist intended, for we have no other clues. But if we identify the content of the artist's intention with the way the work is, then when we compare the work to the intention, we are basically evaluating the work in light of the work—which, of course, is circular.

However, this is not a difficult circle to break. Although we do not have so-called direct access to the artist's intention, we have lots of indirect evidence for it. For, as we have seen in our responses to the inaccessibility argument, artworks come in categories, like styles, movements, tendencies, oeuvres, traditions, and so on, and placing the work in question in an apposite category can provide a fix on the artist's intentions.

Likewise, other evidence external to the work of art itself toward establishing artistic intentions includes sincere interviews, statements, diaries, manifestoes, etc. as well as comparison of the current work with other works from the artist's oeuvre and other works from the artist's milieu, peers, and visionary company. On the basis of all these factors, and more, we are able to figure out the artist's likely intentions and to take note of whether or not the artist fulfilled them.

Perhaps needless to say, the work itself is the most important evidence for the artist's intentions in a number of ways. For, whatever evidence external to the work that we marshal to determine the artist's intention must correspond to the evidence of the work. To place the work in a certain genre, of course, requires that the work actually has the features of the genre that we attribute to it. And to accept the artist's testimony about his intentions demands that what he says of the work is consistent with the work.

But, the circularity argument seems to wrongly presuppose that the only way in which the work could supply evidence about the artist's intentions would be to take the work to be expressing the artist's intention fully and exactly. It is as if the work itself could not provide evidence of a failed intention. But that appears very improbable. Quite often one can tell by observing an action both what the agent intends to do and that he is failing to do it.

For example, I see a man applying a coin to the top of a Philips-head screw, and I see at once that he intends to turn the screw and fails to do so at the same time. Or, I watch a play: the characters exchange nonsensical remarks, fleshed out with winks and double-takes. I recognize their intention to be comic, but I am also sure that they've blown it. Consequently, even if we had not already shown that there is

evidence outside of the work that enables us to capture the artist's intention independently of the work itself, it may in addition be the case that a work on its own is sufficient to deliver evidence of the artist's intention and the failure thereof, thereby dispelling the circularity argument.

Finally, the enemies of our resort to artistic intentions in critical evaluation point out that even if we have ways of retrieving the intention of the artist, why bother? For, a critical evaluation assesses what the artist has achieved, not what she attempted. Why should we care whether or not the artist had noble or aspiring intentions? The critic should only concern herself with the outcome—with whether or not those intentions were executed successfully.

This argument, the achievement argument, misconstrues the nature of our critic's interest in the artist's intentions. For with respect to the kind of evaluation that we are examining here, it is not the artist's intention that the critic is appraising. The critic is not saying, for example: "Oh, that's a very nice intention." Rather it is the artist's achievement, the product of the artist's agency or what she has done, that concerns the critic. Nevertheless, in order to assess what she has done, we need a notion of what she has done. And since what she has done is an action or a series of actions, that calls for a description of what has been done which alludes to the intentions that constitute the action or actions in question.

Intentions enter the critical picture for the purpose of identifying the nature of the artist's performance, including its implicit or internal goals. This information can then be used in order to gauge whether the work is a success on its own terms—a determination that will contribute, to a significant degree, to the critic's overall evaluation of the achievement of the work. What is achieved in the work is a

matter of the artist's doing or skilled agency. To assess that, one needs to comprehend the artist's underlying intentions. In this way, the artist's intentions are relevant indispensably to evaluation.

To return to our previous example, I submit that it could not have been part of Ed Wood's putative achievement that he transgressed the codes of Hollywood moviemaking with his *Plan Nine from Outer Space*. For, transgression, construed as an intentional act, was not an action that Wood could have performed, since it was outside of his ken. And if an action is outwith one's cognitive and motivational stock, then it cannot be an action one could do. Thus, a discussion of Wood's probable or even possible intentions is pertinent in this case to refuting certain claims about Wood's achievement.

Moreover, a cogent argument establishing that what Wood intended by his actions was to make a respectable Hollywood science fiction film is also relevant to ascertaining that *Plan Nine from Outer Space* is an abysmal failure. It makes no difference that many have spent an enjoyable evening chuckling over Wood's follies. He did not achieve high comedy, since he didn't intend that—the moron, in the jokes that bear his name, is not a comedian—nor did Ed Wood achieve much in the way of science fiction filmmaking either, just because he *did* intend that.

Artistic intention is relevant to critical evaluation, even though it is true that it is not what the artist attempts but what the artist achieves upon which the critic should focus. But figuring out the nature of the artist's achievement mandates an understanding of what the artist has intended to create by way of her actions. To assess the achievement of some fledgling abstract expressionist, you want to know that he intended his canvas as a painting and not as a paint-ball target.

One objection to this approach might be that it ignores the fact that sometimes an artist may perform an action with unintended consequences. That, of course, is true, but in order to identify an artistic action as possessing unintended consequences, the critic will have to have an idea of what the artist's intention was.

A related objection is that sometimes the critic may find it appropriate to describe or analyze what the artist has done in terms of concepts that were not available to the artist when he created the work in question. For example, one may wish to call an artwork sexist that pre-dates the currency of the label. Doesn't a commitment to intentionalism thwart this very reasonable critical practice?

I do not think that it does. For it is consistent with doing something under one description that one may also be doing something else under another description, even though one is unaware of the applicability of this alternative description. Someone in the 1920s, for example, who intentionally engaged in smoking cigars may also be described as risking lung cancer, even though the smoker did not know that this description applied to him. Similarly, the artist of an earlier period who intentionally displays the naked bodies of women solely for the pleasure of his male clientele may be described as sexist, even though that is a term that would have been incomprehensible to him.* Moreover, this attribution of sexism itself must involve some cognizance of the painter's intention, since the critic would have to be convinced that the

* Furthermore, it is perfectly consistently with this that, although he knows nothing of sexism, he will readily acknowledge his intention to provide male sexual pleasure through the display of the passive bodies of women.

painter was not being ironic. And, in addition, the critic would have to be confident that the painter intentionally exhibited the female bodies in the lascivious way in which he did and that it was not the result of accident or ineptitude.[9]

The object of criticism is the achievement of the artist, by which I mean the effective agency exercised and made manifest in the process of creating the artwork. It is the work process that is in evidence in the work product, the artwork. And because we need to specify the agency on display in the work, we need to locate the pertinent governing intentions.

Here the opponent of intentions may complain that in situating the object of criticism in the artist's achievement, construed as a performance or process, an ontological howler has been committed. For, obviously the object of criticism is the work as product, the very artwork itself, and not the process made manifest in the artwork.

Here it may be helpful to make two related remarks.

Although there may be reasons to resist thinking of the artwork ontologically as a process, and, in addition, reasons in favor of regarding it as a product, I am not committed to one view or the other in saying that the object of criticism is what the artist has achieved in the process sense. The object of criticism need not be construed as the artwork.[10] For, the object of criticism, logically speaking, may not be the artwork *simpliciter*, as opposed to some aspect of the artwork, such as the artistic agency exhibited by means of the work. Indeed, this would appear to fit with our appreciative practices better than alternative views, for what we appreciate, first and foremost, is the artistry of the work.

Furthermore, there may be something metaphysically too anxiously austere in segregating art as process from art as

product. For, the best account of the object of criticism is that it is, in the ideal case, the effective artistic agency on display—the exhibited achievement of the artists—in the product, the artwork, conceived howsoever your ontological lights may guide you.

IV. A BRIEF RECAPITULATION

In this chapter, I have argued that the object of criticism is the achievement of the artist as displayed in the work. In the previous chapter, it was hypothesized that the role of the critic is to discover what is valuable in artworks. What is valuable in the work of art, then, is the achievement of the artist. This species of value is called success value, since it is inextricably connected to what the artist achieves in the work.

My view contrasts sharply with the opinion that the value of an artwork is a direct function of whatever positive experiences the artwork affords audiences. This approach appears objectionable, if only because it fails to countenance such widely acknowledged sources of artistic value as originality. On the other hand, the success value approach to what is valuable in the artwork can incorporate whatever we should want to say about the reception value of the artwork insofar as, in the pertinent cases, it is generally an element of the artist's achievement that he or she succeeds in making a work that has the capacity to afford the positive experiences in question to his/her target audiences.

Situating the value of the work in what the artist has done by way of achievement of the work entails that artistic intentions are relevant to the evaluation of artworks inasmuch as the critic needs a take on what the artist intended in order to determine what, precisely, the artist has done. Given the way in which we typically approach the actions of others

in the course of daily events, this should seem fairly straightforward.

However, for most of the twentieth century and continuing into our own day, there have been recurring arguments against the resort to artistic intentions in appraising artworks. These include: the inaccessibility argument, the circularity argument, and the achievement argument. Nevertheless, each of these arguments, in turn, has its weak points.

The inaccessibility argument is too excessive. It presumes that intentions in both life and art are perennially and unrelentingly obscure; but clearly, as we have seen, they are not, either in life or art. The circularity argument charges that if we use the work of art to identify the intentions behind it and then go on to use the intention as our gauge, at least in part, for measuring the work, then we are, to that extent, entrapped in a vicious circle wherein we are, in effect, measuring the work of art against the work of art (i.e., itself against itself).

However, this outcome can be averted once we realize two things: 1) we have external evidence of the artist's intentions, and 2) the work can simultaneously afford evidence for both the artist's intention and for his failure to realize his intention, just as witnessing the basketball player's missed foul shot supplies us at once with evidence of his intention and his failure to live up to it.

The achievement argument emphasizes correctly that the critic should attend for the sake of evaluation to what has been achieved by the work, not to what was attempted or intended by it. That is, the critic doesn't appraise intentions, no matter how elevated or ambitious. That's right. But this fact does not preclude a concern with the intention of the artist from the critic's purview, since the critic—in order to

identify what the artist has done, and hence what he has achieved—will need to grasp something of the artist's intention.

Thus, the artist's intention is relevant to critical evaluation, even though it is not the intention as such that the critic is evaluating. As we will see in the next chapter, the artist's intention is also relevant to the critic's interpretation of the work of art. However, there are even more arguments against that view than the position defended here about the relevance of the intention of the artist to evaluation.

The Parts of Criticism (Minus One)
Three

I. INTRODUCTION

By the "parts of criticism," I mean the component operations that go into producing a piece of criticism. Although, as a rule, these operations are not completely independent of each other, but rather inflect one another mutually, we can make some pragmatic distinctions among them. As indicated in earlier chapters, these operations include: description, classification, contextualization, elucidation, interpretation, analysis, and evaluation.

On the view of criticism advanced in this book, the first six procedures typically function as grounds for evaluation.* However, a piece of criticism, properly so called, need not contain all of these operations. For me, a piece of criticism must contain at least one of the first six of these operations, plus, of course, some form of evaluation (either implicit or explicit).

* Though the first six procedures function as the grounds for criticism, sometimes evaluation comes rhetorically in tandem with them. For instance, the descriptions of the work might be voiced in evaluative terms—for example, "Note the strong, clear line of the figure." Likewise, the critic might say: "This is a superb example of the sonata allegro form," when classifying a piece of music. However, the context of the critical production as a whole generally makes clear how the items singled out contribute to the evaluation being proffered.

The requirement that at least one of the first six operations appear in a critical effort follows from the notion that criticism involves *grounded* evaluation. It is on the basis of description, and/or contextualization, and/or classification, and/or etc. that the critic supports her appraisals.

Moreover, without saying something about the work of art by way of discussing it in terms of one or more of these operations, the critic's remarks would be virtually uninformative—little more than a gesture of thumbs up or down. So, the critic undertakes the description, and/or analysis, and/or so forth of the artwork for the sake of producing a communication that is effective rhetorically as well as for the sake of logic.

Although I have underscored the need for a piece of criticism, properly so called, to comprise at least one of the six operations plus evaluation, perhaps needless to say, this allows that a work of criticism might involve all of the first six operations plus an evaluation or, for that matter, any combination of the six operations plus an evaluation. What is essential to criticism is an evaluation backed by reasons— which reasons can be advanced by means of description, and/or contextualization, and/or classification, and/or elucidation, and/or interpretation, and/or analysis.

The purpose of this chapter is to review the parts of criticism (minus evaluation), sketching that which each of the first six procedures involves, and commenting upon some of the special problems and issues that arise with each part.* Given its indispensability and centrality to the work of

* Chapter Three will also include an additional section on the relevance of the artistic intentions to interpretation, since this seems to be the most frequently debated issue when it comes to the interpretation of artworks.

criticism, evaluation merits a chapter unto itself. Thus, the next and concluding chapter of the book will be turned over to evaluation, its problems and prospects.

II. DESCRIPTION

Description is a matter of telling one's readers or listeners something about what the work of art at hand is like.* It gives the reader something concrete to hold onto cognitively. If the work is a representational specimen of visual art, for example, the critic says what it pictures—a haystack at dawn, for example—as well as how it appears in terms of things like its color, its disposition of figures, its facture, etc., as well as often including some observations about their accompanying aesthetic and expressive qualities. If it is an abstract work of visual art, then the critic itemizes its shapes, if any, as well as other parts of the painting, and their relations and qualities. With works of narrative art, the critic usually begins by at least offering a paraphrase of the story.

But whatever the artform, some description of the work is usually put forward if only so that the reader or listener has some cognitive purchase upon that which the critic discourses. For, it is hard to know what a reader or listener could make of a critical evaluation bereft of any description whatsoever of the artwork—other than, maybe, that the critic was either enthusiastic or vexed by something. Still, what that something was would be pretty obscure otherwise.

* Description presupposes that the critic have grounds for knowing what the artwork is like. This principle was violated recently by a critic for the magazine *Maxim* who reviewed negatively an album by the band Black Crows before the album had been sent out to anyone.

I suppose that there could be cases where the work of art is so well known by everyone that a description of it seems redundant.* Perhaps *Hamlet* might be an example of this. But even in cases such as *Hamlet*, it is difficult to imagine that description can be avoided entirely. For not only the evaluation of the work but all the other parts of criticism will require that the critic specify something about the work that he intends to contextualize, elucidate, interpret, or analyze, and, furthermore, that specification will involve description. When analyzing a work or a part or an aspect thereof, the critic will usually describe what she is analyzing, even if the audience knows the work, if only to orient readers to the object of her analysis. For example, the critic may describe Eliot as treating Prufrock compassionately—perhaps supplying a paraphrase or an example—in the process of analyzing how this was done. Likewise when the critic classifies or categorizes the work, she will need to describe the features of the work that warrant the proposed categorization. So, although it may be possible to imagine a piece of criticism with no description, such a feat seems highly unlikely, for reasons of both logic and rhetoric.

One, possibly frivolous, worry about critical description is the charge that, in one sense, critical descriptions can never be adequate to the artwork. Most artworks are very complicated objects. Indeed, even a readymade has many parts, and, in any event, its relationship to its institutional and historical contexts can be both intricate and rich. Because of this

* Perhaps a case of this would be an academic conference where everyone in the audience is a professional who knows the canonical work in question. But even in such examples there is usually some description, undoubtedly for the reasons itemized above.

complexity, artworks can never, it might be said, be fully described. There are just an indeterminately large and practically boundless number of things you could say about artworks as you look at them from every angle—formal, economic, historical, and so on. Consequently, description is inherently quixotic.

Something in the preceding claim is probably true. A full description of an artwork, such that there is nothing left to say about it—no relation of its parts that has gone un-remarked—sounds, to put it mildly, impracticable in the vast number of cases. It seems there is almost always some further angle from which the work may be surveyed, some additional comment that could be made.

And yet there is significant slippage in this argument in its movement from the unlikelihood of full descriptions of the work to the claim that there are no *adequate* descriptions. Simply put, there are adequate descriptions of artworks that are not full descriptions, given the apparent unattainability of so-called full descriptions.

Yet, how can there be adequate descriptions that aren't full descriptions? It is because adequate descriptions are selective. They are selective out of necessity. It is doubtful that anyone could deliver a full, indefinitely large description and, furthermore, it is even more improbable that any reader or listener could process it. Also, such a description would shirk the central task of criticism—to abet the audience's understanding of the work—because such an attempt at criticism would fail to shape the work in such a way that people can comprehend it better.* Rather, a full description would

* In the 1960s and early 1970s—especially in theater and dance criticism, but in film criticism as well—there was a movement whose practitioners

overwhelm them cognitively and perhaps even flabbergast them emotionally.

Moreover, the function of the description of the work in the overall act of criticism is to ground the other operations of criticism, especially evaluation. Clearly, not every aspect of the work and its context, scrutinized from every conceivable vantage point, will be relevant to these other operations. That which needs to be described about the work are those features of the work that are important to draw to the audience's attention for the purposes of classification, contextualization, elucidation, interpretation, and/or analysis, and, of course, evaluation. That is, the demands of these operations provide the frame, in a manner of speaking, in which the critic outlines his portrait of the work; they guide him in his selection of which details and which relations in the work merit description.

Nevertheless, as soon as it is conceded that description is selective relative to certain hierarchically overarching

were called descriptive critics. Michael Kirby, the editor of *The Drama Review*, was a champion of this tendency. Descriptive criticism was supposed to describe its objects as fully and as dispassionately as possible—it was meant to be completely non-interpretative and non-evaluative. Its super-ego was forged on the model of some notion of scientific, value-free description and, possibly also, on the model of the phenomenological reduction. It was the Jack Webb/Sgt. Friday/*Dragnet* school of criticism—"Just the facts, ma'am" (and lots of them). One of the many problems with descriptive criticism, however, was that it was virtually unreadable by anyone who had not seen the work in question (and unnecessary for those who had). That is, for those who had not seen the work, it was just too much information in too unstructured a form. As we shall see, the other hierarchically ordered operations of criticism, among other things, function to organize critical descriptions of works into cognitively manageable packages.

pursuits—such as, for example, interpretation and evaluation —the worry ignites that critical descriptions are bound to be specious or tainted. The critic's evaluation or interpretation of the work, for example, will lead her, so it is charged, to describe the work in what must be a gerrymandered fashion. That is, she will offer a description of the work that suits her evaluation and/or interpretation and that shunts to one side those aspects of the work that contradict or, at least, contest her viewpoint. Description is not only necessarily selective; it is selective in an epistemically suspicious and contaminated fashion. Putatively the critic's conclusions drive her choice of those details and relations that she deems to be the ones important enough to warrant descriptive attention.

Again, there are some grounds for this anxiety. The critic, where competent, will generally put forward—by way of description—the evidence that best suits her case. But there is nothing nefarious about this, since her descriptions can be challenged from a number of directions.

We may find her guilty of mis-describing the work. She may claim that it has certain features that it lacks. Or, she may describe something that is there, but in language that is so vague or misleading that it only supports the pertinent evaluations or analyses by means of equivocation. Of course, it is not only we who may correct the critic in this way; the critic may catch her own mistakes.

Moreover, the critic may fail to describe something about the work that the rest of us—other critics and lay folk alike— recognize to be such an important feature of the work that there is a consensus that any adequate analysis, interpretation, evaluation, etc. of said work should include explicit reference to it as part of an acceptable description of the work.

For instance, a criticism of last night's ballet that neglected

to mention that the male dancer dropped the prima ballerina on her head every time they attempted a lift together is something that everyone will agree should be part of the description of the performance, just as a piece of music criticism that forgot to describe the fact that the orchestra was out of tune would be regarded as remiss from all sides.

In short, it is true that description is tailored to the other operations of criticism, something we will discuss anon under the rubric of the hermeneutical circle. This relativity of description to the other operations of criticism may open the door to bias. But bias does not necessarily enter. For the critic, in crafting her descriptions, can remind herself of important features of the work—perhaps features of the work noticed in all or most of the antecedent criticism of the work—that call for description but which do not fit the viewpoint that she is exploring at the moment.* In this way, she can correct herself. And, failing that, others can call attention to the generally recognized aspects of the work that the critic has failed to include in her description.

Criticism, like every other form of inquiry, is open to bias, since, again like every other form of inquiry, it involves selection. Nevertheless, we can control for bias inasmuch as the descriptions that the critic proposes of an artwork are ultimately corrigible, by the critic herself in the first instance and then by others. In this regard, the descriptive procedures of criticism stand on all fours with other intellectual endeavors.

Bias is possible everywhere. Yet that would be a problem only if it was something impossible to remedy. The bias that might infect a critical description, however, is always

* Of course, the critic may reject these prior observations, but to discount them will require an argument on her part about why they are dispensable.

remediable in principle. For, we can ascertain independently of the critic's evaluations, interpretations, and so on of works whether everything that strikes most of us as important details in a work have been incorporated in the description of the work, and, if not, we can demand to know why the critic has sublated these details.*

And even where there is no consensus that an overlooked detail is important, a case can be made against its omission, by, for example, showing that its description can be connected to a superior, more encompassing view of the work. Furthermore, these are not only ways in which others can correct the descriptions of the critic. They parallel the strategies by which the critic can interrogate her own descriptions in inner dialogues and debates with herself.

As emphasized, a critical description of a work of art sub-serves the other operations or parts of criticism. This is unproblematic, however, since readers of a piece of criticism are not constrained to attend to the work only through the optic or under the aegis of one piece of criticism. For, of course, we have access to other criticism of the work and, indeed, to the work itself sans any given interpretation and its allegedly privileged or preferred descriptions.

Perhaps the most important service that description performs is to segregate out for attention the parts and relations of the work that the critical analysis or interpretation goes on most often typically to demonstrate as

* This allows that in some cases the critic who goes against the tide can try to make a case that what others suppose to be important about the work really is not. Nevertheless, although this can be done, it is an uphill battle since it may often have to unhorse features whose apparent prominence has stood the test of time.

belonging to a functionally organized whole worthy of evaluative commendation for its artistic achievement of unity.

For example, the commentator will include in his description of *A Midsummer Night's Dream* mention of all those episodes where, due to Puck's botanical interventions, the characters awaken to find themselves irresistibly infatuated with the most unlikely partners—as Titania falls for the donkey-headed Bottom. The critic itemizes these subplots descriptively in order to establish interpretively that the play is held together by the theme of the irrationality of romantic love, our capacity to be overcome by desire as the result of virtually physio-chemical forces (Puck's potions) beyond our understanding—i.e., love as a drug.[1] These parallels, then, can be invoked as grounds for applauding Shakespeare for the surpassing unity of his creative achievement.

Of course, serving as grounds for interpretively organizing and then recommending an artistic achievement for its coherence is not the only service description performs for the other parts of criticism, as we shall see as we examine them at greater length.

III. CLASSIFICATION

Although it is probably obvious, it is always useful to emphasize that artworks come in categories. This is most evident at the level of artforms: painting, sculpture, music, literature, theater, dance, architecture, photography, film, video, and so forth. But then each of these artforms comprises further categories of various sorts—for example, genres, movements, styles, oeuvres, etc. Fundamental to the task of criticism is placing the artwork at hand in its proper category (or categories), because, once we know the category (or categories) to which the artwork belongs, we have a sense of

the kind of expectations that it is appropriate to bring to the work—which knowledge, in turn, provides us with a basis for determining whether the work has succeeded or failed, at least on its own terms. That is, situating the work as a certain kind of artwork at the same time implies the type of criticism suitable to bring to bear upon the object.

This appeal to categories may strike some readers as suspiciously reactionary. For, has it not been the imperative of art, since Romanticism or, at least, since Modernism, to break with the past, to initiate a continuous revolution of the new, and to remake everything afresh? "Make it new" was Ezra Pound's battle cry. Indeed, under extreme versions of the Modernist regime, each artwork, it has been suggested, should be a genre unto itself—which is to say a member of no genre, properly so called. A recent exhibition in France in 2003, entitled *Sans commun mesure*, for example, presumes that incommensurability is the distinguishing mark of modernity.[2]

Likewise, it may be urged, new artforms are constantly proliferating—photography, film, radio, video, computer generated imaging—and we can be sure that there are more on the way. When such artforms first burst onto the scene, to what categorical expectations can the critic take recourse? Isn't the category to which the nascent artform belongs just too new to have any expectations associated with it?

Consequently, although in the olden days critics might have relied upon categories in the way suggested by the opening paragraph of this section, serious art since at least the late nineteenth century has rendered the invocation of categories obsolete. Categories of art have been banished, as the modern artist, brandishing Kant's patent for genius, yearns to give the rule to nature. Therefore, there is little point for the critic concerned with serious contemporary art to

appeal to categories. For presumably the serious art world today is a world without categories of the relevant sort.

But, of course, this picture of the art world is far too extreme. Much mass art, including movies and TV, comes in categories. Are none of them serious? Novels too, even serious ones, often are still written in genres, as are plays. Ditto popular songs; even much advanced music is written in forms, such as opera, of long standing.

Yet perhaps the only "serious" art is avant-garde art. And, of course, there is a great deal of avant-garde art, art of the new, which may attempt to defy utterly any categorization. But, *entre nous*, it does not. There are clearly genres and even traditions in the originality game, such as those of trans-gression and reflexivity. It is true that one frequently cannot tell what category a work of visual art belongs to simply by looking, but there is no reason not to use contextual and institutional clues to facilitate classification. Such information is perfectly legitimate when it comes to categorizing artworks. Moreover, most avant-garde art can be sorted into movements, such as Cubism, Photorealism, Pop Art, Minimalism, Postmodernism, and so on.

However brave and stirring, the mandate that every artwork break with its tradition and re-invent its artform was actually never anything more than a wishful fantasy. No one could make a work that completely severs its ties with her tradition, nor could anyone else have understood such a work. On both the reception and the production side of things, the human mind simply does not work that way.* The very ambition to

* In part this is because we tend to render human actions intelligible by placing them in narratives—accounts of how the present emerges from the past (often a.k.a. tradition).

agitate for a perpetual revolution in art is a tradition, the tradition of the new. And the astute critic is quite adept at situating new work into the sub-genres of this nearly century-and-a-half old lineage or tradition, quite often with the help of the manifestoes and interviews that the avant-garde artist and/or his gallery have been generous enough to supply.*

Similarly, we must deny that the new media that become artforms—like photography and cinema—arrive without categorical expectations attached. For, in the earliest stages of these nascent artforms, ambitious practitioners tend to ape the effects of the neighboring, established artforms, as photographers imitated painters and as filmmakers imitated dramatists. In these cases, critics have no trouble fitting such work into already existing categories.

Furthermore, by the time the new artform is ready to declare its independence from the other muses, enough about the new direction the artform is taking is in the air—again in the form of manifestoes and other sorts of institutional or art world chatter—for the savvy critic with her ear to the ground to have a sense of the emerging categories and their associated range of expectations.

Among the major services that the critic performs for her public is to inform us about the categories to which artworks belong. That is a leading aspect of the critic's expertise; she is

* In addition, the critic can also get a fix on a new genre emerging in one artform by looking at developments in other artforms where what is happening in the one artform is animating what is happening in the other. For example, avant-garde film critics derived a sense of what was going on as well as what kinds of projects to expect in the structural film by comparing structural film to its predecessors in the realm of Minimalist painting and sculpture.

an expert concerning the categories of art, or, at least, the categories pertinent to her beat. If she is a contemporary critic, she stays on top of the emerging genres, movements, and styles. But, also, she has command of the history of her artform and the categories that have flourished in the past. In general, the critic will have a larger repertoire of categories of art in her cognitive stock than plain readers. And, ideally, she will have greater facility than her lay readers in applying those categories and classifying artworks.

The critic orients the reader to an artwork that may be initially puzzling to many by situating it in a category and explaining the aims and rationale of that type of art. In this way, the critic alerts us to the kind of achievement to which the artist has committed herself. Turning to the work, then, the critic describes, interprets, and analyzes it in order to weigh its degree of success as the kind of artwork it is. As we shall discuss in the last chapter of this book, this judgment may not be the only type of assessment of the work that the critic issues, but it is one that is always in order.

A major source of critical error is connected to the critic's classification or, rather, misclassification of an artwork. This occurs when the critic places an artwork that belongs in one category in another less suitable or unsuitable category. Frequently, this happens when a critic familiar with one kind of art is confronted by something new and categorically different. This is probably why Samuel Johnson was so harsh to Wordsworth; he brought Neoclassical expectations to a very different kind of verse. Likewise, the literary critic who derides Agatha Christie for her lack of psychological depth misconstrues the genre in which Ms. Christie worked.

I think that this error is quite common. The movie reviewer who complains that an adventure film is poor because it is not

as great as Renoir's *Rules of the Game* or the Broadway critic who derides a musical because it is not quite *Parsifal* has perpetrated an error of classification. It's not just snobbery. It's a category mistake.

On the other hand, a major function of criticism is to reverse errors of the preceding sort, as Hugh Kenner and Guy Davenport did when they demonstrated that Louis "Zukofsky was never the poet of the ideogram: his, rather, was a verbal music based on elaborate patterns of repetition of sounds and syllables, a constraint-based poetry whose buried puns, paragrams and intricate literary allusions would demand a different kind of reading."[3] In cases like this, the critics dispel the misclassifications of earlier critics and thereby clear up the confusions, puzzles, and dissatisfactions instigated by the previous mis-categorizations. It is as if the later critics replace a bad pair of prescription eye-glasses with the proper prescription, allowing audiences to see the work aright and afresh.

In many instances, the category to which an artwork belongs may be so well entrenched that the critic does not need to help the audience situate it. A novel by Zane Gray or Louis L'Amour is obviously a Western, and what makes for a Western is widely known and readily recognized. The critic need only say that it's a Western and leave it at that.

On the other hand, sometimes the critic has to work harder at placing the art for readers' benefit. Pointing out that Damien Hirst's *A Thousand Years*—which involves the rotting head of a cow in a glass case—belongs to the genre of the *memento mori*, for example, enables us to see that it is not just another scandalous art-world prank but rather an invitation to a sober meditation on mortality. Likewise, being told that Mahler belongs to the contrapuntist tradition, rather

than the melodist, assists listeners in recalibrating their expectations.

One way in which a critic goes about locating a work in its genre—say, placing the Harry Potter series as a bildungsroman—is to describe for the reader a number of the likenesses between the work at hand and works in the putative genre. And this is, at the same time, one of the services that description performs for evaluation.* For, in describing an artwork in a manner that establishes its membership in a category, as that of colorism, for instance, one implicitly signals the criteria relevant to an appraisal of the object.

Of course, mention of the relation of description to classification may set you wondering: isn't there a chicken-and-egg problem here, if in order to know what it is pertinent to describe requires knowing the category to which the artwork belongs, while, simultaneously, we situate the artwork in that category precisely by describing it in terms of its similarities with other works in the category? That is, in order to describe the work correctly, it seems that we need to know the category the work instantiates; but we only know the category the work inhabits on the basis of our description. This is our first brush with a problem that was christened the "hermeneutic circle" by the philosopher Wilhelm Dilthey in the nineteenth century.

The hermeneutical circle presently before us is this: we must describe any artwork selectively. The description of the work which will cast it in the most informative light is the one guided by a recognition of the type of artwork it is—that

* Other ways, of course, include the use of evaluative ("an excellent plot turn") and/or emotive language ("a thrilling finale") in one's description of the work.

is, the category or categories of which it is a member. But how do we establish that? By describing it in terms of the similarities it bears to other members of that category. Yet how can we know the category prior to an apposite description of the work where that description, conversely, requires foreknowledge of the category?

Furthermore, commentators worry, the critic will only dig herself in deeper once she hazards a category, since that will guide her descriptions in such a way that they will confirm her classification, even if she's gotten off on the wrong foot.

Let us first deal with the anxiety that postulating that the work belongs to a certain category will blind us to any description of it that is not in accordance with our category. Suppose we start off with the hunch that the painting before us is an instance of Category B. In reality, it is an example of Category Z. But putatively we will never be able to correct ourselves as we proceed blithely along producing only Category-Z-pertinent descriptions of it.

This, however, is a very unconvincing scenario. For, it is not the case that all the non-Category-Z-pertinent features of the painting will suddenly disappear or otherwise be occluded from our view. It might be alleged that our adoption of a category "blinds" us to the details of the picture. But this must be a metaphor—and a seductive and dangerous one at that. Against its siren call, we must reiterate to ourselves that it makes no sense to take it literally.

If there is a man with halo and wings prominently displayed on the left side of the painting who does not fit with our categorization of it as a realist painting, he won't go away. We will see him, perhaps finding him to be a nagging presence, pressuring us to think about classifying the painting differently. Just as a scientific theory does not dispel its

anomalies, the classification of an artwork does not somehow conclusively mask all of the features not relevant to the categorization, especially when the divergent details in question are salient ones and numerous. Indeed, if the features are conspicuous enough or there are enough of them, the critic may be disturbed to the point where she considers re-classifying the artwork.

It is true psychologically, as the circular hermeneut attests, that we move back and forth between our categorizations of the work and our descriptions of the work, attempting to adjust them mutually. This is a process of reflective equilibrium in which we try to align our descriptions with the classification we've postulated for the work, while at the same time modifying our categorizations as various features of the work call out for description. Our classification of the work is a hypothesis, but (and this is key) there is no impediment to standing back and challenging that hypothesis, as we just saw in the previous paragraph.

Moreover, one may wonder whether the circling hermeneuts haven't confused the psychology of discovery with the logic of confirmation. It may be true that as the critic ponders the work in front of her, her mind does, in a manner of speaking, circle back and forth between the categorization of the work and her description of it. However, once she arrives at a classification, she can compare it to the work and to competing classifications of the work, tallying the results on both counts in order to determine whether her own classification correlates sufficiently with prominent features of the work and, also, whether her score is better or worse than rival classifications.

IV. CONTEXTUALIZATION

We have discussed some of the roles that description plays in criticism. But the kind of criticism that we have been talking about so far is the description of the artwork itself. We can call this internal criticism, and it is the kind of description we examined earlier. Yet, there is another kind of description which critics often deploy. Call this external description, by which I mean the description of the circumstances—art historical, institutional, and/or more broadly socio-cultural—in which the artwork has been produced. A less pleonastic name for this part of criticism is *contextualization*.

Often by illuminating the context in which the artwork has been produced, the critic is better able to assist the audience in understanding of the work and, in addition, in understanding of the critic's evaluation of it. Roughly speaking, by placing a work in a historical context—whether art historical or a more broadly social one—the critic is able to refine further the nature of the artist's ambition in a manner that suggests the ways in which to estimate his success or failure, at least on his own terms. For example, if the context of the work is described in terms of a problematic to be solved, then an important aspect of the critical evaluation of the artwork will concern whether the problem was solved or, if not solved, whether some advance was made toward a solution.

The contexts of which the critic can avail himself are various. Some are art historical, and some of the art historical ones blend into the kind of categorization explored above. Specifically, the critic may situate the artwork in terms of a tradition with an animating problematic in order to draw a bead on the work's aspiration.

For example, the critic Clement Greenberg proposed the category—in this case, a tradition—of Modernist painting.

He identified the problematic of this category as the self-definition or the reflexive definition of art. The definition was reflexive in the sense that the artwork itself was purportedly advancing it. The artist pursued the quest for self-definition by assertively forcing the viewer's attention toward whatever the artist had in mind as the essence of painting. Greenberg believed that the essential or defining feature of painting was flatness or two-dimensionality.

Greenberg identified a candidate as Modernist where he saw in evidence an attempt in the painting to acknowledge the essential flatness of painting as such, as in the case of the contraction of the picture plane by the Cubists. Moreover, the Modernist problematic also afforded Greenberg a way in which to appraise a painting. A Modernist painting that affirmed its nature as paint, like Jackson Pollock's drip paintings, was good insofar as it advanced the problematic of self-definition to a new stage. Morris Louis's *Veil* paintings did very, very well on this account, too, since by soaking his canvases in paint the paint and the canvas were fused into one indissoluble surface.

Greenberg assists the viewer by placing certain works in an art historical context, in this case, a historical category, viz., Modernism. He tells the audience what this sort of painting is attempting to achieve. This helps the viewer to grasp the point of the painting. Greenberg then describes the aspects of the painting that answer to the problematic of the art historical context, thereby supporting his own appraisal of the painting. In this way, he invites the audience to share his evaluation of the painting by giving them what they need—the category, the problematic, and the description—in order to replicate Greenberg's own assessment of the painting, while also, perhaps, providing them with the means to expand upon it.

Of course, the art historical contextualization is not the only form of categorization. The critic might point out that the artist was working under a specific institutional charge and then go on to explain how the work the artist produced carried off the charge. For example, Raphael was explicitly commissioned to adorn the library of Pope Julius II. His fresco called The School of Athens presided over the portion of Julius's library reserved for ancient, pagan philosophy. Raphael's charge was to exalt ancient philosophy. The critic, alerting the viewer to this ambition, then goes on to explain how the scale, line, symmetry, color, proportion, and the dignified yet lively disposition of the figures all contribute to engendering a feeling of excitement about philosophy, displayed as an animated conversation, a veritable marketplace of ideas.

Or, the critic might describe an art historical situation as an impasse that needed to be overcome. For example, critics typically explain the appearance of Happenings—and the wing of art performance associated with them—as a reaction by young artists against the limitations that they believed the program of abstract expressionism imposed upon them. They wanted to explore a range of interests foreclosed to them by the discipline of abstract expressionism, so they quite literally released their energies upon a broader field of operations.

Often critics describe the situation in which the artist or artists find themselves in terms of a sense of what needs to be done, given the prevailing state of affairs. For example, the critic of Constructivist-motion-picture-making is likely to begin by pointing out that Soviet filmmakers of the early 1920s, charged with the responsibility of inventing a mass artform capable of politically enlisting the eyes, if not the minds, of the people, experimented with the editing style

they called montage as an extremely effective lever for eliciting and holding onto the attention of viewers by means of rapidly alternating shots that kept viewers irresistibly glued to the screen. Thus, critical discourse about a specific film, like Sergei Eisenstein's *Potemkin*, is likely to place it in the context of this ambition to mobilize the audience by means of a style that keeps us riveted to the action—a context, by the way, in which *Potemkin* scores remarkably well.

That is, the critic will describe *Potemkin* by noting the ways in which its various strategies, particularly its rapid editing, grip the audience and move them to cheer on the Russian Revolution of 1905, thereby implementing the brief with which Lenin charged the aborning Soviet film industry. What the critic is doing here is tracing out the logic of the situation and showing how the artist's choices in context are intended to realize the exigencies that the artist is convinced are called for by the circumstances.

As Hans-Georg Gadamer, adapting the claims of R.G. Collingwood, suggests, the artwork is an answer to a question—a question that arises in the artist's conception of his or her situation.[4] The critic, then, assists the audience in understanding that question both by articulating the question and then describing and explaining how the choices the artist makes contribute to answering it.

As the preceding example indicates, the context in which the critic situates the artist's endeavor need not be narrowly artistic. The critic of *Potemkin* cites broader social concerns as key to understanding the context in which the film was made and, thereby, as key to grasping the ambition of the film. Nevertheless, some readers may fear that there is still something too constrained about the way in which I have suggested that contextualization figures in evaluating the

artwork. For, although I allow that the broader socio-historical context of the work may provide the artist with his brief or charge, it seems that I only consider the artistic execution of the brief for purposes of evaluation and not, for instance, the worthiness of the content of the brief. And that sounds like a kind of formalism.

This is an aspect of a very complex issue that will be taken up primarily in the next and last chapter of this book. However, for the time being, let several comments suffice. First, it need not be the case, on my view, that the execution of the work is the only focus of critical evaluation. For, given certain kinds of ambitions, the value of the artwork, qua the kind of artwork it is, is not simply a matter of the way in which its purpose or purposes have been embodied in the form of the work; the purpose of the work—for instance, what it is meant to say—may also be a target of evaluation.

For example, a dramatic character study is expected to yield psychological insight. If a play serves up humanly implausible beings, while intending to reveal genuine human possibilities, then even if it portrays those characters vividly, it fails on its own terms, because of its lack of psychological verisimilitude, no matter how crackling the lines or vivacious the delivery.

That is, if the work is psychologically false—something which is surely not merely a formal consideration—and it emerges from a context requiring psychological accuracy, then the critic has grounds for declaring that the work has fallen short of its own aspirations.

Similarly, realist novels are not only committed to embodying their observations in serviceable plot structures. The context of realist novel writing also demands that its social observations coincide with reality. The realist novelist not

only has to write well; the realist novelist also has to observe accurately. And a critic may justifiably upbraid a realist novelist for distorting reality where, again, the distortion of reality is scarcely just a formal property of the artwork.

Consequently, nothing said thus far indicates that the only legitimate focus of critical scrutiny is formal—that is, the way in which the artist has embodied the content of the work in a form appropriate to it. The contents of a work—for example, its theme and its psychological and/or social observations—are also, in certain cases, suitable objects of critical comment.

On the other hand, it may be that in different cases it primarily makes sense to look at the artwork from the formal perspective. Nevertheless, this is a question we will return to in the last chapter, in which the discussion of the worthiness of the purposes of artworks—independently of the implementation of said purposes—will be re-opened.

But, in any event, let me briefly recapitulate the theme of this section: contextualizing the artwork is a recurring feature of criticism just because it provides a way for the critic to clarify the purpose or intention of the work by situating it in contexts—art historical, institutional, and more broadly social*—in which the logic of the choices that confront the

* Sometimes when outlining the social context of the work, the critic may find the work to be in the service of an oppressive social project, such as the domination of women. In such cases, the critic may certainly remark upon the injustice of the purpose, even as he distills the strategies that advance it. In fact, refraining from observing the injustice of the point or purpose of the artwork may leave the critic open to the charge of complicity, especially where phenomena like sexism are still abroad. See Susan Feagin, "Feminist Art History and De Facto Significance," in *Feminism and Tradition in Aesthetics*, ed. Peggy Zeglin Brand and Carolyn Korsmeyer (University Park, PA: Pennsylvania State University Press, 1995).

artist is illuminated, thereby guiding the description of the work in terms of the manner in which the work has been articulated in order to answer the perceived demands of the presiding circumstances. Knowledge of these purposes accompanied by the descriptions of the features of the work that implement these purposes, along with an analysis that shows how the features singled out for attention connect up with the artist's purposes, then, serve as grounds for the critic's evaluation.

V. ENTR'ACTE: A TERMINOLOGICAL INTERLUDE

The next two sections concern elucidation, interpretation, and analysis. Because these terms may be employed differently by different writers, it will be prudent for me to preface my discussions with a brief account of the way in which I will be using them. Some commentators might consider all three of these parts of criticism to be one—possibly calling it interpretation or, less likely, analysis.* But I not only now think that it is more exact to separate out three distinct, though related, operations in this neighborhood. I think it might also help to loosen certain loggerheads in the debates about interpretation.

By elucidation I have in mind the critical operation of identifying the literal meaning, narrowly construed, of the symbols in the artwork. These may be conventional or

* I plead guilty here myself. I did not draw these distinctions in the Introduction to my book *Interpreting the Moving Image* (Cambridge: Cambridge University Press, 1998) or my "Interpretation of Art," in *The Encyclopedia of Philosophy*, ed. Donald M. Borchert (Framingham Hills, MI: Thomson Gale Publishers, 2006).

arbitrary symbols, such as words and sentences in linguistic artworks, or graphic associations in visual artworks, as when a wreath of oak leaves stands as an emblem of Pope Julius II or when a death's head in a *vanitas* painting heralds mortality. Elucidating these sorts of established associations is sometimes called iconography in the study of the fine arts.[5]

Iconic symbols, notably pictorial representations, also fall into the domain of elucidation. An example of critical elucidation occurred when Giovanni Pietro Bellori corrected Vasari's misidentification of a figure as the evangelist St. Matthew in Raphael's *The School of Athens*, whereas Bellori established that it was actually Pythagoras.[6]

Elucidation, in my sense, is concerned with determining the correlation between fixed conventional and iconic symbols and what they symbolize—whether by association or natural generativity (i.e., pictorial recognition).[7] Determining the meaning of a word or a sentence also falls into the domain of elucidation. For instance, recovering a forgotten meaning of a phrase can be an important element of a critic's elucidation of a poem for the lay readership.

Of course, I am not claiming that the literal meaning of a word or sentence is independent of any context whatsoever. Literal meaning is relative to background assumptions and contexts.[8] Rather, the literal meaning of a linguistic unit is relative to the pertinent *conventional* background assumptions and context of the kind of discourse in question.

Elucidation transpires not only with respect to linguistic entities. Pointing out which of the actors in René Clair's *Entr'acte* is Satie, which Man Ray, and which Duchamp is also an example of elucidation. In a manner of speaking,

elucidation is a matter of establishing what has been given directly to us by the artist.*

Interpretation, on the other hand, goes beyond the given in order to establish the significance of what has been given. Interpretation is concerned with significance—for instance, the thematic significance or the narrative significance of an artwork or the significance of the behavior of a character in a fiction or the interrogation of the import of a metaphor, whether local or global.

Typically interpretation involves the process of abduction—hypothesizing from the various parts of an artwork to the theme or message or idea or concept that best explains why the assemblage of parts before us coheres together as a whole, i.e., what theme, or message, unifies them. Interpretation also strives to discern the underlying unity of the artwork by attempting to discover what motivates and potentially resolves the apparent anomalies or contradictions in the work of art.

Interpretation aims at excavating the sense of the work, especially in terms of the way in which the sense of the artwork holds it, or salient parts of it, together communicatively. That is, where the artist is committed to communicating a theme or an idea or a concept to an audience, she does so by initiating a series of choices that will reinforce the relevant theme. The critic's interpretation then assists audiences in

* I maintain that elucidation, like interpretation, should be treated intentionalistically. The correct elucidation should track the author's intended meaning where that intention is supported by and/or is consistent with the artwork. Thus, we should accept the author Buck Henry's identification of Dr Strangelove as an allusion to Werner von Braun rather than to Henry Kissinger.

clarifying what the artist is "telling" them, by grounding her interpretation in an account of the ways in which the pertinent artistic choices abet the interpretation—which interpretation simultaneously discloses why the elected features of the work belong together.

Interpretation is an instance of the broader class of critical operations that I call analysis. A critical analysis of an artwork is an account of how the work works—of how the parts of the work function together to realize the point or purposes of the work. Conveying a theme or idea or message or concept or some other article of sense, broadly construed, might be, needless to say, the point or the purpose of the artwork. That is why interpretation is an example of analysis: interpretation is an endeavor predicated upon showing how parts of the artwork operate in concert to communicate or advance a theme or an idea.

Yet at the same time, the organizing point or purposes of an artwork need not be involved with the communication of sense or the telegraphing of a theme. The presiding objective of a work might be to arouse an affective state, like anger, or to project an expressive property, such as sadness, or perhaps merely to please the senses, to thrill the eyes or the ear with delight. Beauty alone might be what the artist is after. In these cases, explaining how the work achieves its ends—perhaps by drawing attention to its specific way of manipulating arresting colors—is an analysis of the way in which the artist achieves his agenda, but since the agenda is not concerned with communicating sense, this is a species of analysis which is not interpretation.

Consequently, on my stipulation, although all interpretation is analysis, not all analysis is interpretation. Analyses that are not interpretations are those accounts of how a piece

of art hangs together and works where the labor under our critical microscope is divorced from the enterprise of making sense in the form of articulating underlying themes, ideas, messages, etc. Analysis shows that the work contains features that are relevant to the realization of the work; that nothing of marked salience that is irrelevant to or in conflict with the point or purpose is present in the work; and that the features of the work work together to secure the purpose of the piece—that the parts of the work are advantageously arranged to support the artist's aims.

Interpretation, on the other hand, bears an undeniable relation to elucidation, since elucidation is concerned with meaning in the narrow sense, while interpretation is concerned with meaning in a somewhat broader sense. An interpretation will tell you what the work is about by showing you how, via some dimension of meaning, it manages to embody whatever it is about. And elucidation is also focused on content—viz., usually upon what the constituent conventional symbols in the artwork symbolize.

With these admittedly rough and ready distinctions before us, let us look more closely at each of these three operations and some of the issues they raise.

VI. ELUCIDATION AND INTERPRETATION

Elucidation and interpretation are both concerned with meaning, though typically meanings, in a manner of speaking, of different orders or gauges. Elucidation, in my sense, for the most part, focuses narrowly on the denotation of the semantic, iconographic, and/or iconic symbols in the work. Elucidation attempts to determine that which constituent symbols in the work denote literally or by fixed associations. For example, it is a matter of elucidation to point out that the

candle in Antonio de Pereda's *Man Dreaming*, in the context of the artistic practice from which it emerged, is code for the warning that life is inexorably wasting away. Similarly, a critic is elucidating the poem when she reminds readers that the phrase "plastic arm" in Mark Akenside's poem *The Pleasures of the Imagination*, which was written long before the twentieth century, refers to a "flexible arm" and not one that is a petroleum by-product.

As these examples indicate, elucidation must go beyond what might be thought of as the intrinsic meaning of a symbol and/or the internal meaning-relations amongst a concatenation of symbols. Elucidation must also attend to pragmatic meaning-making factors that have to do with the background assumptions that are in play in the context of the original presentation of the symbol or symbols. That is, the elucidation of a sentence in a piece of literature is not merely a matter of offering some a-historical or a-contextual account of what the words mean—both individually and in syntactical combination—but rather of illuminating the range of meaning those symbols could have in the context that the critic earmarks or establishes as the one pertinent to the work at hand.

In the main, then, elucidation is dedicated to delivering something like the literal meaning of the work and its parts in context—that is, where the work or its parts have symbolic (that is to say, denotative) content.* This, of course, should

* The qualification "in the main" is intended to allow that some elucidations may involve the elucidation of characters in terms of the beliefs they might have and the significance of their actions in a certain historical context. The case of Hamlet's suspicion that the Ghost might be a demon is an example discussed toward the end of this section.

not be taken to suggest that a proposed elucidation of a work or a part thereof cannot be controversial. To return to Raphael's *School of Athens*, some commentators have identified the figure with the protractor as Archimedes while others say it is Euclid. At the same time, such controversies need not be irresolvable. The most comprehensive elucidation of the data available from Raphael's painting makes the hypothesis that the figure is Euclid far more attractive.

Interpretation, in rough contrast with elucidation, tracks meanings construed more widely than meaning conceived as merely linguistic, semiotic, pictorial, or associative. In the normal course of events, for example, we say that actions have meaning. Your lover gets up abruptly and walks out the door, slamming it with a loud report behind him/her. The next day, quite naturally, you ask "What did you mean by that?" (although the odds are that you probably already know).

Thus, one dimension of interpretation, especially with respect to narrative artworks, involves discovering the meaning, in the preceding sense, of the actions (or inactions) of characters, notably where those actions appear incoherent, enigmatic, or opaque—such as Hamlet's prevarication or Citizen Kane's obsession with Rosebud.* In these cases, the critic as interpreter seeks to unravel the significance of the character's behavior—to disclose what a certain pattern of action reveals about what makes that character tick.

* In terms of the crude distinction between elucidation and interpretation, by the end of the film *Citizen Kane*, identifying the referent of "rosebud" and locating where that referent appeared earlier in the film would be an instance of elucidation, while saying that the thematic meaning of the sled is that it summarizes for Kane his lost childhood is an exercise in interpretation.

Yet with regard to the interpretation of actions, interpretation scrutinizes not only the meaning (or significance) of the character's modes of behaving, but also the meaning of the action or actions that the artist undertook in the creation of the work. That is, interpretation pursues the question of what the creator intended or meant by the work or a part thereof—for example, what is its theme or thesis?

In his *Republic*, Plato opens the dialogue with Socrates going down to the Piraeus. Later, in the parable of the Myth of the Cave, the prisoner who has grasped the nature of reality goes back down into the cave to tell his brothers-in-chains what he has seen. He believes that it is his duty to enlighten them and to dispel their ignorance. And like the historical Socrates, he dies for his troubles. Saying what Plato intends or means to communicate by this subtle parallelism is one of the burdens of interpretation.

As the preceding example perhaps suggests, interpretation may not only pursue the action-meaning of characters, but also the meaning, in the extended sense, of their actions and dispositions as figures in a parable or a story with more general or anagogical implications than their straightforward description might portend. For example, in Mann's *The Magic Mountain*, characters like Septembrini and Naphta are emblems of possible courses of life for young Hans Castorp to contemplate emulating, or, again, in Musil's *The Man without Qualities* Ulrich and Arnheim, among others, represent contrasting ways of being in the world.

This type of allegorical figuration, moreover, requires interpretation rather than elucidation because the connections between the characters and what they represent, in these cases, are not fixed in the way of typical iconographic correlations. Rather, this sort of figuration requires a certain

amount of hypothesis and conjecture in order to propose, for instance, that a Septembrini illustrates the mode of life of an enlightenment rationalist committed to a progressive view of history.*

Of course, not only characters but whole works can have the sort of anagogical meaning that is ripe for interpretation. The prepared, literate reader may grasp—in virtue of the sub-personal, processing routines of reading—the linguistic meaning of every word and sentence in Kafka's *The Castle* as well as comprehending, from the point of view of narrative comprehension, what is happening to Joseph K. from moment to moment and from episode to episode in the story. Nevertheless, there is still the remaining question of what it all *means* thematically—what does it add up to?—or what, in other words, is this story supposed to exemplify anagogically about the human condition? This is a task that the critic undertakes, in part, in order to ground a positive evaluation of *The Castle* in terms of the way in which the incidents are so well chosen, articulated, and integrated for the purpose of expressing Kafka's insights.

Just as there are no fixed correlations between Joseph K.'s misadventures and what they might portend about human

* In Raphael's *School of Athens*, the identification of Plato as the figure holding the *Timaeus* and Aristotle as the figure holding the *Nicomachean Ethics* is a matter of elucidation. Claiming that Plato's raised arm signals his primary commitment to the world of Forms "above," while Aristotle's outstretched arm shows his allegiance to this world, is a matter of interpretation. The former is a matter of routine, albeit informed, association; the latter requires an imaginative leap or abductive inference. There is no dictionary or algorithm that correlates the position of a philosopher's arm to his metaphysical inclinations.

existence, so when it comes to genuine metaphors, whether verbal or pictorial, interpretation swings into action inasmuch as there are no mechanical rules for applying the source domain of the metaphor to its target domain—no way of algorithmically knowing which attributes of "the sun" should be imaginatively extrapolated to "Juliet" in the case of Romeo's expostulation that "Juliet is the sun." Instead, one must proceed in an attempt to finesse the best fit between the two domains in the context of the play, rather than trying to decode the metaphor according to some established protocol or metaphor-dictionary (which, in any case, does not and could not exist). Where the metaphors are dead ones, elucidation is appropriate; but where the metaphor is an authentic living one, it belongs to interpretation.

The compass of things suitable for interpretation is diverse. It includes not only metaphors, but also the actions of characters, narrative structures, such as recurring and parallel motifs, pictorial arrangements, musical elements including leitmotifs, certain forms of allegory, the artwork as exemplum, and so forth. The feature that artworks and parts thereof possess which makes them suitable targets of critical interpretation is the fact that the significance of the elements in question or their combination is mystifying, perplexing, elusive, or, at least, not obvious.[9] The appropriate object of interpretation is that which goes beyond what is directly given or foregrounded.

An interpretation is a hypothesis that accounts, in terms of some notion of meaning or significance, for the presence of the element or combinations of elements in an artwork where the presence of the pertinent elements is not immediately evident to the interpreter and/or to some presumed audience. The item may not be obvious in the sense of being

unintelligible, apparently contradictory, deviant, or simply mysterious, or because it is an open textured symbol, parable, or allegory, or because it is understated, barely hinted at, only suggested, or it is in some other way recessive.

For example, in Manet's *Le Déjeuner sur l'herbe*, the nude figure of Victorine Meurend, whose body is not idealized, stares out shamelessly toward the viewer. She is no demure beauty with academically endowed, perfect proportions. What is Manet "saying" by means of such an anomalous, genre-deviant image?

Alexander Nehamas offers an answer to this question in the form of an interpretation that glosses the figure of Victorine as tantamount to an insult to the tradition of academic painting and its audience. He says: "Victorine's imperfections (imperfections, that is, relative only to the academy's archetypes) were to jolt the audience, especially the men among them, into acknowledging that what they were enjoying was not a painted canvas or an idealized figure with an edifying message, but a naked woman of their own place and time; their pleasure was nowhere near as innocent as they would have liked to think."[10]

The purpose of a critical interpretation is to assist an audience's understanding of a work and to enhance their ability to appreciate it. A critical interpretation explains the presence of elements in an artwork by explicating how they contribute to the significance or meaning of the work. Typically, there are elements in the work whose reason for being there is unclear. In other words, there is something—relative to a target audience—about the work that is obscure, ambiguous, ostensibly inconsistent, anomalous, unexpected, inaccessible, latent, etc. which invites illumination. That is, there is an element in the work that prompts the nagging

question: "Why is it there?" The goal of an interpretation is to relieve that perplexity—to explain the significance of the presence of the disturbing or troubling elements by demonstrating the contribution they make to the meaning of the work, broadly construed.

Of course, whether the meaning of an artwork or some parts thereof is obvious raises the question of "Obvious to whom?" In this respect, a critical interpretation is undertaken with a certain audience presupposed—one to which the interpreter may or may not belong, but one for whom the significance of the work or of some part of it is elusive, puzzling, abstruse, non-manifest, unfocused, or otherwise not immediately apprehensible. The interpretation then, ideally, alleviates the perplexity or gap in the target audience's understanding of the work.

Not every element in an artwork calls for interpretation. Where, with respect to a painting such as El Greco's *The Adoration of the Shepherds*, everyone, by dint of their natural powers of object recognition, sees the subject to be a woman, a child, and two men, then the observation "this painting represents a woman, a child, and two men" is not an interpretation, but a description. Supplying the biblical identity of this cast of characters, on the other hand, would be an elucidation, not an interpretation. Nevertheless, and perhaps needless to say, descriptions and elucidations are relevant to interpretations, since sound interpretations must rest upon accurate descriptions and elucidations.

As previously noted, the literal meaning of many of the words and sentences in literary works is grasped by means of subpersonal routines of processing by literate readers in the language in which the work is being presented. Thus, the literal meaning of the opening line of Kafka's *The Castle*—

"It was late in the evening when Joseph K. arrived"—does not require an interpretation, inasmuch as its meaning is obvious to the prepared reader. But what might call for an interpretation is its significance in the broader design of the novel. What does it "mean" or "signify" figuratively, for example, for Kafka to begin this particular saga at night? What is being suggested?

Interpretation often serves evaluation by unfolding the unity of an artwork through the discovery of the overarching meaning or significance of its narrative, dramatic, and symbolic components. For meaning—in the sense of an overriding theme, or thesis, or concept—is one of the most frequent ways in which an artwork can be unified. The theme of the inhumanity of war, for instance, governs *All Quiet on the Western Front*. The critical interpreter, examining the parts of the novel (e.g., its various episodes), hypothesizes this theme and then goes on to show how this concept colligates or assimilates Remarque's choice of the incidents he recounts to the reader. That is, an interpretation, like this, isolates the principle of selection—in this case, a concept—that makes a coherent package of the amalgam of details assembled in the novel.

Although I have tried to advance an admittedly rough distinction between interpretation and elucidation, I must also acknowledge that sometimes the line between them gets very thin, and perhaps even diaphanous. This can occur, for instance, where one is offering a contextually informed account of the "meaning" of a character's action.

For example, it seems to be a matter of elucidation when a critic deems as creditably motivated Hamlet's worries about whether the Ghost is a demon by showing that that was indeed a belief that Shakespeare's contemporaries took

seriously. But surely this comes very close to judging whether or not certain of Hamlet's reasons for hesitating to avenge his father's death are plausible—a decision which, instead, seems to fall into the category of interpretation. Thus, it must be allowed that, on occasion, elucidation and interpretation converge, while, at the same time, it is still true that there is usually a discernible difference between them.*

One objection to segregating out interpretation as a discrete critical operation revolves around the issue of the hermeneutic circle, discussed earlier. You will recall: the critical description of the parts of the artwork must be selective; after all, we do not have world enough and time. Yet how shall we select the parts of the work that we consider worthwhile to describe? Probably in terms of their contribution to making the work work. But if the work of the artwork is the communication of some theme or thesis, then the interpretation of the artwork will determine what must be described, viz., that which advances the message or idea of the artwork. However, since that which grounds our interpretation is our description of the artwork, we are trapped in a circle insofar as our selection of what to describe

* Another reason that elucidation and interpretation will sometimes appear to merge is due to the fact that interpretation is relative to an audience that does not find the motivation for the presence of the pertinent elements in the artwork to be obvious. But target audiences may differ in what they find obvious. For an audience of film scholars, a shot of waves pounding against some cliffs after a shot of lovers embracing is unmistakably a symbol that the couple has made love. Were a film scholar to note this in a lecture to his colleagues, it would be at best an elucidation. But were he to explain this trope to an audience of utterly naïve movie-goers, depending upon how he did it, it might qualify as an interpretation.

has been effectively preordained by our interpretation of the whole.

That is, before we begin to describe the parts of the work, in the relevant cases, we need some conception of the meaning or significance of the whole—a.k.a. an interpretation. But then our interpretation cannot be genuinely supported by our descriptions, since they are always already biased in its favor. Worse than that, if we start out with a misguided interpretation, we will never be able to extract ourselves, since we have insulated ourselves epistemically from any countervailing descriptions.

Therefore, interpretation and description are of such an indissoluble piece that the suggestion that they are two rather than one is feckless.

Although the hermeneutic cyclist has justly described the phenomenology of the way in which we typically go about describing artworks, it is far from persuasive to imagine that we then go on to test our interpretations in the same way. Our interpretations and our descriptions of works may evolve in tandem as we assemble our account of the work. But when it comes to confirming (or disconfirming) that account, the two processes can be pried apart.

The interpretation can be held constant while we look for details in the work that we have not described, especially in terms of parts of the work that have been described by most other interpretations, including rival ones, but which we have putatively left out due to the slant of our interpretation. That is, we do have access to descriptions of the work that are not contaminated by our interpretation, and we can weigh the omission of those descriptive details against the adequacy of our interpretation and, in doing so, can even find our interpretation insufficiently grounded. We should not mistake

our ordinary, psychological inclinations for making sense of artworks for our epistemological scruples. Of course, some critics may stubbornly cling to their own interpretations, come what may. But we should not misconstrue the pig-headedness of some for the epistemic fallen-ness of all.

Moreover, although our interpretation of the whole does predispose us in our decisions about what needs to be described, it is not the case that it is only our own interpretation of the whole that beats the drum in this matter. Parts of an artwork can have an arresting degree of salience that no attempted interpretation can evaporate. An interpretation of the sitcom *Frasier* that failed to notice the recurring and pronounced sexual tension between Daphne and Niles would be inadequate because it fails to square with facts in the fiction that are up front and in our face.

Although interpretations dispose us to look here rather than there, they are not doxastic cocoons so enveloping and so darkening that they blind us to everything they have not cast in the spotlight. Doubtlessly description and interpretation are intimately related; but nevertheless they are twain.

One fashionable way of cleaving description and interpretation that I have not attempted to exploit is the idea that while descriptions (and even elucidations) can be true, interpretations, it is alleged, can never be anything more than plausible. That is, they may be false, but they can never be true.

At best, interpretations are constitutionally weak, epistemically speaking. They are only ever plausible or probable, but never true, whereas a description of Matisse's *Blue Nude* claiming it contains the image of just one woman or a description of Manet's *Olympia* saying that it pictures, among other things,

a black cat would both be flat-out and with no frills true. Indeed, if a critic elucidating a poem maintained that mentions of the "whore of Babylon," "the Beast," and the number 666 were references to the Antichrist, his statement would also be true, full-stop and cross the t.

In contrast, there is the suspicion that interpretations can never be true and that this is what distinguishes interpretation from description (and elucidation).[11] But does this hypothesis really demarcate the distinction?

I resist this suggestion because I distrust the allegation that interpretations are never true. Isn't the interpretation that *Animal Farm* is *about* totalitarianism just true?[12] That is, a theme or organizing idea of *Animal Farm* is the topic of totalitarianism. This certainly isn't false. And, in any event, it strikes me as being true in precisely the same sense as is the descriptive statement that the novel includes a character named Napoleon who is a pig. Why suppose that there is a difference here?*

One quite common suggestion is that the interpretation of *Animal Farm* as a fable about totalitarianism does not tell us everything there is worth saying about *Animal Farm*. It does

* Perhaps it will be said that the theme of totalitarianism in *Animal Farm* is so blatant that articulating it hardly counts as an interpretation. However, when I first encountered the book in high school, this was news to me. It lit up the work like a search light and helped start me on my career as an interpreter. I suspect that the interpretation that the *Harry Potter* series is organized around Harry's search for a family will perform a similar service for many of the children who have grown up under the shadow of Harry's adolescence. And, in any event, it strains the notion of elucidation to claim that that is what the critic is doing when pointing out that *a* theme of *Animal Farm* is totalitarianism. For, there are no fixed associations between farmyards and the political arrangements of nation states.

not, for example, tell us that *Animal Farm* is specifically anti-Stalinist, and not just vaguely anti-totalitarian. Fair enough. But now we are playing with a very special and, I suspect, extravagant and ultimately untrustworthy notion of truth. Call it "the final word conception of truth"—whereby a proposition about some state of affairs x is true if and only if that proposition exhausts x to such an extent that there is nothing left to be said about x, once we have delivered the "final word."

But the "final word conception of truth" is simply a non-starter. At the very least, it is utopian. For, there is no inquiry in which some observation necessarily counts as the last word, precluding any further comment. This is indubitably true of description. There is no landscape that can be exhaustively described. There is always the view from Alpha Centauri or from an indefinitely large number of elsewheres that are ever game. The only reason that the proposal that interpretations are never true gains any credibility is probably on the basis of a phony conception of truth.

Perhaps the proponent of the "final word conception of truth" is misled by the fact that we sometimes speak of the interpretation of an artwork. The definite article here might suggest "the one and only" interpretation of the work. However, once we realize that generally we are speaking of *an* interpretation of a work—which may be complemented or supplemented or otherwise enlarged by others—then the temptation to dragoon "the final word" argument, I wager, becomes less pressing.

Another motivation for proposing that interpretations are only plausible, but never true, is that we may confront cases where we cannot decide which of two conflicting interpretations is true. So, we say instead that both are

plausible. I do not dispute that there may be situations like this. But here we are talking only about what we know in these instances, not what is the case. For, one of the interpretations can be true, even if we do not know it. That is, the concept of plausibility is epistemic; truth, a matter of what is the case whether we know it or not, is of a different order of evaluation, one upon which the notion of *plausible* itself is parasitic (since *plausible* means "probably true"). And for this reason, it is not clear that the assertion that all interpretations are merely plausible is even a direct challenger to the thesis that some interpretations are true.

Admittedly, there may be examples of interpretative conflicts that cannot be resolved where we agree to call each of the contenders plausible. But there is no reason to generalize from such instances. For, there may be other cases where one interpretation has no competing interpretations, but only complementary ones. In fact, I contend that the aforesaid interpretation of *Animal Farm* is such a case.

In response, it might be said that the proposition "*Animal Farm* is about totalitarianism" is not an interpretation but a description, and, as such, it is not surprising that it sounds right to say that it is true. But this is a stretch. For example, the reviewers at the distinguished American publisher Knopf rejected *Animal Farm* on the grounds that animal stories would not sell to their readership—a pronouncement, at the very least, that indicates that the actual subject of the book was not obvious to them.*

* The defender of the view that interpretations are never true, but only, at best, plausible, may say that if a putative interpretation, like that of *Animal Farm* above, is true, then it is really a description, and not an interpretation, which, of course, merely begs the question.

In sum, then: *Animal Farm* is about totalitarianism—that is, totalitarianism is one of its themes. This is unquestionably *an* interpretation of *Animal Farm* and, furthermore, it is *true*.

VI. ANALYSIS

Analysis is the label that I reserve for the broad class of critical operations—of which interpretation is a leading, but not the only, example—devoted to explaining the ways in which artworks work. Indeed, it may be that, at present, interpretation—with its resort to significance or meanings—is the most frequent mode of explaining artworks. For we live in garrulous times. However, since artworks are susceptible to explanations that do not rely upon the attribution of meaning to the work in question, interpretation is not the entirety of analysis, but only one of its more eminent instances.

A way to see that interpretation is not the whole story when it comes to the analysis of artworks is to recall that there are some artworks that are arguably "beneath interpretation." Some art, for example, is purely decorative. An Amish, checkerboard quilt, for example, may have nothing to say. It may simply be an object of beauty, intended to brighten the bedroom and make it more habitable. But since the work is not in the business of communicating anything, it leaves nothing over for interpretation.

Nevertheless, although it does not make sense to interpret such a work, the critic may still analyze it—explaining how the color, texture, and pattern of the work invite, engage, and delight the eye, promoting perhaps a soothing and restful atmosphere. Even if the work does not have significance and means nothing, even in the extended construal of meaning that is relevant to interpretation, the work still has a point or

purpose. And explaining the way or ways in which that point or purpose is realized by its component parts is the mission of analysis.

Interpretation, of course, is a sub-species of analysis, since the point or purpose of a great many artworks involves conveying a theme or a thesis to an audience. The analysis of such works calls for an interpretation that articulates what the artist intends to communicate by the work and explains how the artist went about transmitting it. For example, part of what the movie *Sunset Boulevard* wants to impart is the idea that Hollywood transforms people—stars—into monsters. The critic gets at this theme—the meaning of *Sunset Boulevard*—by drawing our attention to all sorts of details in the film that allude to or employ the techniques of horror films.

There is the way Norma Desmond makes her initial appearance in shadows, reminding one of a vampire, as well as the way she holds her hands, always claw-like. There is macabre imagery, such as the dead monkey and its nocturnal last rites. Norma's huge house appears abandoned; the thought that it is haunted is made explicit. And there is that organ, the sort of contraption favored by the Phantom of the Opera. It occasionally wheezes ominously in the background when the butler Max isn't playing it in the style of a mad scientist.

Norma's old time movie friends are called "Waxworks," the title of a famous silent horror film. And when Norma, in preparation for her comeback as Salomé, undergoes her strenuous physical regime, the montage reminds one of those experiment-scenes in monster films in which some unholy creature is about to be brought to life or re-animated. Through the citation of these allusions and more, the critic is able to articulate the theme of *Sunset Boulevard* with precision,

while, at the same time, showing us how the movie is able to get its idea across.

But not all critical analyses take the form of interpretation, for the simple reason that the communication of a theme or a thesis is not always the point or purpose of an artwork. The point or purpose of an artwork might be to arouse an emotional state, like sorrow. In that case, the critic's assignment is to identify the state the work aims to engender and to explain how the artist has engineered the effect at which he has aimed.

For instance, contemplating a painting of Christ's crucifixion, the critic, on the basis of her own experience, may classify the emotion it provokes as a deep sadness and then explain that a major factor in promoting this reaction is that the artist has surrounded the dying Christ with wailing disciples, including his doleful mother, Mary, who is prominently and affectingly displayed weeping in a way that helps shape the normal spectator's response to the array.

Similarly, sometimes an artwork may be invested in the projection of certain expressive properties, rather than in sending us a message. The Four Temperaments, a ballet choreographed by George Balanchine, contrives a series of dances designed to capture the qualities of the four traditional mental attitudes: the melancholic, the sanguinic, the phlegmatic, and the choleric states of mind. The critic's job, in terms of analysis, is to draw our attention to the shrewd, contrasting movement constructions that Balanchine creates in order to elicit our apprehension of those four different, anthropomorphically charged or expressive atmospheres.

For instance, the observant critic will point out that the choreography marks the qualitative disparity between the sanguinic and the phlegmatic modes by changing the way in

which space is engaged in the different segments of the dance in the transition from one mood to the next. During the Sanguine interlude, for example, the vista, given the way the dancers attack the stage space, is wide open; in the Phlegmatic section, it becomes more confined and claustrophobic; the ambit of movement is more constrained.

There is a circuit of lively lifts at half-height that dominates the Sanguinic variation; the Phlegmatic variation is earth-bound, hovering close to the floor. The Sanguinic ballerina is an allegro technician; the Phlegmatic male soloist appears indolent and detached, leaving the impression that he is slowly lifting bundles of invisible burdens.[13] These movement choices, particularly due to the way in which they sharply oppose each other, give each of the segments of the dance a distinctive expressive profile—one sanguine, the other phlegmatic—which the critic enables the audience to detect as well as to reflect upon in virtue of the ways in which these profiles have been achieved.

The pervasive expressive quality of Jim Jarmusch's film *Broken Flowers* is existential paralysis. It is not that Jarmusch appears to have anything to say about this mood—no thesis about how it comes about, for instance. Rather, it seems as though he will be satisfied if he can pith this mood qualita-tively. He employs a number of cinematic strategies to this end, and it is the responsibility of the critic to pick them out and analyze them for the audience.

For example, the astute critic will emphasize the extreme, multi-dimensional stillness of many of the compositions. The camera is often fixed and unmoving with the central character, Don Johnston, planted stolidly, almost frozen, in the center of the screen. The shots are held for an unusually sustained amount of time before anyone else enters Johnston's

domain or before anything happens there, and when people leave or the action subsides, the camera nevertheless holds on the residual stillness. Likewise, when Johnston speaks, he waits a beat before making a typically laconic comment, again accentuating an aura of hesitancy—of a reluctance to start. Throughout, the feeling is glacial, reinforced by the cinematic and dramatic techniques that the critic underlines and explains —which techniques are in fact responsible for translating the theme of existential paralysis into an audio-visually correlative, expressive ensemble.

Likewise, the critic analyzing Alice McDermott's *At Wakes and Weddings* will focus on one of the novel's most arresting expressive effects—its pervasive aura of detachment—in order to discover and analyze the aspects of the book that give rise to it. Here, the critic may point to the unusual narrative point of view through which the past is filtered by McDermott. It is not the point of view of a single character, but rather appears to be that of all the children. And in that way its being decoupled from an individual person gives it a somewhat impersonal accent.

Artworks have points or purposes, like promoting certain expressive qualities, and critical analyses demonstrate the ways in which those points or purposes are attained (or not attained). In this respect, the critics enable audiences to appreciate artworks by assisting them in understanding how the work as a whole and its parts function in concert.

Analysis can focus on parts of a work—like the Sanguinic variation in *The Four Temperaments*—or on the purpose of the work as a whole—such as the purpose of *Broken Flowers* to project systematically an expressive penumbra of existential paralysis. Critical analysis supports an evaluation of an artwork by showing how the artist's choices regarding the

constituents that comprise the work enable the artwork to achieve its goals successfully (or by explaining why these choices have failed to do so).

Whether focused upon a part of the artwork or on the work as a totality, the overall direction of analysis is usually holistic, dedicated to establishing the unity of intent, thought, or design in the artwork in its entirety or in a component thereof. This tendency stems from the two central functions of analysis: to promote the audience's understanding and appreciation of the artwork and to ground an evaluation of the work. For, understanding requires coherence—something the critic helps us find in the work—while unity, a high degree of organization, and repleteness are generally good-making features in artworks, that is, where their lack of variation does not promote monotony.

This last claim may draw the ire of aficionados of avant-garde art. They will find my invocation of unity as nothing more than retrograde sentimentalism. Art, they may proclaim, should affirm disunity and disorganization, irreparable fragmentation, and incoherence in order to acknowledge the absurdity of existence, the fissures in the human mind, the contradictions in society, the incapacity of language, and/or perhaps all of the above. Avant-garde works are often intended to derange sense and coherence and often they appear to succeed in doing so.

In one of the paradigmatic works in this tradition—*Le Chien Andalou*—the filmmakers Luis Buñuel and Salvador Dali were resolutely committed to subverting intelligibility whenever it began to make an appearance. If the connection between one sequence and the next started to look comprehensible, they broke the adhesive splice linking them and attached the scene onto something entirely different. And, in fact, the result

gives every appearance of being a parade of unrelated fragments.

Since the time of Buñuel and Dali—and of Dada and Surrealism in general—artworks that celebrate disunity, dissociation, and fragmentation have been legion. Surely a conception of critical analysis characterized in terms of the holistic search for the unity of intent in artworks is swimming against the tide of modern art. Surely mine is an archaic, if not decrepit, account of critical analysis.

But is it? Even an avant-garde film like *Le Chien Andalou*, which is predicated upon insistently transgressing our expectations by means of a series of what appear to be narrative *non sequiturs*, may be shown by an analysis to exhibit a sort of second-order unity in virtue of its consistent choice, for Surrealist purposes, of incoherent sequences of events. The aspiration to affirm the incoherence of the mind by means of the representation of an incoherent series of events is, oxymoronically enough, a coherent purpose, which can be intelligibly implemented by what appears to be a randomly selected concatenation of happenings. Nevertheless, these disparate doings have a *raison d'être* which a critical analysis can explicate in terms of the unity of the intention on the part of the pertinent artists to foreground disunity.

(Admittedly, I have only discussed one case here. Nevertheless, I think that the notion of second-order unity introduced above can handle virtually every case of avant-garde disjunction that concerns us.)

However, although analysis is holistic, it may also have a role to play in revealing the disunity in a work. For after identifying the intended effect of a novel to be the provocation of a feeling of mystery in the audience, the critical analyst may then go on to point out that that purpose

was badly served by the ineptly transparent way in which the murderer (once again the butler) was crudely marked as guilty from his first appearance onwards.

VII. A VERY SHORT SUMMARY OF THE CHAPTER SO FAR

In this chapter, we have reviewed the components of criticism (minus evaluation). In particular, I've discussed description, classification, contextualization, elucidation, interpretation, and analysis with an eye to addressing some of the problems that might be thought to arise with respect to each of these operations. The distinctions drawn between these operations have been crude and pragmatic rather than sharp. Classification, for example, may sometimes overlap with art-historical contextualization, while, in some cases, the boundary between elucidation and interpretation is too murky to call. However, I think it is heuristically valuable to go over the operations considered in this chapter, even if we haven't managed to sort them into hermetically sealed categories. For these operations, howsoever we label them, supply the critic with the wherewithal to ground her evaluations in reasons.

VIII. ARTISTIC INTENTIONS AGAIN: ROUND II—INTENTIONS AND INTERPRETATION

There is probably no more disputed issue concerning interpretation than the question of what role, if any, the intention of the artist should play in criticism. It is so important that I have reserved this special, concluding section of this chapter for an examination of the debate surrounding this most vexing and problematic issue regarding interpretation.

Insofar as interpretation is said to be devoted to discovering the meaning of artworks, there is an understandable tendency among many commentators to propose linguistic meaning as

the model for understanding interpretation. Perhaps the major reason for this is that linguistic meaning is better understood than any other sort of putative meaning.

Linguistic meaning, of course, is highly structured in terms of conventions of semantics and syntax. So, there is an initial temptation to conceive of interpretation as a matter of discovering the meaning of an artwork by applying the rules of the pertinent artform. With respect to a poem, for example, it might be said that, in order to determine its meaning, one need only appeal to the public meanings of the words, the rules of grammar, and the rules of tropology. No recourse to authorial intention is necessary. This view is called anti-intentionalism and it has been the most influential stance with regard to this debate in literary theory and the philosophy of literature since the middle of the twentieth century.[14]

To the extent that anti-intentionalism depends upon our understanding of linguistic meaning in terms of conventions as a model for the interpretation of artworks, it cannot be generalized across the arts. For, most of the arts do not possess the highly structured meaning-conventions that language does. The fact that a stage director chooses to incorporate a swimming pool into the set of her theatrical production of *A Midsummer Night's Dream* is certainly a decision worth pondering in an interpretation of the production ("What might the director be suggesting by this?"), but there is no fixed, public meaning attached to the appearance of swimming pools onstage.*

* In terms of the component operations of criticism, itemized earlier in this chapter, many of the anti-intentionalist's best examples fall into the category of elucidation rather than interpretation, since the anti-intentionalist's best

Indeed, even with respect to the literary arts, many of the traditional concerns of interpretation are inhospitable to the linguistic model championed by the anti-intentionalist. For example, interpreters often focus upon the significance of plot ellipses, or they question why a character possesses a certain set of apparently conflicting attributes. But neither of these recurring concerns of interpretation, and myriad others, can be referred for a decision to pre-existing codes or conventions of decipherment.

Furthermore, literary works often mobilize irony and allusion. The conventions of language will be of no avail with radical cases of irony, since in these instances the author means to say exactly the opposite of what the rules of language entail; while there are also no conventions to tell us the difference between allusions, properly so called, and coincidental similarities of phrasing. And, even in the case of metaphor, we have no laws—no rules of tropology—to tell us how to proceed when working through this figure

intuition pumps advert to understanding verbal behavior of authors in terms of the semantics and syntax of a language. However, the more it is granted that these kinds of cases are not the primary loci of interpretation, the less compelling anti-intentionalism will appear to us.

Nevertheless, I would not want to be understood to be saying that I think that the intention of the artist is irrelevant to the operation of elucidation. At the very least, what might be called negative intentionalism must be pertinent to determining the meaning of artistic utterances where by "negative intentionalism" we mean that no elucidation should be proffered that is beyond the repertoire of beliefs and/or desires that the artist could have actually possessed. Elucidation, like interpretation, must be constrained by what is or was possible for the artist to intend.

interpretatively. When it comes to a great many forms of figuration, there is nothing like a metaphor-dictionary to guide our exploration of a trope. Thus it is even controversial whether the anti-intentionalist or conventionalist stance can serve as a comprehensive account of the arts of language which, on the face of it, would appear to be its most welcoming venue of application.

Perhaps an even deeper problem with the linguistic model of the anti-intentionalist or conventionalist stance is that it appears to presume that the object of an interpretation is always construable in a manner parallel to linguistic meaning—that is, as a proposition, an utterance, or a concept. But as we have seen, the object of interpretation is frequently (maybe most frequently) not a linguistic meaning, narrowly construed.

Indeed generally the object of interpretation is what the artist has *done* rather than what she has said. For instance, the art historian may explain to her class the significance of the artist's placement of the crucified Christ at the vanishing point of the painting in terms of the artist's intention to emphasize that it is Christ's death that is the subject of the painting, and not, for example, the Roman soldiers playing dice at the side of the cross. This is a matter of rhetorical or dramaturgical significance that, inasmuch as it may not be apparent to many viewers until it is pointed out, is worthy of interpretative attention.

Nevertheless, it does not involve meaning, linguistically construed. It does not literally say "look here"; rather it has the effect of tending to draw the eye of the normal viewer in that direction. Yet, explaining the significance of this device in the design of the work as a whole is interpretative because it contributes to revealing the unity of intent of the work—that

is, to explaining the way in which this strategy reinforces the plan, point, or purpose of the work by forcefully advancing the content of the work.

The limitations of the conventionalist model encourage us to search elsewhere for a way of understanding interpretation. Moreover, we need not look far afield. For interpretation is not some strange activity that we indulge in only with respect to rarefied objects like artworks; ordinary life is shot through with interpretation.

Barely an hour goes by when most of us are not involved in interpreting the words and deeds, the sayings and doings, of our conspecifics. The ability to read the minds of others is an indispensable part of social existence, and those who are extremely deficient at it, such as people stricken with autism, are typically thought to be disabled. The interpretation of artworks appears simply to be a specialized extension of this natural capacity of our human endowment, no different in kind from our interpretation of the behavior, verbal and otherwise, of the family, friends, strangers, and enemies who surround us daily.

Thus, our ordinary practices of interpretation may be expected to shed some light on the interpretation of artworks. In every life, interpretation is typically aimed at understanding the intentions of others. We scrutinize the speech and the action, often including the nonverbal behavior, of our conspecifics in order to make sense of them by inferring the intentions that gave rise to them. If the behavior takes place against a background of conventions, as speech does, we factor those conventions into our deliberations.

However, arriving at our interpretation of an action, including a speech act, rarely involves applying conventional rules to behavior mechanically. We appeal to what we know

about the agent, about her beliefs and her desires, about the context of her activity as well as what we know about pertinent conventions, to arrive at our interpretations. Interpretation is more a matter of pragmatics than of anything else.

Why not approach the interpretation of artworks in the same way in which we interpret our conspecifics every day? Isn't it very likely that the interpretation of artworks is on a continuum with the interpretive propensities that appear to have been bred in our bones by natural selection as a beneficial adaptation for social beings like ourselves?

If it is plausible to answer these questions affirmatively, then the narrow model of linguistic meaning favored by the anti-intentionally disposed conventionalist may be exchanged for the broader notion of sense that is invoked when we speak of making sense of an action—where what makes sense of an action, or what contributes to rendering an action comprehensible, is the identification of the coherent intention that lies behind it. Why not suppose that making sense of an artwork is of a piece with making sense of an action—in this case, making sense of what the artist intentionally does or performs in creating her artwork? One advantage of this view, in contradistinction to the preceding version of anti-intentionalism, is that artforms that are not governed by rules as strict as those of semantics and syntax are still readily interpretable under an intentionalist understanding of interpretation.

Artworks have a communicative dimension. Consequently, all things being equal, we should try to engage them as we do the other communicative behaviors of our fellow humans— as sources of information regarding their intentions. Where interpretation comes into play, its point is arguably to discern

the communicative intentions of the creator of the work.* Thus, the intentionalist claims that an interpretation is successful to the degree that it tracks the intentions of artists and uses them as a factor in the hypothesis the intentionalist proposes as to the meaning of the work.

Intentionalism is often rejected because it is thought to force its proponents to the nonsensical position of holding that the preferred interpretation of an artwork is that the artwork has whatever meaning or function its creator says that it does. So if the poet says that the word "blue" in his poem means "red," then "blue" means "red." But that's absurd.

Of course, in a case like this, we may suspect the poet is dissembling about that which he truly intends. In the ordinary course of affairs, we do not always allow our interlocutors to have the last word about their intentions. So it needs to be stressed that intentionalism is not committed to the view that an artwork means whatever the author merely says it does. Rather, intentionalism is after the actual intention of the artist.†

But let us imagine in this case that we are somehow able to ascertain that the poet really does intend "blue" to mean "red." Surely, we will not accept that this is what the word means, for that way lies Humpty-Dumpty. Moreover, the anti-intentionalist will tell us why we will not permit the poet's intention to determine the meaning of "blue"—

* By "communicative intention," here I mean *what* the artist intends to communicate as well as *that* the artist intends to communicate.

† Which may even be an unconscious intention.

viz., because what the poet has in mind violates the laws of language.*

This objection is fatal to the most radical variety of actual intentionalism.[15] However, there may be more modest forms of actual intentionalism that are capable of dodging this objection. One strategy in this respect is to regard the intentions of the creators of artworks as pertinent to the interpretation of artworks just in case the work itself—including in this instance the words and their conventional meanings—can support the putative intention of the artist. Where said intentions cannot, isolating the artist's intention will not, the intentionalist concedes, facilitate a successful interpretation of the work.[16] In this way the modest actual intentionalist acknowledges the role of both conventional meaning and intention in interpretation.[17]

Nevertheless, the modest actual intentionalist must surmount further challenges. One charge is that any form of intentionalism misdirects the interpreter away from where he

* In the name of fairness, it should be noted that anti-intentionalism incurs some absurdities of its own. It allows in as meanings all sorts of anachronisms. For example, it endorses the petroleum reading of "plastic arm" in the Akenside poem cited earlier. But it seems downright silly to think that that poem, let alone that poet, could be referring to a substance that did not yet exist and that the poet and his contemporaries could have no knowledge of. Every noun that I use in this essay could come, in the future, to have an added meaning that is presently unbeknownst to me. Am I invoking those meanings here and now? How could I be? Surely, at the very least, what I earlier called negative intentionality is a constraint on interpretations that captures a basic principle of meaning attribution. For an example of an anti-intentionalist who thinks that Akenside's text does refer to petroleum by-products, see Monroe Beardsley, The Possibility of Criticism (Detroit: Wayne State University Press, 1970), pp. 19–20.

should be paying attention. Instead of focusing on the work, the interpreter is focused on something outside the work, specifically, the artist's intention. However, in response the modest actual intentionalist may note that the artwork is the primary source of our evidence about the artist's intention. For example, once we understand the political context in which Bulgakov was writing, it is primarily from the text of his *The Master and the Margarita* that we recognize his intention to mask the subversive content of the book by making the Devil the messenger of Christ. In such a case, this form of intentionalism does not beckon us to turn away from the artwork, but to inspect it ever more closely.

Furthermore, the intentionalist contends that it is not quite right to maintain that our interest is in the artwork as if it were an object in nature—a well wrought urn magically spat out of a volcano by some statistical fluke. Surely, since so many of the critical remarks we lavish on artworks presuppose the notion of achievement, our interest in the work is in the way intentions are realized (or not) in the work. But to appreciate that, as we argued earlier, requires a grasp of the intentions that gave rise to the work. For, the achievements of artists are the actions they performed in the creation of the work, and intentions are relevant, though perhaps not solely, to determining the significance of actions. Thus, our practices of critical appreciation would appear to be underwritten substantially by intentionalism.

Moreover, if one listens carefully to the ways in which we talk about artworks, one will undoubtedly be struck by how often we employ locutions that seem to anthropomorphize the art object. We say that the painting does thus and so, or that the poem says this or that. But paintings and poems don't do anything literally. Nevertheless, it seems natural to speak

this way just because what we care about with respect to the art object is what the artist has done—that is, what she has accomplished—where the artist's action is best captured under some intentional description which we figuratively extend to the artwork.

The intentionalist argues that the interpretation of artworks is on a continuum with our everyday interpretation of our conspecifics. However, critics of intentionalism maintain that once we enter the realm of art, things change. Even if standardly we interpret in order to identify the intentions behind the words and deeds of others, art is not like that. Art has purposes above and beyond the practical concern with gathering information from our conspecifics. An essential function of art, it might be said, is to afford aesthetic experience—experience valued for its own sake—by encouraging the imagination of the reader, listener, or viewer of the artwork to enter into lively interpretative play. The claim that the proper aim of interpretation is to identify the intention of the artist may run afoul of the aforesaid putatively central function of art. Thus, in order to engage artworks appropriately, our normal inclination toward interpreting for intention should be suspended.

On the one hand, the view that the central function of art, one that trumps all other functions, is to engender aesthetic experience by abetting the imaginative play of interpretation is, to say the least, controversial. Nor can it be bolstered, without begging the question, by suggesting that the authority for this viewpoint is clearly manifested in the behavior of informed participants in the art world, since one finds that, in fact, informed participants in the art world traffic in intentionalist interpretations with remarkable frequency.

On the other hand, it is difficult to gainsay that an artwork has at least a communicative dimension—that it is meant as an expression of thought or a feeling or as the projection of a design for contemplation, or is meant to have some other intersubjectively detectable effect. Furthermore, it may be argued that once we enter a communicative relationship with another, it would appear that we are bound by certain moral responsibilities.*

That is, we must treat the communiqué of the other fairly, with charity, and with accuracy; we must engage our interlocutor justly and attempt to get at what she intends to communicate. Perhaps the best evidence for this moral commitment is the injustice we ourselves feel when we believe that others are "putting words in our mouths." The irritation that we experience when this happens is an indication that we feel "wronged." Similarly we wrong artists when we strongly suspect and even know what they intend and, in addition, we acknowledge that what they intend is consistent with what they have made, but nevertheless we persist in interpreting them contrariwise.†

* Likewise there would appear to be something almost silly about ignoring an artist's stated intention about what she is doing, and offering an interpretation at variance with her statement, when what she has created accords with her pronouncements. Would we deny the assertions of a shoemaker who claims to be making footwear and whose products people can use as footwear and, instead, maintain that he is really doing something different? But if that is a silly way to behave with respect to shoemakers, why is it any less silly with respect to artists?

† For truth as a regulative ideal is fundamental to genuine communication, including being true to the meanings of those who address us, as well as being an indispensable feature of extending real respect to them.

Furthermore, if such moral considerations are germane to interpretation, then it does not seem that the supposed pursuit of aesthetic experience through the free, or, at least, intentionalistically independent, play of interpretations trumps all of our legitimate interests in artworks. Rather, the range of acceptable interpretations will be morally constrained by our best hypotheses about what the creator of the work intended.

One misgiving about the critic's claim to be disclosing the intentions of artists is that the critics discoursing upon the intentions of artists often seem far more articulate than artists are wont to be when asked about what they are up to. This is to be expected, however, since the critic is an expert in words, whereas the artists may work in oils or bronze. The artist expresses herself through her artform, which, even if it is literature, is not expository and analytic. So it should be no surprise that the critic's characterization of the artist's intention may be more elaborate and nuanced than what the artist might say to an interviewer.

But, the fact that the critic's account of the artist's intention may be more perspicuous than the artist's words does not entail that the critic can't be stating the artist's intention. He may be—only he is stating it more explicitly and sharply. Moreover, in order to insure that the critic is not putting words in the artist's mouth, the critic should strive to formulate her hypotheses about the artist's intentions in terms that the artist could recognize with little strain and ratify as his own.

Many, perhaps most, artists may not be articulating their intentions to themselves in the sort of essayistic statements in which critics specialize. Nevertheless, this does not imply that said artists are not behaving intentionally. Rather, their

intentionality is evidenced by their sense of the purposiveness of their project, as expressed, for example, when they say things like "this brushstroke is right," "that one is wrong," and "the work feels finished." Thus do they articulate their satisfaction with their plan and endorse it, although it may take a critic to spell out that plan to the rest of us. The composer declares he feels that the song should end just here. The critic explains how the songster intentionally aimed at closure and how she achieved it.

X-rays of many of Mondrian's paintings reveal that he often experimented with rectangles of different proportions when creating his works. Even if Mondrian was unable to say why he settled on the arrangement he sent off to the gallery, there is no reason to think that he was not acting intentionally in a way that the critic might go on to explain, since obviously Mondrian ratified the final disposition of figures.

At times, it appears as though the anti-intentionalist has too narrow a view of the intentions about which intentionalist critics care. For example, the anti-intentionalist may point out with references to cases such as that of Mondrian that the artist was not simply implementing some "fore-intention." Mondrian did not know what he wanted until he got it. But there is no reason to think that artistic intentions are not clarified in the process of creating the work and that those are quite often the kind of intentions to which the intentionalist critic is referring.

The creators of the motion picture *Darjeeling Limited*, for example, did not originally plan the baggage motif to be interpreted as "baggage" in the psychological sense, but recognized this possibility in the course of filming, ratified it, and exploited it finally as the brothers lose their literal (and, therefore, psychological) baggage toward the end of the

movie. That this was not part of the original design of the film does not discount it as an authorial intention. For artistic intentions can emerge in the process of a work and be ratified on the spot.

One complaint about intentionalism, even modest actual intentionalism, is that it seems to deny that there can be something valuable in the work that was not intended to be there by the artist. But surely the artist has not planned every valuable feature of her artwork in advance. Nevertheless, it is important to recognize that typically every feature in the artwork is intentional at least in the sense that the artist has ratified its presence in the finished product. The artist may not have intended the inclusion of the feature at issue ahead of time, but still settled upon it intentionally in the heat of creating the artwork. And this warrants an intentionalist approach to her artwork.

However, even if it is conceded that the work of interpretation is involved with hypothesizing the actual intention of the creator of the artwork, there is a dispute among intentionalists over what should count as the preferred interpretation. One side—call them hypothetical intentionalists—claims that the preferred interpretation of the artwork is one that would be conjectured by an idealized, fully informed audience member, helping herself to all of the publicly accessible information surrounding the artwork (including knowledge about the rest of the creator's oeuvre, about the history and practice of the pertinent genre and style of the artwork, about the social context of the work, and even information concerning whatever is in the public record about the artist's life).[18] The other half of this debate—call them modest actual intentionalists—holds that the preferred interpretation of the work is whatever is constrained by what can be known or

reasonably conjectured of the actual intention of the creator so long as that intention is supported by the work itself.

Since both hypothetical and modest actual intentionalists will usually rely upon pretty much the same kinds of considerations to arrive at their interpretations—historical context, art history, the rest of the creator's oeuvre and so forth—in practice the two positions are apt to converge generally on the same interpretations of the work. There is a point where they do clash, nevertheless.

Since the goal of the modest actual intentionalist is the retrieval of the actual intention of the creator, she will be prepared to use information—wherever it comes from—about what the author really intended, so long as what the creator is thought to intend is consistent with his finished creation. This includes being ready to exploit clues from the private diaries, letters, and notes of the creator as well as from the reliable testimony of friends and relatives of the creator about personal communications to them regarding the work. In contrast, the hypothetical intentionalist believes that the interpreter must be restricted in her hypothesizing to just what can be found in the public record.

The hypothetical intentionalist defends his viewpoint, in part, by asserting that the preceding limitations on the kinds of evidence to which an interpreter has a genuine right are part and parcel of the principles undergirding art world practice. It is a violation of the rules of the game, in other words, to use the private papers of an artist to formulate the preferred interpretation.

Nevertheless, it is not clear where the hypothetical intentionalist locates the basis for this alleged rule of criticism. For, it cannot be observed in the actual practice of interpretation, since many critics and, it would seem, all critical biographers

appear quite happy to plunder unpublished biographical confidences in their interpretations. Perhaps they are in violation of some rule, but, since the eclipse of the New Criticism, that bastion of anti-intentionalism, no one appears to call them on it anymore.

Of course, this is not to say that hypothetical intentionalists disallow reference to the autobiographies of artists. They grant that is legitimate, but only so long as the autobiographies are in public circulation. However, this seems to be an arbitrary constraint. Is it that a critic can consult an artist's auto-biography, if it is on a bookshelf in the Yale library, but not in the university's collection of the author's papers? And if it is alright if it is in the university's collection of the author's papers, why isn't reference to those private papers acceptable, if they are in the author's garage? It seems hard to find non-arbitrary boundaries here, especially since once one critic (allegedly illegitimately) makes reference in his published writing to what is in the papers in the garage, then other critics can (legitimately) refer to what the offending critic has put on the public record.

Moreover, the notion that such rules, as the hypothetical intentionalist supposes, could govern the art world seems improbable. For especially when we become interested in an artist and her artworks, we are grateful to learn everything we can about her and to incorporate it into our understanding, irrespective of whence the information originates.

Because interpretation is so often identified with the iden-tification of meaning, it is quite natural to suppose that it is connected to intentions. For, the meaning of an utterance—such as "The door is closed"—depends upon whether the speaker intends to be reporting a fact or asking a question (signaled, perhaps, by changing one's intonation at the end of

the sentence). Modest actual intentionalists and hypothetical intentionalists are agreed on this connection between utterance meaning and intention and they anchor the pertinent intention in the creator. However, while agreeing that the meaning of an utterance requires an intention, other parties to the discussion may question whether the relevant intention needs to be that of the author or the creator of the work. Might not the intention be supplied by the consumers of the work—the readers of the poem, for example?

On this view, which we may regard as a variant of reception theory or reader-response aesthetics, the author of the poem supplies his readership with a text—a mere sequence of words whose meanings are to be imputed by the audience, albeit usually within the constraints of the possible dictionary senses of the words at issue and the rules of grammar. In this way, each reader may be thought to construct her own artwork, just as the interpretation of a score by a musician counts as a work of performing art in its own right. That is, in the inevitable process of filling-in the indeterminacies of the text (conceived as a sheer sequence of symbols sans fully determinate meaning), the reader—the plain reader and the critic alike—putatively creates her own artwork.

Even if this view of interpretation suits some artforms, like literature, it is difficult to generalize across the arts. What exactly is the text of a painting? And how would this approach apply to architecture? It strains language violently to say that each spectator *constructs* his own building, and where, in any event, would those *buildings* be located exactly? There would appear to be room for only one Notre Dame on the banks of the Seine in Paris. Or, are those imputed cathedrals immaterial? Surely such thinking leads to strange forms of architecture. Likewise, the musical artwork constructed by the

listener as she listens to the sonata, bizarrely enough, would appear to have no sonic dimension.

Another problem with this way of talking is that it would seem to evaporate the category of critical interpretation entirely. In ordinary language, we countenance at least two notions of interpretation—the notion of a critical interpretation (which has been our focus in this section) and what might be called a performative interpretation—the sort of interpretation that a musician gives to a piece of music or that an actor gives to a role. These two kinds of interpretation may be related—the actor may produce or consult a critical interpretation of a play before creating his role through an interpretation/performance. But the two sorts of interpretation are usually thought to be distinct.

However, on the variation of reception aesthetics now under review, the difference disappears. There is no artwork to be interpreted critically because the interpretation—the performative interpretation—by the reader, viewer, or listener just is the artwork. There is no conceptual space left over for the critical interpretation to gain a foothold. Or, in other words, the distinction between the artwork and its critical interpretation has disappeared.

Furthermore, if each interpretation, in the sense germane to the reception theorists, amounts to a different artwork, then it is not clear how we will go about comparing different interpretations. What will be the reference point in such comparisons? But we do compare interpretations. So, if the reception approach makes this seem impossible, then so much the worse for reception theory.

In addition, if audiences and critics create artworks, what is it precisely that artists do? Is it that short-story writers produce texts—strings of symbols without intended meanings?

This is certainly not what writers think they do, nor does it really seem humanly feasible for an author to produce a document on such a scale with no definite utterance meanings in mind.

And how would we go about evaluating the works fabricated by artists on this construal? Would the "text" that generated the most (or the least) reader-response artworks be the best and why? Or would there be some other criteria? Like what?

At the very least, the reception account of interpretation just laid out would call for a radical overhaul of the way in which we talk and think about art. This approach hardly models the practice as we know it. Before embracing such a dramatically revisionist view of interpretation rather than what seems to be flourishing in the existing art world, we should require a more fully developed articulation of this alternative conceptual framework than any on offer thus far.

On the other hand, it may just be an added virtue of modest actual intentionalism that it fits our current interpretative practices as snugly as it does.

Evaluation

Problems and Prospects

Four

I. INTRODUCTION

The view of criticism being advanced in this book is that it is essentially a matter of evaluation grounded in reasons. The support for the critical appraisal of an artwork is supplied by the description and/or classification and/or contextualization and/or elucidation and/or interpretation and/or analysis of the artwork.

For example, in her very positive review of Mark Morris's *Mozart Dances*, Joan Acocella classifies the piece as a work of modern-dance abstraction.[1] She notes that this kind of choreography can often leave viewers bewildered, but she emphasizes that, like much of Morris's other work, *Mozart Dances* is immensely pleasing. By placing the dance in the category she does, Acocella, at the same time, identifies its problematic—to make abstract movement accessible. Acocella maintains that Morris meets this challenge and she goes on to describe, interpret, and analyze how he succeeds in doing so.

She argues that Morris makes abstract movements that nevertheless insinuate or suggest a vague but discernible narrative. This hint of narrative is what gives the audience, if only subliminally, something to hold onto. Of course, for this conjecture to ring true, Acocella must help us see that

narrative. She does this then by describing and interpreting the movements that carry this gossamer story forward.

In the opening section—"Eleven," set to Mozart's Piano Concerto No. 11—Acocella pinpoints what she calls the "danger motif." She describes the repetitively sharp movements of the women dancers, which rhyme with the bold strokes of the painted backdrop, and the emergent and then repeated image of a woman on the floor jabbing her arms sideways. Acocella interprets these violent gestures as a premonition of trouble.

She then identifies the trouble as it evolves in the second dance, "Double," set to Mozart's Sonata in D Major for Two Pianos. There, a male soloist looks upward with his fisted hands against his chest, which Acocella interprets as a sign of desperation and abandonment ("Why me, God?"). Then the young man collapses and, stiff as a corpse, he is carried off by a group of men. And to etch the tragedy emotionally on the audience, it is reprised.

The final section, "Twenty-seven," ends with the sense of troubling ambiguity, in which some of the dancers hold their hands over their hearts while others hold out their arms in a questioning gesture; these clashing signals intimate that the group's story may not have reached closure, but rather a nagging, even unsettling, state of irresolution.

Throughout, woven into her description and interpretation of *Mozart Dances*, Acocella contextualizes her account by citing personal interviews with the choreographer and she even considers an alternative analysis of the ending in order to motivate the one that she finally endorses. By carefully selecting, describing, and interpreting movements in the dance, Acocella enables her readers to understand her grounds for maintaining that Morris has subtly articulated the

outline of a story. This, in turn, she maintains, gives the viewer a way into a dance of the sort that is often confusing to audiences, presupposing, as she does, that a narrative, typically, enhances accessibility. In this way, then, Morris succeeds in solving a problematic of much modern abstract choreography—which success grounds Acocella's commendation of *Mozart Dances*.

The reader, of course, might disagree with either Acocella's description or her interpretation of *Mozart Dances*. That would be to challenge the premises of her evaluation. But if one assents to her descriptions and interpretations of the movements and, furthermore, agrees that nothing significant has been omitted in a way that would point in another interpretive direction, then one would appear to have compelling grounds for agreeing with Acocella's evaluation, since it appears to be based on sound observations and reasoning. That is, if things are as I've presented them, Acocella's review seems to be an exemplary case of objective criticism.

And yet the very notion of objective criticism is often disparaged. Criticism, it may be asserted, is always, inescapably subjective, a matter of taste. Moreover, it must be this way because there are no laws of art—no generalizations about what makes an artwork successful—for the critic to invoke in the process of appraisal. These are some of the leading problems for the notion of objective evaluative criticism. In what follows I will attempt to make out the prospects for objective criticism in the face of these objections.

II. BUT IT'S ALL SUBJECTIVE

It was the eighteenth century, and the philosophy of criticism got off to a bad start. David Hume is, I think, the main culprit here, although he was presaged by folks like his friend Francis

Hutcheson, and then Hume's missteps were compounded by Immanuel Kant, or, at least, by the way in which many people chose to read Kant.

The bad start had to do with Hume's use of *taste* (*la goût* in the French tradition) as the model for critical judgment.[2] Hume was not the first or the only person to propose this association, but he is surely one of the most influential. Hume seems to think that what critics specialize in is declaring artworks to be *beautiful* (or ugly). In tune with Hutcheson, another empiricist like himself, Hume believes that beauty is the name of a sensation, not a feature of the object that provokes the sensation. That is, just as the pain is in my hand and not in the piece of glass that cuts me, so beauty, strictly speaking, is a sensation of pleasure that I undergo when exposed to, for example, the opening of Beethoven's *Pastorale*. My approbation of the stimulating object is rooted in my experience of delight in, my attraction to, and my liking of the object.

This approval or liking is, of course, subjective. It is in the experiencing subject, even though we may have a tendency to project it into or onto the object under the rubric of *beauty*. Nevertheless, the pleasure isn't in the music; it's not out there in what we can call the objective world—the world of objects. How could it be, since the relevant objects, by definition, are not sentient? Rather, the feeling of pleasure is like the agreeable charge of sweetness that bursts upon my tongue when I taste ice cream. No one would say that the pleasure is in the ice cream. It is in me.

Beauty is the name of the pleasure we derive from artworks. When critics say that a work is beautiful, they are saying that it will yield this sort of pleasure, at least in normal percipients who are suitably prepared to receive the stimulus.

Critics have a taste for beauty that is analogous to the sensitivity for sweetness that certain of our taste buds possess. Like a quality-control taster at the dairy plant, who tastes this batch of ice cream to confirm that it is sweet, the critic affirms that she has experienced the pleasure we call beauty in her encounter with some artwork. Just as there is an outer sense of gustatory taste, there is an internal capacity for the experiencing of beauty. When certain artworks come under the critic's perusal, she undergoes sensations of pleasure with a built-in inclination toward attraction to the artwork which is the phenomenological correlate of approval.

Because critical taste is being analogized so closely to sensory taste, and beauty is being associated with sensations like sweetness, the use of the very model of taste for critical judgment brings with it not only the notion that critical approbation (or disapprobation) is subjective, in the literal sense of *being in the subject* (where, in fact, all experiences belong), but also the suggestion that critical judgments are subjective in the contemporary sense of being highly personal, individual, widely variant, and even idiosyncratic.

The latter surmise follows smoothly from the analogy between critical approval (Taste with a capital T) and taste (with a small t). For, we know that gustatory taste is extremely variable—highly personal and even idiosyncratic. So isn't it reasonable to suppose that Taste is likewise?

For example, many people like ice cream, but others have a decided preference for savory things. This variation is even more pronounced when we get down to more fine grained cases. Some people like vanilla ice cream but not chocolate and vice versa. Some have a taste for champagne but not beer, and even have a disliking of it. If critical Taste is like ordinary taste, it is not only something internal to the subject; it is

highly personal and, in that regard, subjective in the agent-relative sense, and not objective.

Kant's monumental work in aesthetics—*The Critique of Judgment*—at least agrees with Hume (and other empiricists like Hutcheson) that what is now called an aesthetic judgment—e.g., "This fantasia is beautiful"—is a feeling of pleasure, albeit a disinterested one, rooted in subjective experience.[3] Thence, philosophers and art theorists after Kant—perhaps forgetting that in the relevant passages Kant was discussing free beauty—began to treat beauty in art as a subjective experience of pleasure merely projected onto the stimulus.

To be fair, although their treatment of beauty as something experienced in the subject opens the door to the notion that judgments of beauty are highly personal—subjective in the sense of being wildly variable inter-subjectively—it is a door that both Hume and Kant, and for that matter Hutcheson before them, struggle heroically to keep shut. All three advert to the idea that there are certain regularities, innate to normal percipients, which govern our (small t) taste-reactions. Most, unless our sensory apparatuses are defective, for example, find sugar sweet, not bitter.

Likewise, with reference to what Hume thinks of as the uniformity of the human frame and what Kant calls our common sense—our shared psychological systems of perception and cognition (notably our imagination and our understanding)—both hope to establish that judgments of beauty can be grounded inter-subjectively. That is: that the same stimulus should be presumed to cause the same pleasant reactions in all human beings so similarly constituted.

However, to the extent that moderns have become skeptical of the idea of a common human nature and, instead, embrace

a really thorough-going relativism, currently the analogy of critical judgment with sensations of pleasure naturally invites the supposition that critical approbation, liking, and preference are personal, relative to the person or agent who issues them.

I do not initially wish to challenge the notion of human nature upon which Hume and Kant rely, especially if we are speaking of beauty, very narrowly construed—i.e., as connected to the pleasures of sight and audition. I have other bones to pick with these philosophical giants, though most explicitly with Hume.* Specifically, I think that Hume's tendency to relegate all critical judgments to judgments of beauty is a grave error. And, furthermore, suggesting that the detection of value (a.k.a. beauty) with reference to artworks operates on the model of taste compounds the misunderstanding of criticism by encouraging the allegation that it is subjective (in the sense of merely being a highly variable, personal preference).†

Quite clearly, determining whether or not artworks are beautiful, although it may be a part of criticism, cannot be the

* Kant is not directly guilty of the same errors as Hume, since he is not writing with specific reference to the criticism of artworks in the sections on pure aesthetic judgments. But, I would claim that historically what he says there has reinforced certain views of criticism as a result of people misreading this section of the third *Critique* and extrapolating, and perhaps over-generalizing, its application to the case of the criticism of artworks.

† Again, let me emphasize that I am not claiming that this is Hume's official view, but instead is the view which many favor when they find Hume's official view unsatisfactory. Moreover, I contend they are moved in this way precisely because of the analogy of critical Taste with sensory taste.

whole of it. One obvious reason for this is that there are many artworks that critics hold in high repute that are not beautiful in any ordinary acceptation of the word. Goya's *Saturn Devouring His Children* and the countless representations of the crucifixion in the Christian tradition provide ample evidence here, as does Titian's *The Flaying of Marsyas*. When commending an artwork to us, critics employ a broader repertoire of praise than simply calling our attention to beauty or the lack thereof.

If we conceive of beauty narrowly—as related to the pleasures of vision and hearing—then it should be obvious that beauty is too limited a concept to supply us with the critical vocabulary we need to estimate the value of artworks—not only because there are valuable artworks in virtue of features other than beauty (as cited in the preceding paragraph), but also because there are artforms like literature that, apart from certain elements of prosody, have qualities important to critics that are unrelated to beauty, strictly conceived, as well as genres, like comedy (e.g., slapstick comedy), where beauty is extraneous to the value of the gag. Therefore, criticism needs a more varied arsenal than *beauty* in the narrow sense.

Perhaps when it comes to beauty in this narrow sense, the proposals of Hume and Kant to the effect that beauty touches something common in the human frame—something bred in the bone—may be more reasonable than many contemporaries allow. For, beauty as related to the pleasures of seeing and listening—or *some* of the pleasures of seeing and listening—might very well be connected to, as they say, our perceptual hard-wiring. Some cross-cultural studies in facial preferences may support this idea. I do not say that it is true, but it is plausible, or, at least, it is not an outlandish conjecture.

However, if this is persuasive, that is yet another reason for rejecting the notion that beauty is the be-all-and-end-all of criticism, since criticism is concerned with so many valuable attributes of artworks that are not conceivably reducible to triggering our perceptual flesh-ware.

For much of the value critics discover in artworks has to do with the kind of intellectual achievements in the work that are hardly comprehensible on the model of our basic operating perceptual system. Critical admiration of the intricacy of Dante's allegory in his *Divine Comedy*, or of the cleverness of the portmanteau word-constructions in Joyce's *Finnegan's Wake*, certainly requires much more than exposing one's innate perceptual system to the works in question.

Hume, of course, would concede this. On his view, criticism requires good sense, which capacity includes the ability to understand the works in question. Yet, according to Hume, good sense is not part of critical Taste; it merely sets up Taste so that the automatic operation of the human frame can swing into action, once it is properly oriented, cognitively speaking, to the stimulus. Then the prepared subject will suffer the pleasure Hume calls beauty. However, I wonder how one can non-arbitrarily separate the wit of Joyce's puns from their cognitive elements and our appreciation thereof. In any event, even if we regard "beauty" as the name of a sensation, isn't beauty different from humor?

It is extremely important to remember that there is a great deal to criticism beyond finding beauty. Indeed, I suspect that by far the major portion of the criticism of the arts is unconcerned with beauty. When one commends Shakespeare for his psychological perspicuity, we are certainly not talking about beauty. But, if we reject the comprehensiveness of

beauty to the critical task, then we simultaneously undermine the picture of the critic as essentially a broker of Taste. For appreciating the observations of social life made by a realist novelist can hardly be modeled on savoring the acidity of a ripe lemon as it presses against the tongue.

The conception of beauty as a subjective experience of pleasure segued nicely with the portrait of the critic as a person of Taste. For it did not seem unreasonable to analogize sensations of pleasure associated with artworks to those pleasant feelings that issued from the "outer" senses. However, once we concede that the detection of beauty cannot encompass the whole of criticism, then it must be granted that there is much more to the critic than Taste.

Perhaps some part of criticism involves Taste as Hume conceives of it. But since not all of criticism is a matter of tracking beauty, criticism is not reducible, without remainder, to Taste. Furthermore, since it is the equation of criticism with Taste that encourages the belief that all criticism is subjective, it would follow that the refutation of that picture of criticism allows that there may be some criticism that is not subjective, since it is not a matter of Taste.

That is, one argument leading to the conclusion that all criticism is subjective goes like this. All criticism is an exercise in Taste (since it is a matter of being sensitive to beauty understood as a sensation of pleasure). All Taste is subjective. Therefore, all criticism is subjective.

However, there is a counterargument present to hand. Not all criticism is an exercise in Taste (since not all, and perhaps even not most, criticism is concerned with locating beauty, narrowly construed). Thus, by challenging the first premise above, the argument that all criticism is subjective is stopped dead in its tracks and the conceptual space for the

possibility that some criticism might be objective has been carved out.*

Nevertheless, before exploring that space more intensively, another argument against the possibility of objective criticism needs to be addressed.

III. ON THE PURPORTED ABSENCE OF CRITICAL PRINCIPLES

The association of criticism with the exercise of Taste is one source of the conviction that all criticism is subjective. But another source involves the argument that, in the absence of critical laws, the only other possible origin of critical pronouncements must be the subjective preferences of the critic. That is, either critical appraisals are based on objective critical principles or they are based on the subjective preferences of the critic. Since there are no critical principles of the relevant sort, critical appraisals must be the result of the subjective preferences of the critic.

This argument, of course, must be supplemented by a further argument that establishes that there are no critical principles. An important argument to the effect that there are no general critical principles was popularized by Arnold Isenberg and later refined by Mary Mothersill.[4]

* It should be noted that the second premise in the argument in the preceding paragraph is also open to debate. For example, if we are talking about beauty, understood narrowly as certain perceptual pleasures, then it may not be the case, despite its being located in the subjects, that it is subjective in the contemporary sense of being peculiarly personal and wildly, even idiosyncratically, variable in non-converging and conflicting ways. For beauty conceived of as the pleasure of vision and/or audition may trigger some feature of our common perceptual apparatus in a way that is constant across normal human specimens whose judgments are not clouded by personal interests and negative associations.

Their argument goes like this: a critic attempts to ground her evaluation of the work by describing, or interpreting, or analyzing some feature of the work. Joan Acocella, in the example that opens this chapter, commends Mark Morris's *Mozart Dances* because of its possession of a vaguely suggested or submerged narrative. So it looks like what she is doing logically is inferring from the presence of a suggested or submerged narrative to a positive evaluation of Morris's choreography, or

1a) *Mozart Dances* possesses a suggested narrative.

2) Therefore, *Mozart Dances* is good.

But, there seems to be something missing here, namely, the general premise:

1b) Artworks that possess a suggested narrative are good.

However, there is a problem with the soundness of this argument, if this is what the critic is arguing, since premise 1b) appears to be false. Surely, in some artworks, a suggested narrative, as opposed to a clear and concretely developed one, would be a bad-making feature. For example, a suggested or submerged narrative in a Hollywood action film would be typically lamentable.

Next, the Isenberg–Mothersill line of attack proposes to generalize this observation, claiming that there is no feature F of artworks such that it always contributes positively to the value of artworks. Pratfalls are excellent in Harold Lloyd comedies, but their presence would have marred Bergman's film *Shame*. And so on, putatively, for any feature you can name.

That is, the general structure that a critical argument supposedly takes is:

1a) This artwork has property F.

1b) Artworks that possess property F are good artworks.

2) Therefore, this artwork is a good artwork.*

Yet, premise 1b) is always allegedly false, since there is no property F that guarantees the goodness of any and every artwork in which F appears. Even properties as general as unity are not such that they always contribute to the goodness of a work, just because works can be unified in such a fashion that they become overly monotonous. Similarly, variety is no assurance of merit either, because too much of it may result in chaos.

However, if there are no general critical principles of the sort that would make an honest (or, at least, a logically compelling) argument out of critical reasoning, then the conclusions the critic reaches must be subjective. From where else but their own personal preferences could their verdicts hail? That seems the best inference to explain the critic's behavior that is available to us, given the ostensible absence of critical principles.

Of course, critics may do what looks like describing and analyzing artworks. But they are not really grounding their evaluations in a logically acceptable manner. Rather, they are using language to express their partiality to the artwork in question, and perhaps they are also attempting to persuade us readers to adopt their predilections.

* It is interesting to note that the structure of the critical argument as sketched by Isenberg is extremely reminiscent of the hypothetico-deductive model of scientific explanation developed by Carl Hempel, Isenberg's one-time colleague at Queens College in New York.

When they point at the work and freight their gestures with all kinds of accolades, they are trying emotively to work us into the same favorably disposed state that they bring to the artwork. The critic is not making a logical argument based upon objectively established premises.

Rather, he uses beguiling language to get you to love what he loves, or to see it the way he sees it. He has not grounded his evaluation but rather has attempted to seduce his readers into concurring with him. He strives rhetorically to make his own subjective preferences yours. Or, at least, this seems to be a fair supposition of what he is up to in the absence of general critical principles of the order of: "Artworks that possess property F are good artworks."

Nevertheless, there is something troublesome about the way in which the notion of general critical principles is being dispatched by people like Isenberg. To see the difficulty, notice how extremely general Isenberg and his followers demand that the relevant critical principles be. Said principles must apply to absolutely every artwork. But aren't principles this general far more than critics need to make their case with reference to the works that concern them?

It is true that whereas pratfalls are good-making features in Harold Lloyd comedies, they would be defects in Bergman's *Shame*. However, it also seems to be the case that pratfalls are good-making features in the kind of film, namely, slapstick comedy, of which Harold Lloyd films are examples. That is, given the point or purpose of this kind of comedy— its function, if you will—pratfalls contribute to the goodness of a slapstick comedy and the lack of them, all things being equal, would be detrimental, unless that absence was compensated for by means of some other type of gag.

In order to see my point, notice that there doesn't seem to be any problem with this particular critical communication.

1a) Harold Lloyd's *Safety Last* contains (let us agree) many successful pratfalls.

1b) *Safety Last* is a slapstick comedy.

1c) Given the purpose or function of slapstick comedy, slapstick comedies that contain many successful pratfalls, all other things being equal, are good (*pro tanto**).

2) Therefore, *Safety Last* is good (*pro tanto*).

The fact that Bergman's *Shame* and a massive number of other artworks are not improved by the presence of pratfalls—and might even be compromised by them—does nothing to challenge the preceding argument, since *Shame* and the other putatively persuasive counterexamples simply are not slapstick comedies, nor do they have the function of films in that category.[5]

The preceding general premise, derived from the purpose of things in the category of slapstick comedy, that I have deployed above (i.e., 1c) is general *enough* logically to ground the critic's conclusion. 1c) is not as general as the principles at which the Isenbergians aim their counterexamples. Yet it seems to me that those principles are supposed to be so general that their unavailability is a straw consideration. It may be just too extravagant to expect to find general good-making features of artworks that are so encompassing that they augment the goodness of any artwork, irrespective of the kind of artwork it is. And, in any case, critics, especially by adverting to categories of art and their purposes, have access to general principles about what counts as success

* We will discuss the significance of this qualification in the next section.

in the pertinent artforms, genres, and so forth—which principles, in turn, are sufficient to ground their evaluations.

The Isenbergian may grumble about my Harold Lloyd example, suggesting that it can be the case that under some strange conditions a particular pratfall might not contribute to the goodness of a slapstick comedy. But that is why the *ceteris paribus* clause has been added to our formulation. Moreover, if the Isenbergian objects to that, it seems reasonable for us to demand to know why such clauses are acceptable in scientific generalizations, but not in critical ones.[6] Permitting scientists but not critics to use such devices seems downright arbitrary.

Once we establish the objective of slapstick comedies—say, the provocation of laughter through physical business, often of an apparently accidental sort—we can ground the principle that pratfalls, *ceteris paribus*, are good-making features in slapstick comedies. The function of slapstick comedy indicates to us why the possession of pratfalls is good for the genre, just as the function of steak knives grounds sharpness as a virtue of this sort of cutlery, since there is a teleological relation between the purpose of a kind and what counts as an excellence of that kind.*

When Joan Acocella commends Mark Morris's *Mozart Dances* in virtue of its suggested narrative, she is not supposing that a suggested narrative is a good-making feature of every artwork. Rather, she is restricting her claim to works of

* My strategy for blocking subjectivism as it is based on the alleged lack of critical principles is not the only maneuver available for challenging subjectivism. One might also attempt to formulate a version of aesthetic particularism, modeled on ethical particularism, as a way of thwarting subjectivism.

modern abstract choreography and saying that, all things being equal, it is a good-making feature in such works. This grants that in some cases things might not be equal. In some work of modern abstract choreography, a suggested narrative may not be a positive feature of the work (and in such an instance the critic should be able to say why, things being unequal, the suggested narrative has aborted). Likewise, a work of modern abstract choreography may lack a suggested narrative but succeed nevertheless in virtue of some other feature that solves the problematic or acquits the function that otherwise a suggested narrative would.

Considering the case of Joan Acocella's review of *Mozart Dances*, we see there is no reason to suspect that there is something logically amiss about it. One might attempt to challenge Acocella's first premise by arguing the work does not contain a submerged narrative, perhaps by questioning the descriptions and interpretations that advance the attribution of a narrative to the work. But that would not show that the logic of Acocella's case is weak, which is what the Isenbergian complaint is all about.

In sum, there may be generalizations that are sufficient to ground the evaluations of critics, but which are not as grandiose as those demanded by the Isenbergians. If this is the case, then we can derail the inference from the alleged lack of critical generalizations to the claim that criticism must be subjective.* For, there may be some principles that are *general enough* to support the critic's evaluations.

* It should also be noted that even if there were no critical principles, it may not be the case that that logically forces the concession that critical appraisals are subjective. Moral particularists, for example, argue that ethical judgments lack general rules, but are objective. One could imagine comparable aesthetic particularists. Perhaps on one reading, Kant is one.

One place where we may frequently expect to derive the requisite, critical inference-tickets is in the purposes and expectations that are connected to the multifarious categories to which artworks may belong. For, the category or categories that an artwork inhabits come(s) replete with certain purposes and expectations whose satisfaction is linked to the features of the relevant kind of art which we deem to be value-makers.*

Therefore, if the critic can objectively—that is to say, in a way that is inter-subjectively verifiable—establish that an artwork belongs to a certain category and, furthermore, that that category or those categories have certain purposes that are best served by the possession of certain features, the critic will have the logical and conceptual wherewithal to issue objective verdicts.[7]

However, in order to substantiate the possibility of object-ive evaluation, we will need to explain how the determination of the category of an artwork and the purpose or purposes of artworks in that category can be objective rather than subjective.

IV. CLASSIFICATION (ONCE AGAIN)

It will not take long for anyone who is convinced of the thoroughgoing subjectivity of critical evaluation to regroup when confronted by the argument in the preceding section. For, even if they are forced to concede that it may be the case

* When we critically evaluate a work relative to a category, it should be clear that we are not praising or chiding the work because it satisfies the criteria for being a member of that category, but, rather, because it dis-charges (or fails to discharge) the function or functions that are expected from works that fall into the pertinent category.

that critical verdicts can have a certain kind of objectivity relative to categories, they will go on to charge that the way in which a critic *chooses* to classify an artwork is itself a subjective process. The subjectivist agrees that whether you classify Robbe-Grillet's novel *Jealousy* as a work of psychological verisimilitude or a modernist exercise in reflexivity makes a world of difference in terms of the direction of the content of your description, interpretation, and evaluation of the work, as well as in terms of your account of the specific relations that those operations will bear to each other as you build your case. However, the subjectivist adds, which category the critic opts for is subjective, not only in this case but always. Criticism is voluntaristic through and through. Thus, the debate has escalated from the allegation that critical verdicts are subjective to the charge that the classifications upon which critics depend for their verdicts are subjective.

But this suggestion—especially in its most general form— surely sounds deeply counterintuitive. Isn't it obvious to everyone that DaVinci's *The Last Supper* is a religious painting and not a still life, and that the critic who opts to treat it as a still life would be objectively way off target?

The subjectivist may concur that this is how we conventionally classify the *The Last Supper*, but then add that just because that is what is customarily done fails to show that there is a fact of the matter about correct genre membership here. To claim otherwise, the subjectivist adds, is merely so much arm waving on the part of the objectivist.

For, the subjectivist maintains that there are no objective reasons behind the classification of DaVinci's *The Last Supper* as a religious painting rather than a still life. It is simply a habit, albeit a widely shared one. It may be what a lot of people say, but that choice is no more objective than the choice a lot of

men make to wear tuxedos at their weddings rather than Bermuda shorts.

At this stage in the argument, the subjectivist is attempting to shift the burden of proof to those of us who would defend the objectivity of critical evaluation. The subjectivist will not accept—sans further argumentation—our example of *The Last Supper* as objectively belonging to the category of religious painting rather than of still life. To blandly assert this, the subjectivist contends, begs the question. Moreover, he contends that he can dismissively explain away the apparent objectivity of the classification as nothing more than fashionable.

In effect, the subjectivist challenge is this: if there are supposedly objective reasons underpinning the classifications that support critical evaluations, then let's see them. Stop merely asserting that there are objective classifications; rather show how this can be done. Needless to say, the subjectivist does not think that this is possible. So, let me attempt to demonstrate the error of his ways.

There are at least three kinds of reasons—objective reasons—that can be marshaled in support of the types of classifications that are relevant to critical evaluation.[8] These include structural reasons, historico-contextual reasons, and intentional reasons. It will be useful for us to review these at this juncture in order to meet the subjectivist's challenge.

The first type of reason for classifying an artwork as belonging to one category or conjunction of categories may be called structural. That is, where a work has an abundant number of features that are typical of the artworks already adjudged to belong to a certain category, then that provides the critic with a strong reason to place it in

the pertinent category. That reason, moreover, becomes stronger as the features in question mount in number and/or salience.

Conversely, the fewer features a work possesses in common with works in the category at issue or the greater the number of dissimilarities between the candidate and other members of the category, the more dubious becomes the membership of the artwork in question in that category. For example, DaVinci's *The Last Supper* shares more features with religious paintings than still lifes, even though it possesses a supper table. Moreover, it contains a very salient and recurring feature that still lifes do not, viz., people.

The similarities between *The Last Supper* and other religious paintings (such as the representation of Jesus Christ) and the dissimilarities between *The Last Supper* and still lifes proper—such as the presence of people—provide us with a reason, an objective reason, to classify the painting as a religious painting rather than a still life. Given these considerations, that is, it is far more reasonable to classify *The Last Supper* as a religious painting than it is to say it is a still life.* Moreover, this particular classification is not arbitrary in any way that invites accusations of subjectivity (in the contemporary sense of ultimately a matter of personal—and, therefore, highly variable—choice).

Admittedly, the number and/or salience of the relevant structural similarities and dissimilarities pertinent to classification may not always afford the critic with conclusive reasons in favor of one categorization rather than another, but

* This is not to deny that one can go on to place *The Last Supper* in some more fine-grained category of religious art. But that too can be objective, if it follows the procedures sketched above.

statistics of this sort typically supply evidence in the direction of one classification instead of another. Furthermore, these reasons are clearly objective insofar as they are inter-subjectively both debatable and verifiable.

Whether or not *The Last Supper* contains salient images characteristic of religious paintings—such as the figure of Christ and the apostles—is not a matter of subjective choice. It is there for every prepared viewer to see and to confirm. Nor is the notion that such images are typical of religious paintings, but not of still lifes, up for subjective determination. These are historical facts that can be confirmed by study of the pertinent genres. They are not my subjective fancies. Indeed, if anyone wanted to dispute them, they would have to point to other historical facts about the genres in question.

A second kind of consideration that we bring to bear when attempting objectively to place a candidate artwork in its correct category (or categories) is to situate it in its art-historical context—whether institutional or more broadly cultural. If a certain art-making practice is alive and abroad in the art-historical context from which the work emerges, then, all other things being equal, that gives us a certain degree of rational warrant for classifying a candidate as an instance of that practice, especially where alternative classifications invoke practices not in evidence in the context of the work's production.

Against the subjectivist, note that the question of the correct historical classification of an artwork is not a matter of personal inclination. It is, in the main, a question of fact, historical or social. Despite some of the tight black costumes in Feuillade's *Fantomas*, it would be a mistake—specifically an anachronism—objectively speaking, to classify that motion

picture as a ninja film. In virtue of the period in which it was produced—not to mention its place of production—there were no ninja films yet. And that is an historical fact, not a personal whim of mine.

Similarly, to classify the designs of tribal artists as proto-Modernists—as occurred in the Museum of Modern Art's "'Primitivism' in 20th Century Art" show (as presaged and probably blessed by Clive Bell)—is to commit a historical category error.[9] Of course, the subjectivist may respond: "So, what? Who cares about the historically correct category?" But then, at the very least, the subjectivist has changed the subject, since, *prima facie*, the correct category—presently the topic of our investigation—is surely the *historically* or *contextually* correct category.

But again the subjectivist parries: "Why must the correct category be the historically correct one? Why not say that the correct category is the one that yields the greatest aesthetic pleasure to the percipient (something that may undoubtedly be a matter of subjective inclination)?" However, at this point, it seems we have strayed from any commitment to the idea of criticism as directed at what the artist achieved by way of her work. Rather we are in the realm of whatever classification jollies the reader, listener, and/or viewer.*

Furthermore, it is not even clear that the experience yielded by a free-wheeling subjective election of categories is really aesthetic experience, since, on most accounts, aesthetic experience ensues from processing the artwork in terms of what it authentically is and relative to its correct

* At this point, the reader may wish to re-visit our earlier discussion of success value versus reception value in Chapter Two.

historical category, rather than relative to some subjectively imposed one.

As in the case of the structural reasons on behalf of artistic classifications, historical and contextual grounds for categorization are not absolutely conclusive. Rather, they supply us with some rational motivation to elect one classification rather than another, especially in those cases where competing categorizations are historically or contextually inapposite or strained. Moreover, when contextual information is added to structural information, the objective purchase of our classifications rises proportionately.

The third type of objective reason germane to the issue of correct categorization has to do with the intention of the artist. In perhaps the largest number of cases historically, the way in which the artist or artists intended their work to be categorized is an inter-subjectively determinable matter of fact, and in a substantial number of the remaining cases, an extremely plausible conjecture about the intended classification of the artwork is readily available. What conceivable grounds do we have for doubting that David's *Oath of the Horatii*, Dürer's *Self-Portrait*, and Henri Fantin-Latour's *Still Life* were intended to be respectively: a historical painting, a portrait, and a still life?

Moreover, if it is claimed that we cannot glean the intentions of the dead, we should remember that few find it troublesome that archaeologists speculate upon the intentions of prehistoric peoples who are far more removed from us temporally than the likes of David, Dürer, or Fantin-Latour.

Even where we are told neither directly nor indirectly into which category the artist intends her artwork to fall, it is often easy enough to grasp the intention. When we see an ordinary, everyday object on a pedestal in a gallery, we know that the

artist intends it to be scrutinized and interpreted as a found object and that the critic (and the spectator) should mobilize the protocols appropriate to that genre in responding to it.

As we saw in the previous chapter, many critics, particularly in academic circles, are wary of invoking the intentions of artists in their intercourse with artworks. Often these worries are advanced on the basis of epistemological considerations— the critics in question are afraid that the aforementioned intentions are ultimately beyond our reach. But these anxieties are certainly excessive, especially when it comes to discussing the categorical intentions of artists (i.e., the intentions concerning which categories they mean their artworks to instantiate). There is no special difficulty in attributing to Robert Musil, with respect to *Young Torless*, the intention to create a psychological novel. This is no more an elusive piece of mind-reading on our part than our almost always correct inference that when a student raises her hand, she means to speak.

Nor should we distrust the artist when she claims that her work belongs to such and such a category because we fear she is radically low-balling her stated aspiration in the hopes of getting a "better grade" for her work. It is not a characteristic of the artistic ego to downgrade the level of her attempted achievement, nor to make something unworthy for the sake of faint praise.

Needless to say, the intention of the artist may not invariably afford sufficient grounds for a particular categorization. On occasion we might suspect that the artist is being less than honest or maybe just confused. And, of course, the evidence may be simply too indeterminate. However, in a truly staggering number of cases, our information is adequate

to support the presumption in favor of one categorization rather than another.

For example, with respect to his *The Turn of the Screw*, Henry James informs us that it is a ghost story in his introduction. And, of course, the pertinent novels come labeled as mysteries. Likewise the titles of paintings often signal their category, as when a picture is called a "landscape" or a "still life with this or that." Furthermore, perhaps it goes without saying that the content of a work of art is also generally an excellent indicator of the category in which the artist intends it to be placed.

Structural, contextual, and intentional considerations, then, supply us with objective reasons for classifying artworks in certain ways rather than others. When all three reasons are available, their combined force may frequently be conclusive or, at least, as conclusive as it is reasonable to expect.

Moreover, these reasons often work hand in glove in a number of ways. Contextual reasons may play a role in substantiating our attributions of the intentions of artists, insofar as knowledge of the historical context may fix the horizon of what the artist could or could not have meant her work to be.

Likewise, structural considerations reinforce our hypotheses concerning artistic intent, since, although there are some, very few artists, historically, who have had an interest in confusing their audiences about the intended category of their works, such confusion courts rejection. Thus, it is generally safe to presume that if a work bears sufficient and salient enough correlations with the works of an established category, it is intended to be taken as a member of that category.

Although I have just emphasized some of the ways in which structural, contextual, and intentional reasons working

in concert may ground a critical classification, a successful classification need not always depend upon backing from all of these sources. Sometimes a structural or a contextual or an intentional consideration alone will be enough to get the job done, especially in cases where there are no viable, alternative categorizations available.

By identifying the category to which an artwork belongs, the critic gains some sense of the point or purpose of the artwork. And knowing the purpose or range of purposes of the work, the critic can begin to assay whether or not the work has succeeded on its own terms. Furthermore, knowing the point or purpose of the kind of work in question alerts the critic to the features of the work that she needs to describe and/or analyze in order to ground her evaluation of the work. For, just as knowing the purpose of a steak knife is connected to the fact that sharpness is an excellence for that type of cutlery, knowing that the purpose of a religious painting is to instill awe enables the critic to describe and/or analyze as virtues of the work those features—for instance, features of scale and elevation—that contribute to taking the spectator's breath away.*

This approach to evaluation and its solution in contradistinction to the Isenbergian demand for general principles of artistic evaluation is obviously category-relative. The principles it relies upon are those that pertain only to certain kinds

* Some may worry that this account of evaluation is too cerebral and bloodless. But that is a mistake. Emotions will often be involved in identifying the pertinent category. In part, we know a suspense novel is such because it arouses suspense. And, as well, knowing the category of the work tells the critic about which emotion she should be on the lookout for. For example, thrillers should thrill.

of artworks rather than to all artworks. This contrasts strongly with the sort of principles that the Isenbergian was after, since those were supposed to pertain across all art kinds. However, that expectation seems to me extremely unrealistic. Why suppose that there are principles that apply equally to realist novels and Persian carpets?

Moreover, whereas the Isenbergian critical syllogism is framed in terms of features that lay claim to the overall goodness of the work, on my approach—which we may call the plural-category approach (since there are many, many categories of art)—the category-relative evaluation of an artwork is a *pro tanto* evaluation insofar as it commends the work for being good of its kind just insofar as it realizes the points or purposes of the type of artwork it is. And this result accords with the sentiment that I expressed earlier in this book to the effect that the primary role of criticism is to isolate that which is valuable in an artwork.

An initial objection to the plural-category approach to criticism is that it is inherently formalist. For by assessing the artwork in virtue of its categories—whether genres, movements, oeuvres, styles (period and otherwise)—it appears that we are only concerned with the way in which the work executes its purposes—i.e., with the way in which the form of the work embodies its category-relative points and purposes. One putative problem that this poses is that it would appear to insulate the work from other-than-formal evaluation in terms of, for example, its moral, political, and/or cognitive chops.

But this objection can be defeated by two considerations. First, many works of art are committed directly to various moral, political, and/or cognitive projects. Thus, a work committed to moral inspiration that fails to possess a

genuinely inspiring moral message, because its message is morally objectionable, will count as a failure on the plural-category approach. Likewise, a work of social protest that fails to raise an issue appropriate to political indignation can be criticized negatively on the plural-category approach. And, a realistic novel whose observations are inaccurate can be declared a cognitive failure relative to the expectations that are pertinent to the category of realism.

Furthermore, even where the artworks in question are not directly connected to the realization of some moral, political, cognitive, and/or otherwise "extra-aesthetic" commitment, considerations of such dimensions of the work are very frequently integral to the success of the work on its own terms. Often, narrative artworks aim at currying admiration for certain characters. But if such a work fails to do so because the artist has invested the character with a morally repulsive attribute, not only may the critic chide the artist's decision because it failed to realize the aim of the work but she may also lambaste the artist for his ethical shortcomings in mistaking vice for virtue.

Another line of complaint against the plural-category approach might be that it is ontologically naïve. So far I have acted as though I presume that each artwork falls squarely into one and only one category without remainder. But that is not very plausible. All sorts of mixtures and hybrids are not only conceivable, but actual. The movie The Black Book has been referred to as a film-noir, costume film, while Norman Mailer's Executioner's Song is a nonfiction novel. Cervantes's Don Quixote is both a chanson de geste and a satire. And there are prose poems.

Pirandello's Six Characters in Search of an Author has been called a "dramedy," a mixture of comedy and drama, while The

Sopranos is both a gangster fiction and a family melodrama. And Thoreau's *Walden* is in part a nature book, a do-it-yourself guide, social criticism, belles-lettres, and a spiritual exercise.

In the world of dance, there are: Jerome Robbins's *Fancy Free* (in which ballet crosses with Broadway); Balanchine's *Stars and Stripes* (which blends ballet and a halftime football show); Balanchine's *Union Jack* (which mixes ballet with Edinburgh tattoo and the English music hall); Mark Morris's *Striptease* (modern dance plus strip show); Morris's *Championship Wrestling* (modern dance plus TV wrestling); and so on.

In literature, there is the hybrid form of the novel-in-stories, including: Sherwood Anderson's *Winesburg Ohio*, Isaac Babel's *Red Cavalry*, Hemingway's *In Our Time*, Dos Passos's *Manhattan Transfer*, Cheever's *Housebreaker of Shady Hill*, Selby's *Last Exit to Brooklyn*, Erdrich's *Love Medicine*, Joyce's *The Dubliners*, Faulkner's *Go Down Moses*, O'Brien's *The Things They Carried*, and David Shields's *Handbook for Drowning* (not to mention Jean Toomer's genre-crossing *Cane*).[10]

However, although, as these examples more than amply attest, it is true that artworks may inhabit more than one category, this does not refute the plural-category approach; it only reminds us that evaluation is sometimes more complicated than my examples thus far may have suggested. Where an artwork involves a fusion of two or more categories, the realization of the points and purposes of the different kinds should be calculated in terms of each category's proportionate influence on the overall outcome of the work.

For example, the movie *Beetlejuice* is an example of genre-splicing—the conjunction of horror and comedy. Though it is predominantly comic, it also aspires, at moments, to frighten. A critical evaluation of *Beetlejuice* should

estimate the capacity of this motion picture not only to deliver laughs, but also to change moods rapidly in order to elicit a sense of foreboding creepiness. (And, I am quite happy to report that Beetlejuice does superbly on both counts.)

Of course, since a single artwork may belong to more than one category, the possibility arises that a given work may serve, in a manner of speaking, one of its masters well and the others poorly. Many horror-comedies are less successful than Beetlejuice; very often the comedy is effective, but the horror is lame. In that case, the critical evaluation will have to record mixed results.

However, the fact that the plural-category approach may often lead to mixed evaluations does not constitute a problem of any sort, since mixed results should come as no surprise when it comes to the evaluation of artworks. It happens all the time.

Indeed, even when considering a work in a single category of art, there may be mixed results, if only because even a single category of art may have more than one point or purpose. All sorts of adventure stories involve both a romantic plot and a problem solving plot—for example, two secret agents must thwart the conspiracy led by an international terrorist at the same time their courtship is supposed to move apace, usually from initial hostility to mutual adoration. But there is nothing strange about the presentation of these two endeavors coming apart qualitatively—the problem-solving part being successfully suspenseful, but the love-making being forced and dull. In other words, there is nothing anomalous or embarrassing about a critical approach that makes mixed results possible or even likely.

In fact, when you come to think about it, probably most critical assessments of artworks are or should involve mixed

results. For, most artworks, save perhaps some of the most incomparable masterpieces, warrant mixed appraisals. And, even some of the masterpieces have their defects. For example, some of Dostoevsky's greatest novels trade off unity for intensity.

So, mixed results are really the norm. Consequently, the fact that the plural-category approach readily leads to mixed results is not a liability. It shows that this approach is in conformity with the facts on the ground. Moreover, that the plural-category approach is often able to clarify exactly why we are issuing a mixed result in the relevant cases should count additionally in its favor.

There is also the worry, broached in the previous chapter, that the plural-category approach is too conservative. The basis for this suspicion is the presumption that, in speaking of categories, we must have in mind a finite number of fixed categories, whereas, in truth, a sober consideration of art history reveals that there is an indefinitely large number of categories, many of which are in the process of continuous mutation.

However, the defender of the plural-category approach can and should acknowledge this. New categories are emerging all of the time and even many of our standing categories are undergoing constant evolution. But, these new categories and categorical developments do not pop into existence *ex nihilo*. They emerge through the operation of well-known processes of development, including: hybridization or category-splicing; the inter-animation of the arts (the movement of the concerns of one artform to the formation of a new category in another artform as in the case of the influence of minimalist painting on minimalist dance); amplification (the discovery of new solutions to earlier problems); repudiation

(the rejection of a dominant or reigning style in the name of some neglected but acknowledged value of art—as Duchamp rejected art that addressed the eye in favor of art that addressed the mind); and so forth. Therefore, insofar as the processes by which new categories of art arise and come to the fore and by which old categories evolve are understood, it is possible for the plural-category critic to keep track of them, their purposes, and their connected standards of value in *medias res*, so to speak.

This may appear to fly in the face of the phenomenon of the avant-garde. However, not only do the developments within the avant-garde and its proliferation of new categories follow the recurring patterns of artistic innovation that were alluded to above; the institution of the art world in which avant-garde art operates also swells with information about emerging categories of art, even as they exfoliate before our very eyes. There are interviews, manifestoes, artists' statements, curatorial statements, grant applications, and lectures/demonstrations, not to mention a constant circuit of conversations (a.k.a. incessant gossip) between artists and artists, artists and critics and curators, critics and critics, curators and curators, and all of the permutations thereof and more.

Although the appearance of an apparently new kind of art may dumbfound the bourgeoisie (as it is meant to, although perhaps with decreasing success), the informed critic, covering the experimental beat, usually has a general grasp of the contours of the emanent avant-garde forms and their subtending aspirations as those forms unfold before us. Perhaps needless to say, one of the major functions of such critics is to keep the interested audience apprised of the appearance of new artforms, genres, styles, and movements

and to explain their points and purposes in a way that assists the laity in understanding them.

It may seem questionable that critics can have a handle on the new as it explodes onto the scene. Some philosophers of art—of the epistemologically musclebound variety—may even suggest that such a feat of criticism is paradoxical or, at least, suspect.* Yet it happens all the time, and the factors that make it possible are, as I have itemized: 1) that the processes, like repudiation, through which new artforms evolve from the tradition recur at a frequency such that the informed critic can use knowledge of the past to plot the direction of the emerging categories, and 2) there is ample information in the form of art world chatter for the informed critic to have a good sense upon its arrival of the points and purposes of the latest avant-garde breakthrough, even as it is occurring.

For example, in his infamous article "Art and Objecthood," Michael Fried was able to track the category of Minimalist art—which he called literalist art—as it coalesced before his very eyes and to identify its aims with great accuracy (even though those were aims of which he ultimately disapproved).[11] And he was able to do this by paying close attention to the stated intentions of artists like Donald Judd, Robert Morris, and Tony Smith, while also charting the structural convergences in their work.

A final objection to the plural-category approach may be that it makes evaluative comparisons between artworks in different categories impossible. This is surely an exaggerated anxiety. As we have seen, sometimes artworks belong to more than one category, and where the categories of two artworks overlap, they can be compared in virtue of those categories. In

* Here I am thinking especially of anti-intentionalists.

a similar vein, many categories of art share points or purposes, such as narration. Clearly, works from different categories can be compared in terms of their converging points and purposes.

On the other hand, given my view of criticism as primarily an affair of discovering what is valuable in an artwork, I think that frequently too much is made of the role of the critic as a person whose business it is to pronounce upon which artworks are best, which better, and which are worse. Critics are not art world touts; their primary assignment is not to provide the rest of us with tips about which artworks will win, place, or show and in what order. Rather, we expect critics to assist us in seeing what there is of value in the work at hand. Thus, it is not a liability of the plural-category approach that it is not obsessed with comparison, especially evaluative comparisons that reach across categories.

In order to pinpoint that which is valuable in a work, the critic may compare artworks. But such comparison is generally undertaken in order to show how the choice of this strategy instead of that one enabled the artist to achieve her purposes more expeditiously than an alternative strategy, as exemplified in another artwork. This sort of comparison undoubtedly has a role to play in analyzing artworks. One artwork, in other words, is used to cast light on the structure of another artwork. Yet a piece of criticism does not strike me as incomplete if after it shows us what is valuable in a work (or, at least, some of what is valuable), it does not then go on to say whether or not the work is better or worse than other artworks, even artworks of the same kind.

Being shown what is excellent about *The Miser* or *The Bourgeois Gentleman* doesn't require some added comment about how the excellence of either of these compares to that of *Pygmalion*.

And even less does an account of the merits of *Gulliver's Travels* require a comparison with the achievement of Jasper Johns's target paintings or Mussorgsky's *Pictures at an Exhibition*. Criticism suffices that assists its readers in comprehending what is valuable in the work under discussion—period and full stop.

In short, on my view, there seems to be a misplaced emphasis on the critical comparison of artworks, especially for the purpose of ranking them—as if critics were essentially aesthetical accountants. In most cases, ranking the artworks in question seems beside the point. We want the critic to tell us what to be on the lookout for in a particular work, e.g., what of value can we find in this particular musical composition? It is not as if the focus of our attention is a wrestling competition between this work and a bunch of other works. Or, to shift metaphors, attending to an artwork is not like following a baseball game early in the season with an overriding interest in who will ultimately win the World Series.

Some intra-category, evaluative comparisons are possible, as we have seen, although I am not convinced that even this activity is of the utmost critical importance and urgency. Yet many other inter-category critical comparisons are incommensurable and are best left to one side (though we will discuss the grounds for certain sorts of cross-categorical comparison in the next section). And finally, many critical comparisons may be downright silly and/or distracting.

For example, the question of which is better, *As You Like It* or the Parthenon, or *The Well-Tempered Clavier*, seems almost impossible to get one's mind around. It strikes one as silly. And even if you could answer it, who cares? What would be the point? Especially when it comes to masterpieces, there seems to be little pressure to say which one is the winner. This

may be an enjoyable pastime for connoisseurs and fans, but not critics. What we want from the critic is guidance regarding the excellence to be found in each of these works. Arguing over which is superior, even if we could pull off a decision, has nothing to do with being put in a position to appreciate the particular value of each masterpiece in its own right.*

So, once again, the fact that the plural-category approach to critical evaluation is not perfectly suited to making every imaginable sort of comparative evaluation may not be a flaw in the approach, but rather an indication that it is on the right track.

In sum, then, some criticism can be said to be objective in virtue of its mobilization of categories of art as a crucial element in the process of evaluation. Some critical disputes can be settled objectively, since some disagreements will rest on debates over the correct categorization of the works in question and many debates of this variety can be settled objectively.

Of course, not all critical disagreements about works of art are disagreements about categories. There may be disagreements about how to describe, contextualize, interpret, and/or analyze works, but these disputes may also be objectively tractable. If one claims that a painting is symmetrical, but it is

* It might be charged that I am too hasty in my demotion of the importance of critical comparisons. It might be claimed that critics should rank, since there is so much art available that audiences need rankings for the purpose of deciding what to consume. But I think that this does not coincide with the facts. Most pieces of criticism do not end with the advice, see this rather than that, these rather than those. Nor does the ranking of masterpieces in this regard make much sense. We should see as many as we can.

not, that is not something that is subjectively up for grabs. Needless to say, it is not my contention that the invocation of categories will dispel every critical disagreement. But since I know of no area of inquiry where disagreement has been banished entirely—not even physics—I do not think this is either a unique or a deep problem for criticism.

One of the leading arguments against the prospect of objective criticism is that there are no general critical principles. For, it is presumed that if there are no general critical principles, then all critical evaluations can only be subjective. We have blocked this inference, however, by showing that, in some cases, the requisite generalities are available through a consideration of the category of art to which the work in question belongs and its subtending points and purposes.

Nor do I think that the word "*some*" here is niggling. For, I conjecture that a great many, if not most, of the evaluative judgments that critics issue with respect to works of art are category-relative, whether or not the critics realize it, if only because humans in general have a natural tendency, psychologically, to key their appraisals to categories. And, if this is correct, it suggests that a substantial number of critical evaluations are objective, despite the common sentiment that they all must be no more than subjective,* just because a great many categorizations can be shown to be correct objectively.

* Although this section has emphasized the possibility of objectively ascertaining the point or purpose of the work through a consideration of its correct categorization, it should also be clear that another way of grounding one's evaluation of an artwork might be through contextualization. That is, even if there were a work that defied all categorization—something whose likelihood, I believe, must be close to nil—there are absolutely no grounds

V. CRITICISM AND THE LIFE OF CULTURE

I have been arguing that most critical evaluation is category-relative and that it is very often ridiculous to engage in comparison for the sake of grading when it comes to works from disjoint categories. Attempting to rank a hard-boiled detective novel by Raymond Chandler vis-à-vis a Fabergé egg either just taxes sense or is downright silly. However, there do seem to be some cases where cross-categorical comparisons are advanced which are not absurd. Thus, if it is the aim of this book to account for our practices of criticism as they are, something needs to be said about the grounds for cross-categorical, critical evaluations where said evaluations appear to be legitimate, or, at least, unexceptionable.

Throughout this text, emphasis has been placed on critical appraisals of artworks on their own terms, which are most frequently the terms of the category or categories of art to which they belong. But if there are evaluative judgments of artworks across disjunct categories, then these cannot be category-relative appraisals. How are such appraisals possible?

I think that there are two major kinds of occasions where cross-categorical assessments are made confidently. The first is relatively uncontroversial. If we are comparing a work of questionable value from one category to a masterpiece of

to suppose that we could not objectively establish the presiding points or purposes of the work through an account of its context—whether institutional, art historical, or more broadly social—which account, moreover, could divulge the standards of achievement appropriate to the work on its own terms. Artworks, like other artifacts, are made for reasons; we can discover those reasons by examining the context in which the work was created; and we can use those reasons to estimate the degree of success of the work on its own terms.

another category, there does not seem to be much strain in saying that the latter is superior to the former. No one blanches at the assertion that the St. *Matthew Passion* is greater than *The Three Stooges in Orbit*. For where one work is pretty close to the top of its game and the other is near the bottom of the league of its own, the comparative ranking seems well motivated. Where things very often get giddy, it appears, is when masterpieces from wildly different classes are measured against each other.

Nevertheless, even here, there are some cases where it seems that many of us are comfortable with cross-categorical comparisons. There is nothing so exquisite as a well-wrought Jeeves-and-Wooster story by P.G. Wodehouse. And yet I suspect that many, including Wodehouse lovers like myself, would agree that such a story is not the equal of Michelangelo's also undeniably spectacular accomplishment, the epic *Sistine Chapel*.

Here it is not the case that the lower ranked work is poor of its kind. Quite the contrary, it's superlative. So on what grounds do we rank the Wodehouse beneath the Michelangelo? I think the answer is unavoidable. We think that the kind of artwork that Michelangelo's work represents is regarded to be more important than the genre in which the Wodehouse story excels. "More important" relative to what? More important to the life of society. Michelangelo's achievement is virtually an encyclopedia of the culture of his age. Obviously the ambition—and achievement—of a Jeeves-and-Wooster story are of a different order of cultural significance. The point here is not that comedy per se is a lesser genre than epic. Rather, the kind of comedy in which Wodehouse excelled—frivolity for its own sake (which is rather a good thing)—is not of the same cultural heft as the

encyclopedic ambition on display in the *Sistine Chapel*. I suspect even Wodehouse would concur.

The Jeeves-and-Wooster story is excellent of its kind as is the *Sistine Chapel*, but the kinds and their related purposes are valued differently. The Michelangelo is the mythic expression of some of the deepest beliefs and feelings of the Catholic civilization into which Michelangelo was born. The Jeeves-and-Wooster story is an absolutely splendid comedy with little or no redeeming social value (and, undoubtedly, Bertie would have been proud of it). When confronted with masterpieces from genres with these very different claims upon the interest of the culture at large, I suspect that we do not think that it is silly or beside the point to concede that the masterpiece from the genre with greater cultural substance outweighs the masterpiece from the less socially significant genre.

Moreover, to return to the question of the objectivity of criticism, I do think that *sometimes* we can reach agreement rationally about the relative cultural importance of different categories of art. Novels that explore forgotten or unacknowledged dimensions of the human psyche—such as *Beware of Pity* by Stefan Zweig—are more culturally important than comic strips, like *Hagar the Horrible*, of slovenly, overweight, dysfunctional, and lazy middle-aged Vikings, as delightful and amusing as those cartoons may sometimes be. Indeed, I believe that we can grant that this is the case, even if in our hearts of hearts we prefer comic strips. And on some occasions the critic may think that it is not only important to comment on the success value of the work, but also on the significance of the purposes of that kind of art.

Of course, I would also admit that there are cases where there can be reasonable disagreement about the relative

importance of a category of art for the culture at large—cases where there is nothing that either side in the debate can appeal to for objective leverage. In those cases, it may be just silly or beside the point to contrive a cross-categorical ranking.

As I said, I do not think that the kind of cross-categorical ranking which requires a determination of the relative importance of the pertinent categories of art to the culture at large is the norm. In my guess-estimation, most criticism is conducted within the bounds of categories. Moreover, when the critic works within the categories in her chosen domain of expertise, her criticism is *art* criticism narrowly construed—that is, criticism based in her knowledge of the traditions, histories, theories, styles, genres, oeuvres, and categories of the artform or the artforms that comprise her field of expertise. This is the sort of specialized learning that one may acquire by attending art classes—historical, theoretical, critical, and practical—or by reading up on or exposing oneself widely to the kind of art in question.

However, the weighing of the cultural importance of different categories of art is not art criticism narrowly construed. Perhaps we should call it cultural criticism. It demands that the critic function not simply as an art expert but as something more of the nature of a public intellectual. In order to pull this off, the critic must be informed about and be a participant in the conversation of his or her culture. This requires general understanding in addition to a specialized background.

At this point, it may be objected that we have gone beyond the compass of art criticism and into the realm of social punditry. But I am not so sure. My ambition throughout this book has been to rationally reconstruct our critical practices.

In order to do so, especially in terms of certain of the cross-categorical rankings with which critics seem comfortable, it seems advisable to speculate that the sort of cultural criticism discussed above plays a role. To say it ought not—because it is not art criticism, properly so called—seems legislative, rather than descriptive. The boundary between art criticism narrowly construed and what might be called cultural criticism is porous, a fact that should be readily apparent to anyone who reads criticism regularly.

But the need for a critic to be an informed citizen of her culture at large not only becomes evident when the issue of cross-categorical comparisons erupts. It may also be important when comparing works in a single genre where both serve the genre well but one, in addition, contributes something of greater social significance than what is usually expected of the category in question.

For example, *The Bad and the Beautiful* and *Sunset Boulevard* both belong to the genre of the Hollywood exposé. But in addition to its caustic view of the movie industry, *Sunset Boulevard* offers something else—a popular philosophical exposition, if you will, on the very human tendency to deny aging and thereby to deny, as Heidegger might have it, our mortality.

Although ostensibly at the sunset of her life, Norma Desmond fails to grasp that she is no longer the young starlet she was when Max and Cecil B. De Mille were her directors. Her failure to acknowledge aging leads to her tragic end. Like *Oedipus Rex*, which reminds viewers to call no one happy until they are dead, *Sunset Boulevard* recalls our attention to a Heideggerian fact about human existence which we all know but deny in the way we conduct our lives—the fact that we are headed toward death.

That in addition to being a very well designed and polished Hollywood exposé, *Sunset Boulevard* also performs the function of popular philosophizing—of bringing to mind truths about the human condition that have been forgotten, neglected, or repressed—makes *Sunset Boulevard* more socially significant than *The Bad and the Beautiful*. And this is something that the accomplished movie critic should figure into her evaluation of *Sunset Boulevard* and assist the viewers in appreciating.

A good critic should be a master of the history and categories of the artform about which she has elected to specialize. She should be an art critic, narrowly construed. However, that is not enough. She should also be a cultural critic. For, the arts are not simply hermetically sealed enterprises. The arts are among the major conduits for the ideas, beliefs, and feelings that form the warp and woof of a living culture. This is as much a part of the function of the arts as is the solution of the problems that beset the individual practices of the arts. Consequently, even though most workaday criticism is art criticism, narrowly construed, the critic-in-full of art cannot altogether shirk the responsibilities and risks of cultural criticism.

Notes

INTRODUCTION

1 Monroe Beardsley, *Aesthetics: Problems in the Philosophy of Criticism* (New York: Harcourt, Brace & World, 1958). Another example is Jerome Stolnitz's *Aesthetics and the Philosophy of Criticism* (New York: Houghton Mifflin, 1960).

ONE CRITICISM AS EVALUATION

1 This view corresponds to the one developed by Barbara Gardener in her *The Business of Criticism* (Oxford: The Clarendon Press, 1959), especially Part I. I have been greatly influenced by Gardener throughout this book.

2 The poll was conducted by the National Arts Journalism Program at Columbia University; 160 art writers were questioned. The results were reported in Raphael Rubinstein, "A Quiet Crisis," *Art in America*, 91, No. 3 (March 2003), pp. 39–45. The study that Rubinstein was reporting on was *The Visual Arts Critic: A Survey of Art Critics at General Interest Publications in America* (New York: National Arts Program—Columbia University, 2002). The flight from evaluation is also discussed at length in James Elkins, *What Happened to Criticism* (Chicago: Prickly Paradigm Press, 2003).

3 Arthur Danto, "The Fly in the Fly Bottle: The Evaluation and Critical Judgment of Works of Art," in his book *Unnatural Wonders: Essays from the Gap between Art and Life* (New York: Farrar, Straus, Giroux, 2005), pp. 355–68.

4 John E. Booth, *The Critic, Power, and the Performing Arts* (New York: Columbia University Press, 1991), p. 176 and p. 177 respectively.

5 This argument is suggested by Francis Sparshott in his book *The Concept of Criticism* (Oxford: Clarendon Press, 1967). I have benefited immensely from Sparshott's insights in this splendid book throughout the preparation of my text.

6 Ibid.

7 See D. B. Wyndham Lewis, Charles Lee, and Billy Collins (eds.), *The Stuffed Owl: An Anthology of Bad Poetry* (New York: New York Review Books Classics, 2003). There is also a Museum of Bad Art; check out their postings at http://www.museumofbadart.org/. Moreover, the Nazis did not intend to be commending the work featured in their exhibition of Decadent Art.

8 The example comes from *General Criteria in Aesthetic Theories* by Susan Louise Feagin (Madison, WI, an unpublished doctoral dissertation for the Philosophy Department of the University of Wisconsin, 1975), p. 62.

9 David Denby, "Teen Dreams," *The New Yorker*, 20 August 2007, pp. 76–7.

10 Arthur Danto, "Deep Interpretation," in his *The Philosophical Disenfranchisement of Art* (New York: Columbia University Press, 1986), pp. 47–67.

11 Quoted in the Preface of *The Business of Criticism*.

TWO THE OBJECT OF CRITICISM

1 For further argument, see Matthew Laurence Kieran, *Revealing Art* (London: Routledge, 2004), especially Chapter 1.

2 See Guy Sircello, "Expressive Properties of Art," in *Philosophy Looks at the Arts*, 3rd edition, ed. Joseph Margolis (Philadelphia: Temple University Press, 1987); and Berys Gaut, *Art, Emotion and Ethics* (Oxford: Oxford University Press, 2007), pp. 72–6.

3 This is what I think Flint Schier meant by the "aesthetics of agency." See his "Hume and the Aesthetics of Agency," *Proceedings of the Aristotelian Society* (1986–7), pp. 121–35; and his "Van Gogh's Boots: the Claims of Representation," in *Virtue and Taste*, ed. Dudley Knowles and John Skorupski (Oxford: Blackwell Publishers, 1993), pp. 176–99. An emphasis on what is done by means of the artwork is also defended by Alfred Gell, *Art and Agency: An Anthropological Theory* (Oxford: Clarendon Press, 1998). Gell, however, supports this position from the perspective of anthropology rather than art criticism.

4 See Sircello and Gaut.

5 The term "success value" derives from George Dickie, *Art and Value* (Oxford: Blackwell Publishers, 2001), p. 104.

6 See Kieran.

7 See J. Hoberman, "Bad Movies," *Film Comment*, July–August 1980; and Hoberman, "Vulgar Modernism," *Artforum*, February 1982.

8 Perhaps the most famous brief against the relevance of artistic intentions to evaluation is: Monroe C. Beardsley and William Kurtz Wimsatt, "The Intentional Fallacy," *The Swanee Review*, LIV (1946), pp. 466–88. Beardsley continued the debate in his *Aesthetics: Problems in the Philosophy of Criticism* (Indianapolis: Hackett Publishing Co., 1981; originally published 1958).

9 For further discussion, see Noël Carroll, "Anglo-American Aesthetics and Contemporary Criticism: Intentions and the Hermeneutics of Suspicion," in my *Beyond Aesthetics: Philosophical Essays* (New York: Cambridge, 2001).

10. In this way, my position does not reduce to that of either Gregory Currie in his *Ontology of Art* (New York: St. Martin's Press, 1989) or David Davies in his *Art as Performance* (Oxford: Blackwell Publishers, 2004).

THREE THE PARTS OF CRITICISM (MINUS ONE)

1 See Colin McGinn, *Shakespeare's Philosophy: Discovering the Meaning behind the Plays* (New York: Harper Collins Publishers, 2006), pp. 17–34.

2 Jacques Rancière, *The Future of the Image*, translated by Gregory Elliott (London: Verso, 2007), p. 34.

3 Marjorie Perloff, "Read the Poem," *The Times Literary Supplement*, No. 5449 (7 Sept. 2007), p. 22.

4 Hans-Georg Gadamer, *Truth and Method* (New York: Sheed and Ward, 1975), pp. 333–5.

5 See Erwin Panofsky, *Studies in Iconology* (New York: Harper Colophon, 1972).

6 Giovanni Pietro Bellori, "The Image of the Ancient Gymnasium of Athens, Or, Philosophy," in *Raphael's "School of Athens"*, ed. Marcia Hall (Cambridge: Cambridge University Press, 1997).

7 See Flint Schier, *Deeper into Pictures* (Cambridge: Cambridge University Press, 1986).

8 John R. Searle, "Literal Meaning," in his *Expression and Meaning* (Cambridge: Cambridge University Press, 1979).

9 See Annette Barnes, *On Interpretation* (Oxford: Blackwell Publishers, 1988).

10 Alexander Nehamas, *Only a Promise of Happiness: The Place of Beauty in a World of Art* (Princeton, NJ: Princeton University Press, 2007), p. 27.

11 This is a view robustly defended by Joseph Margolis in a number of publications including his *Art and Philosophy* (Atlantic Highlands, NJ: Humanities Press, 1980).

12 The example comes from Annette Barnes's *On Interpretation*.

13 See Arlene Croce, "Momentous," in her book *Afterimages* (New York: Alfred Knopf Publishers, 1978), pp. 189–90.

14 See, for example, Monroe Beardsley, *Aesthetics* (Indianapolis, IN: Hackett Publishers, 1981).

15 For example, the view defended by Steven Knapp and Walter Benn Michaels, "Against Theory," *Critical Inquiry*, 8 (1982), pp. 723–42.

16 See E. D. Hirsch, *Validity and Interpretation* (New Haven, CT: Yale University Press, 1967); Gary Iseminger, "Actual Intentionalism versus Hypothetical Intentionalism," *Journal of Aesthetics and Art Criticism* (1996), pp. 319–26; Noël Carroll, "Interpretation and Intention: The Debate between Actual and Hypothetical Intentionalism," in *The Philosophy of Interpretation*, ed. Joseph Margolis and Tom Rockmore (Oxford: Blackwell Publishers, 1999).

17 Robert Stecker, *Interpretation and Construction* (Oxford: Blackwell Publishers, 2003).

18. The leading hypothetical intentionalist at the moment is Jerrold Levinson. See his "Intention and Interpretation in Literature," in his *The Pleasures of Aesthetics* (Ithaca, NY: Cornell University Press, 1996).

FOUR EVALUATION: PROBLEMS AND PROSPECTS

1 Joan Acocella, "Mozart Moves," *The New Yorker*, 20 August 2007, pp. 84–5.

2 David Hume, "Of the Standard of Taste," in *David Hume: Selected Essays*, ed. Stephen Copley and Andrew Edgar (Oxford: Oxford University Press, 1993).

3 Immanuel Kant, *Critique of Judgment*, translated by Werner Pluhar (Indianapolis, IN: Hackett Publishers, 1987).

4 Arnold Isenberg, "Critical Communication," *The Philosophical Review*, 58 (1949), pp. 330–44; Mary Mothersill, "Critical Reasons," *Contemporary*

Studies in Aesthetics, ed. Francis Coleman (New York: McGraw Hill, 1968); and Mary Mothersill, *Beauty Restored* (Oxford: Clarendon Press, 1984). For excellent critical discussions of the Isenberg–Mothersill position, see Daniel Kaufman, "Normative Criticism and the Objective Value of Artworks," *Journal of Aesthetics and Art Criticism*, 60 (Spring 2002), pp. 151–66; and Daniel Kaufman, "Critical Justification and Critical Laws," *The British Journal of Aesthetics*, 43 (October, 2003), pp. 393–400.

5 A similar line of objection to the Isenberg–Mothersill school of thought can be found in Susan Feagin, "General Criteria in Aesthetic Theories," unpublished doctoral thesis in the Philosophy Department of the University of Wisconsin at Madison, 1975.

6 This point is emphasized by Daniel Kaufman in "Normative Criticism and the Objective Value of Artworks."

7 Looking to the function of the artwork as a way of challenging the Isenbergians is also a move made by Susan Feagin, although, since she appears to see the function of all artworks as affording a certain experience, her solution of the problem is different than mine. See Susan Feagin, "General Criteria in Aesthetic Theories."

8 This section has been deeply influenced by Kendall Walton's seminal article "Categories of Art," in *Art and Philosophy: Readings in Aesthetics*, ed. William E. Kennick (New York: St. Martin's Press, 1979). However, where Walton recognizes four reasons in support of objectively correct classification, I countenance only three.

9 For a discussion of this example, see Mary Bittner Wiseman, *The Ecstasies of Roland Barthes* (New York: Routledge, 1989), pp. 166–73.

10 Stuart Dybek, "Foreword," in *Handbook for Drowning* by David Shields (Medical Lake, WA: String Town Press, 1993).

11 Michael Fried, "Art and Objecthood," in *Minimal Art: A Critical Anthology*, ed. Gregory Battcock (New York: E.P. Dutton, 1968). Fried disapproved of minimalist or literalist art because he claims that, in its address to the beholder, it is *theatrical*, and therefore in violation of the Lessing-esque prohibition that one artform should not traffic in the effects of another—e.g., that painting should not intrude upon the domain of theater.

Index

.

Printed in the United States
149606LV00001B/42/P

9 780415 396202